Williams
scene,

William Carlos Williams and the American Scene, 1920-1940

# William Carlos Williams and the American Scene 1920–1940

Dickran Tashjian

Whitney Museum of American Art · New York
in association with the
University of California Press · Berkeley · Los Angeles · London

This book was published in conjunction with an exhibition at the Whitney Museum of American Art, December 12, 1978 February 4, 1979, supported by a grant from the National Endowment for the Humanities, a Federal agency. The publication was organized at the Whitney Museum by Doris Palca, *Head, Publications and Sales*, Margaret Aspinwall, *Editor*, Anita Duquette, *Rights and Reproductions*, and Anne Munroe, *Assistant*.

Published simultaneously in a hard-cover edition by the University of California Press, Berkeley and Los Angeles, and the University of California Press, Ltd., London.

Cover: Excerpt from William Carlos Williams,"The Fault: Matisse," unpublished manuscript D6(c)1, The Poetry Collection, Lockwood Memorial Library, State University of New York at Buffalo.

**Library of Congress Cataloging in Publication Data**

Tashjian, Dickran, 1940-
   William Carlos Williams and the American Scene, 1920-1940.

Bibliography: p. 153
   1. Williams, William Carlos, 1883-1963—
Exhibitions. 2. Art, American—Exhibition.
3. Art, Modern—20th century—Exhibitions. 4. Art
and literature—Exhibitions. I. Whitney Museum
of American Art, New York. II. Title.
PS3545.I544z89          811'.5'2          78-11667
ISBN 0-520-03854-1

# Contents

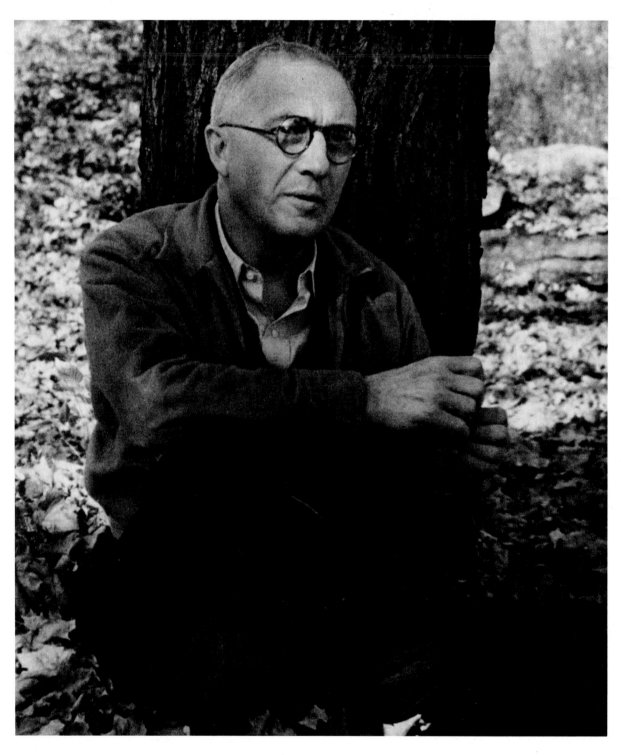

Charles Sheeler, photograph of William Carlos
Williams, 1938. Courtesy of the Estate of Florence
H. Williams.

# Preface and Acknowledgments

By seeing Williams at the center of an essay concerned with the visual arts in America, we acknowledge a person who found sources for his poetry wherever he could and found them frequently enough in the visual arts, which provided him with clues for experimentation as well as corroboration of his own ideas.[1] We are also recognizing the interaction of writers, painters, sculptors, and photographers who made up the changing contexts of the American avant-garde. They came together most often, I suspect, because of the social and hence artistic lacunae in their lives. They needed to create a social fabric for themselves in which they might develop — invent? discover? — a cultural design. Thus the avant-garde never became a hermetic subculture in America. Social instability combined with cultural uncertainty made an emerging avant-garde a tenuous affair, but it also made inevitable a mix of artistic, cultural, and political concerns among the avant-garde during those exciting years following the 1913 Armory Show — those years when Williams committed himself to the new, the "everlasting new."

What happened to the avant-garde in America during the 1920s and 1930s? Was it overwhelmed by "reactionary" American scene painting of the Regionalists and the radical politics of the Social Realists, only to emerge after the Second World War with the "triumph" of Abstract Expressionism? This conventional view largely ignores the complex development of the American avant-garde.[2] Its course was not simply directed against American academic art and its middle-class patronage. The contexts of the avant-garde were constantly shifting. American artists with avant-garde aspirations were often divided by ideology and just as often by personal allegiances. What these conflicting and conflicted groups held in common was their quest for the American scene, which was hardly the exclusive domain of the Regionalists. This quest, as we shall see, was replete with the contradictions and paradoxes governing American life of the period.[3]

Williams serves as our guide to art of the American scene during the 1920s and 1930s. In seeking to create distinctly American art forms through "contact" with America, he charted the basic aesthetic, political, social, and cultural issues facing his contemporaries in and out of the avant-garde even as he remained on the periphery of events and major groups. As early as 1920, in what must have been among his first reactions to Williams, Robert McAlmon recognized the difficulty of categorizing him as a poet.[4] McAlmon's insight should be extended from Williams' poetry to the doctor's situation in American life, which conditioned the writing profoundly. Williams himself acknowledged this elusiveness. "But my failure to work inside a pattern — a positive sin — is the cause of my virtues," he wrote to John Riordan in 1926. "I cannot work

inside a pattern because I can't find a pattern that will have me. My whole effort — in the light of your observations — is to find a pattern large enough, modern enough, flexible enough to include my desires. And if I should find it I'd wither and die."[5]

Williams' cultural significance derives precisely from his marginality during those two decades between the wars — a marginality that deeply shaped his ambiguous and ambivalent perception of the issues of his time. He characteristically stood — to use Victor Turner's term — a liminal figure among the polarities of American culture and society.[6] Of mixed ancestry, Williams was determined to possess America at the same time that he was attracted to Europe, remaining ambivalent toward both continents. He began as a painter and quickly became a poet, yet retained a vital and abiding interest in the visual arts; he experimented in both poetry and prose, often in areas between the two and moved along coordinates of improvisation and painstaking craft; he was an urban poet who was extraordinarily sensitive to nature; he rejected bohemianism as a way of life while embracing the middle class with a full career as a physician in touch with all levels of society in Rutherford; nevertheless, he remained consistently avant-garde and considered himself a revolutionary! The cultural interstices multiply, and thus Williams provides a broad measure of his contemporaries in the arts, many of whom moved in other directions with differing views and commitments. As the quintessential avant-gardist, precisely because he grasped the ambiguities of art in America, Williams guides us through the complexities of the American scene during the 1920s and 1930s.

This study was made possible by the Public Programs Division of the National Endowment for the Humanities, which provided planning and implementation grants to the Whitney Museum of American Art to survey its Permanent Collection for a humanistic study of American art. These were the first such grants to the Whitney Museum from this Federal agency primarily because many of the activities of the Museum which concern living artists are not eligible for consideration. Members of the staff of the National Endowment for the Humanities, particularly Nancy Englander, former Assistant Director, Division of Public Programs, were notably helpful in assisting with the difficult task of making an exhibition based on the relationship of objects with twentieth-century intellectual thought, political ideas, and social concepts.

I want to thank Tom Armstrong, Director of the Whitney Museum of American Art, for his unstinting support in all phases of the project. His staff and associates were no less helpful. Patterson Sims worked closely with me in assessing, gathering, and

organizing the appropriate visual material; Doris Palca, David Hupert, and Pat Westlake were instrumental in bringing this study to its fruition in the publication, the educational projects, and the exhibition arrangements. For their work in these areas I also want to thank Paul Cummings, Anita Duquette, Helen Ferrulli, Barbara Haskell, Lorraine Karafel, Anne Munroe, Walter Poleshuck, Ella King Torrey, and Palmer Wald.

James Laughlin of New Directions Publishing and his staff, especially Else Albrecht-Carrié, generously shared resources and information while preparing *A Recognizable Image: William Carlos Williams on Art and Artists*, edited by Bram Dijkstra. And William Eric Williams and Paul Williams kindly allowed me to intrude in their lives for their memories of their father.

My intellectual sources have been numerous, but I would like to single out Robert Coles for his humanistic scholarship, Victor Turner for his ideas on ritual and culture, Mike Weaver for his exhaustive view of Williams' "American background," and Emily Wallace, whose definitive bibliography of Williams was more than an invaluable tool: it set a high standard of research to follow.

For facilitating my research I want to thank the library staffs of the following institutions which house material pertaining to Williams: The Archives of American Art, The Harris Collection of American Poetry and Plays of the John Hay Special Collections Library of Brown University, the Poetry Collection of the Lockwood Memorial Library of the State University of New York at Buffalo, the Manuscripts Division of the Lilly Library of Indiana University, the Museum of Modern Art Library, the Rare Book Collection of the Charles Patterson Van Pelt Library of the University of Pennsylvania, the Rutherford Public Library, the Humanities Research Center of the University of Texas, the Manuscript Division of the Clifton Waller Barrett Library of the University of Virginia, and the Beinecke Rare Book and Manuscript Library of Yale University. Among librarians I must thank Arthur J. Breton, Rosemary L. Cullen, Mrs. Paul Eckardt, Donald C. Gallup, Karl Gay, Sally Leach, Clive Phillpot, Mary Russo, Samuel Streit, Beverly Vander Kooy, and Neda M. Westlake for their efficient service, cooperation, and hospitality.

An endeavor of this scope required the energy, enthusiasm, and cooperation of many individuals. I can only begin to acknowledge my debts to the following: John Barry, Nathaly C. Baum, Louis Berrone, Celia Betsky, Adelyn D. Breeskin, Milton Brown, Sven Bruntjen, Doris Bry, Barney Burstein, Arthur Cohen, Roderick Davis, James Dennis, Ann and Andrew Dintenfass, Terry Dintenfass, Ruth Ford,

Tom Freudenheim, Deborah Frumkin, Theodora Graham, Juan Hamilton, William I. Homer, Susan Kismaric, Beverly Mallard, James Maroney, Richard Martin, William J. McClung, George Monteiro, Dorothy Norman, Georgia O'Keeffe, Robert Pincus, Robert Schoelkopf, Joseph Slate, Marion Stroud, Joshua C. Taylor, John Allan Walker, Stan Wiederspan, and Virginia Zabriskie.

Finally, a special measure of gratitude belongs to Sam Carmack, III, Dore and Mimi Gormezano, Dick Horoshak, Philip Johnson, Joseph Jorgensen and my colleagues in the Program in Comparative Culture, Harold and Melanie Snedcof, and Nate and Nan Sumner. And of course Ann, Hannah, and Lootfi. This one is for him as my father did for me with his work.

Dickran Tashjian
Laguna Beach, California, 1978

# Introduction    13

"What do you consider your strongest characteristics?" asked the editors of *The Little Review* in their valedictory issue of 1929. "My sight," answered William Carlos Williams, the poet who practiced medicine in Rutherford, New Jersey. "I like most my ability to be drunk with a sudden realization of value in things others never notice." In 1929 Williams was forty-six years old, though remarkably youthful and energetic. As he approached fifty, he took stock of himself, noting in a letter to Marianne Moore that he had taken to wearing glasses: ". . . I don't like not being able to see dust flecks quite so distinctly as formerly — and the grains of pollen in the flowers." Again, an emphasis upon sight and those things which usually go unseen. More than a decade earlier, in his Prologue to *Kora in Hell*, published in 1920, he had pointed out "the virtual impossibility of lifting to the imagination those things which lie under the direct scrutiny of the senses, close to the nose. It is this difficulty that sets a value upon all works of art and makes them a necessity." If we expect a poet to talk about words, we have this a few years later in *The Great American Novel*: "But can you not see, can you not taste, can you not smell, can you not hear, can you not touch — words?"[7]

Since seeing came first for Williams, it should cause little surprise to learn that he had been a Sunday painter while attending the medical school at the University of Pennsylvania. He soon gave up painting for poetry, appreciating, among other things, that writing required less apparatus. It could be done on the run, between patients, if necessary. What remained, and not just peripherally, was a strong interest in the visual arts. "French Painting and Modern Writing," a terse note scribbled to himself on a prescription blank (Fig. 1), was filled out more completely in a letter to Wayne Andrews in 1932: "The French poets have had no influence on me whatever. . . . I have, however, been influenced by French painting and the French spirit, which, through my mother, is partly my own."[8]

What Williams gained from the French occasionally came from direct observation of their work. During the decade of the Armory Show he made weekend forays into New York to the few galleries that displayed modern art, where he encountered a handful of French emigrés seeking relief from the European war. Chief among them in 1915 was Marcel Duchamp, whose *Nude Descending a Staircase* had caused such a furor at the Armory two years before. Duchamp was taken up by Walter Arensberg, who later sponsored *Others*, a little magazine edited by the poet Alfred Kreymborg from a small artists' colony in Grantwood, New Jersey. Williams took charge of the final number in 1919.

The Williamses invited the whole crew out to Rutherford just prior to America's entry into the First World War (Fig. 2):

We fed 'em and wined 'em all day long. They were under the cherry tree when the snapshot was made of the Arensbergs, M. Gleizes, Marcel Duchamp, Kreymborg, [Robert Alden] Sanborn, Man Ray, [Alanson] Hartpence and [Maxwell] Bodenheim. In another picture were their wives and sweethearts, Gertrude Kreymborg among them. There were besides Ferdinand Rhyer, and Skip Cannell leaping upon the trunk of a car which was on its way to my brother's to fetch ice that Sunday. I was afraid he would be thrown off and injured. Duchamp was much amused at Bodenheim's tragic posturing. We were in and out all over the lawn. If anything was said I've forgotten it. Yet it was a good party.[9]

In those days and in the decades following, the three great avant-garde movements from Europe — Cubism, Dadaism, and Surrealism — passed almost imperceptibly through New York and into the environs of Rutherford. Since Williams' appetite for avant-garde contacts was only whetted by occasional festive gatherings, he finally took a year's leave from his practice to visit France in 1924.

It was not entirely necessary to go abroad to feel the French influence. Foremost among the private galleries that exhibited modern art was Stieglitz's "291" until 1917, and then his Intimate Gallery, which he opened in 1925, and finally An American Place, inaugurated in 1929. Stieglitz's colleague Marius De Zayas ran a gallery after the First World War, and Charles Montross, Charles Daniel, Edith Halpert, and Julien Levy all sponsored modern artists during the 1920s and 1930s. The Société Anonyme, Inc., begun in 1921 under the auspices of Katherine S. Dreier, held numerous exhibitions and lectures on modern art and was soon joined in common endeavor during the 1920s and 1930s by the Whitney Studio Club, the Museum of Modern Art, and Albert Gallatin's Modern Gallery of Living Art. These institutions, differing in their programs and struggling though they were, all provided Williams with a varied visual environment in which to see modern European and contemporaneous American art.[10]

Most importantly, Williams came to know three Americans who, early in their training as artists, responded favorably and sensitively to European modernism. While still a medical student, as Williams tells us in his *Autobiography*, sometime around 1905 he chanced upon Charles Demuth "over a dish of prunes at Mrs. Chain's boarding house on Locust Street" in Philadelphia, where the young painter was attending Drexel Institute.[11] Within the next decade of the First World War Williams met Marsden Hartley among a common circle of New York friends and acquaintances. In 1923 Williams was introduced to Charles Sheeler. They remained lifelong friends. All three painters had been to Europe prior to the

1913 Armory Show: Demuth and Sheeler to France, and Hartley to Germany as well. Although they developed as independent artists in their own right, they were powerfully attracted to the achievement of the European avant-garde, Hartley especially to the German Expressionists with whom he exhibited in Munich in 1913. Williams was witness to their subsequent efforts to accommodate European experimentation to their own work, which they hoped would have a distinctively American quality.

The three artists became affiliated with Alfred Stieglitz in New York and gave Williams ready access to the photographer and others of his circle, particularly Georgia O'Keeffe and John Marin, but also Paul Strand and Arthur G. Dove. Although the poet's friends were centered around Stieglitz, the group itself was hardly narrow in its artistic outlook, given the photographer's emphasis upon the individualism of the artist. Moreover, Williams was attracted to artists outside the Stieglitz group, ranging from Stuart Davis and William Zorach to Pavel Tchelitchew and Walker Evans. When we consider the individuality of the artists in question and the diversity of their means and preoccupations, we

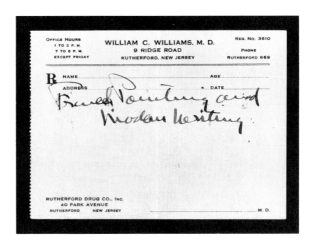

Fig. 1. Prescription blank of Dr. Williams. From the Poetry Collection of the Lockwood Memorial Library, State University of New York, Buffalo; courtesy of New Directions, New York.

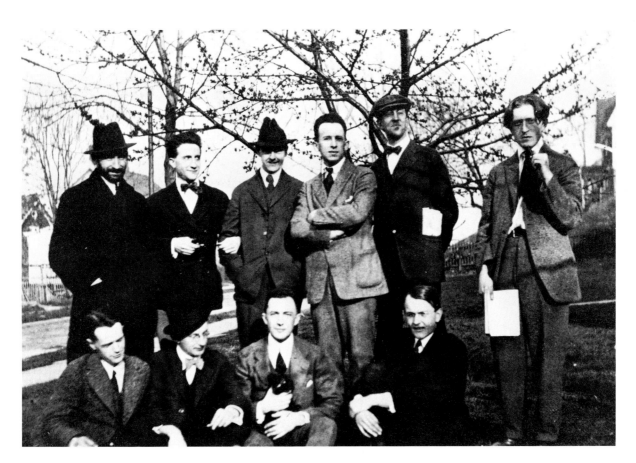

Fig. 2. The *Others* group, 1916. In front, from left Alanson Hartpence, Alfred Kreymborg, William Carlos Williams, Skip Cannell; in back, from left, Jean Crotti, Marcel Duchamp, Walter Arensberg, Man Ray, Robert Alden Sanborn, Maxwell Bodenheim. From the Poetry Collection of the Lockwood Memorial Library, State University of New York, Buffalo; courtesy of New Directions, New York.

realize that there was no American school to speak of, nor was there a single coherent movement that encompassed and directed them. Those few Americans who committed themselves to the avant-garde most often developed slowly and painfully as artists, rarely conforming to the notion of progress underlying the concept of an avant-garde. Even fewer artists sought Williams as a leader or example to follow. In no way did he ever become an André Breton, a "magus of Surrealism," dispensing favor or ultimatum according to an established program.[12] As a consequence, the artistic and cultural significance of these relationships is characterized much less by influence than by confluence, artists coming together to share, discuss, argue, and, of course, disagree about the making of art.

Despite the eclectic appearance of these various relationships, their inner coherence becomes visible through their artistic import for Williams. Although his first encounter with Demuth was serendipitous, his subsequent attraction to painting, photography, and sculpture had the markings of deliberate choice. It was conditioned by his commitment to the art of poetry and fostered by his primary artistic context, that of the avant-garde in New York. In looking back on his contemporaries during the 1913 Armory Show Williams emphasized their common enthusiasm for the new European art. "What were we seeking?" he asked. "No one knew consistently enough to formulate a 'movement.' We were restless and constrained, closely allied to the painters. Impressionism, dadaism, surrealism applied to both painting and the poem."[13] An incipient American avant-garde — made up of painters and writers, sculptors and photographers interacting among themselves — turned to Europe for new forms, new ideas and values, finally for new ways to measure American life.

Through this pervasive chaos Williams could identify, directly and indirectly, even by deflection, European movements and corresponding aesthetic ideas in his friends and acquaintances in the visual arts. But movements are finally abstractions, no matter their seeming embodiment in individuals, and Williams was a poet, intensely committed to words. Thus he directed his restless curiosity, not to imitate naively the work of those visual artists he admired, but to understand the essential aesthetic principles that led to their innovation so that he might apply them toward the creation of new poetry. Even though the European avant-garde dominated American artists (as the Academy had before it), Williams sought a distinctly American art free from European standards. It was to be achieved through the perception and understanding of the particular locale in which an artist lived. So Williams settled in Rutherford, where he might make "contact" with America, as he put it in the early 1920s. He vigorously maintained this position throughout his entire life. Williams' concerns were typical. What had begun at the time of the Armory Show as a common attraction among artists for the creation of new forms gradually transcended technique or style in order to take on the central problem of correlating European forms with American culture and society.

This problem was intensified by the fact that social and political events had a way of drawing one's attention during the 1920s and 1930s. Like so many others during the 1930s Williams extended his political commitments, which brought him in touch with different groupings of artists in and out of the avant-garde. Through Sheeler he knew the work of those painters loosely related as "Precisionists" whose depictions of technology raised political controversy because they apparently had little to do with the plight of the worker. Williams' abiding interest in the Stieglitz group made him aware of the disputes over modernism stirred up by Thomas Hart Benton and his Regionalist following. His review of Evans' photography indicates knowledge of the photo-documentary movement in the 1930s with its visualization of the urban and rural poor, devastated by the Depression. Reading *The New Masses* and other radical magazines brought him in contact with the Social Realists. His involvement with Charles Henri Ford, a young Surrealist poet, apprised him of the tensions between the Social Realists and the Surrealists. Joined in these conflicts were black artists and immigrant artists who were attempting to establish their vantage points of creativity in America. Folk artists past and present became the center of interest for a wide range of artists because folk art was deemed uniquely American, free from European traditions.

These diverse groups all laid claim to the American scene in offering competing versions of the life around them in their work. Renderings of the American scene hinged finally upon conceptions of the artist's role, made all the more crucial in a time of crisis. Issues pertaining to the artist's role in American society inevitably took on a bewildering coloration from the confusing events of the period.[14] Given the ambiguities and contradictions of American society and culture under severe stress, a sense of role or even roles was hardly clear to artists of any persuasion. Although Williams was no exception in this regard, he strenuously addressed himself to the issues by arbitrating among his aesthetic, social, and political concerns. In the final analysis Williams' ideas and poetry allow us to understand the American scene, not simply as a category of art history, but more properly as a cultural category situated on the complex interface between American society and those varied groupings of artists who wanted to create a distinctive and authentic American art. Through Williams and his life along the Passaic River we can regain contact with the American scene of the 1920s and 1930s.

# A Self-Portrait of the Poet as Avant-Gardist 17

A few paintings by Williams still exist: two still lifes, a bucolic scene, and an impressionistic version of the Passaic River painted in 1912—hardly the "filthy Passaic" that Williams would depict in his first long poem, "The Wanderer," in 1917. Among these paintings the work that strikes our attention is Williams' *Self-Portrait*, painted in 1914 when he was thirty-one years old (Fig. 3). Williams had arrived at an age when most Americans have settled down. He was married, already had a young son (the first of two), and had begun a medical practice in Rutherford. Yet he was embarking on another career—as a poet not as a painter. Even so, the promise of the *Self-Portrait* confirms his later assessment:"Had it not been that it was easier to transport a manuscript than a wet canvas, the balance might have been tilted the other way."[15]

What are we to make of this *Self-Portrait*? Does it reveal anything about Williams the avant-garde poet he was to become? Williams stares directly at us, his hair tousled and clipped short, his ears slightly protruding. No attempt to prettify himself. The open collar recalls Whitman's engraved daguerreotype, which served as the frontispiece for *Leaves of Grass*. Yet for all the informality, Williams' *Self-Portrait* does not approximate Whitman's "leaning and loafing at ease." This Williams appears intense and on edge, so that if the bright colors and visible brushstrokes suggest something of Matisse, they most certainly remind us of van Gogh. Impressive company for a Sunday painter, but Williams had seen the Matisses and van Goghs at the Armory Show the year before.[16]

The avant-garde implications of the *Self-Portrait* have less to do with an imitation of Matisse or van Gogh than with the epistemological dimensions of the image. What the painting suggests about how knowledge is defined and gained can be elucidated by comparing it to two other works: *Light of Learning*, a mural by Kenyon Cox for the Winona Public Library in Minnesota, completed by 1913 (Fig. 4), and Thomas Eakins' celebrated *Agnew Clinic*, painted in 1889 (Fig. 5). Cox, of course, was a leading academic and vehement spokesman against the new European art at the Armory Show. Eakins, on the other hand, was a maverick who had been forced to resign from the Pennsylvania Academy in 1886 for mixing male nudes and female students in class.

*Light of Learning*, painted "In Memory of Charlotte Prentiss Hayes," a local benefactress in Winona, is neoclassical in subject and design. The women in this symmetrically composed set piece look to a central source for knowledge, just as Cox himself did by his use of classical models. Tradition and hierarchy provide eternal order and reason. Above all, knowledge is taken to be genteel, exemplified by chaste women as its guardians. The mural's setting in a library further suggests that knowledge is derived mainly from books.

Eakins' conception of learning was radically different from Cox's. Instead of idealized forms and mythological situations, he emphasized close observation in his art. *The Agnew Clinic* dramatizes Eakins' thoroughgoing empiricism. In an amphitheater of the University of Pennsylvania Medical School, Dr. Hayes Agnew is seen lecturing to a group of attentive medical students observing an operation for breast cancer. Tradition is certainly not ignored in this learning ritual, inasmuch as medical knowledge is passed from one generation to another. Knowledge is seen as rational and methodical. But learning, it is suggested, requires action, at the very least a demonstration for others to see. Knowledge here involves the process of pragmatic experimentation; it is not entirely abstract. Thus Eakins' painting proposes an art that is correspondingly alive, responsive to living people, living situations.

Almost furtively watching the operation from one side is Eakins himself, his portrait painted into the scene by Mrs. Eakins. This self-conscious inclusion suggests that the artist take the doctor as his aesthetic (and moral) exemplar — a model that Emile Zola had advocated the same decade in his essay "The Experimental Novel."[17] Although Eakins was not avant-garde in the European sense, he went far beyond the stale pictorial formulas of his American academic colleagues by the tenets of empiricism and experimentation that led to avant-gardism. Whereas public sentiment could accept Cox's mural, even though his imagery was far removed from midwestern life, *The Agnew Clinic* was rejected at the 1891 exhibition of the Pennsylvania Academy.

Public disavowal of modernism in the visual arts and literature continued unabated throughout much of the lifetime of Williams, who fell heir to Eakins' attitudes. Most crucially, he managed to synthesize gradually, imperfectly, the roles of artist and doctor that Eakins saw split between himself and Dr. Agnew. Much later, in his *Autobiography*, integration of the two roles appears complete. The puzzle before him, that is, the need and obligation to diagnose a patient's problem, became the mainspring of his writing. "Was I not interested in man?" he asked. "There the thing was, right in front of me. I could touch it, smell it. It was myself, naked, just as it was, without a lie telling itself to me in its own terms."[18] In retrospect, Williams' statement describes the *Self-Portrait* thirty-seven years before, the young man staring intently, seeking direct contact with the world.

Seen in this conjunction, the *Self-Portrait* looked forward to a complex empiricism. Throughout his life Williams engaged in an uncompromising search

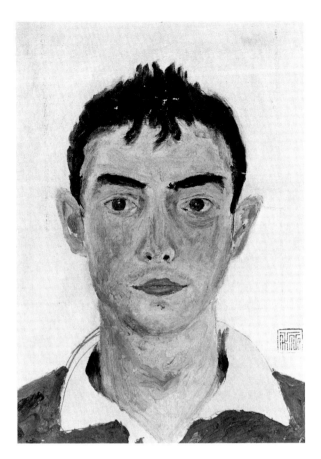

Fig. 3. William Carlos Williams, *Self-Portrait*, 1914. Oil on canvas, 13½ x 9¼ inches. University of Pennsylvania, Philadelphia; Gift from Mrs. William Carlos Williams, 1965.

Fig. 5. Thomas Eakins, *The Agnew Clinic*, 1889. Oil on canvas, 74 x 130 inches. University of Pennsylvania, Philadelphia.

Fig. 4. Kenyon Cox, *Light of Learning*, 1910-13. Mural, 144 x 240 inches. Winona Public Library, Winona, Minnesota.

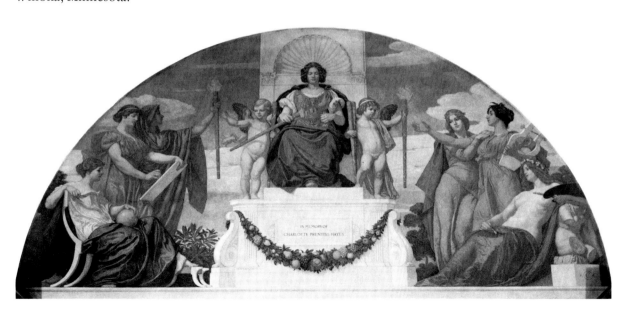

for truth in experience by stripping away nonessentials to get at the thing itself. Implicit in this process was a primitivism that is antagonistic toward all that clothes us, antagonistic, in short, toward culture. Such tensions were at the heart of his work. More discernible was Williams' sense of the tangibility of experience, the bedrock which we seek, that ground on which art is created. But the poet was not simply advocating mimeticism. A wide-eyed search for experience in art finally revealed one's self, so that the work came full circle, gaining an integrity and autonomy in the process. Williams' was an empiricism that could engender self, that could come back on itself as it moved outward to experience, an empiricism which, along with its primitivism, would animate Williams' avant-garde explorations of American life.

The young doctor writing poetry in 1914 was not as sanguine as the older Williams of *The Autobiography* in bringing the two roles together. In 1919 he concluded his "Three Professional Studies" with the plaint, "I want to write, to write, to write. My meat is hard to find. What if I have not the courage?" Ten years later in response to *The Little Review* questionnaire, he said bluntly, "I'd like to be able to give up the practice of medicine and write all day and all night."[19] And so the scrawls on prescription blanks, providing a different kind of relief aimed at the doctor himself, and so the hurried improvisations, getting it down on paper, and so the enduring tensions between roles.

Williams was not a heroic figure of the stature of Eakins' Dr. Agnew. Although he might have become a surgeon in New York, he decided instead to be a general practitioner in the suburb of Rutherford, where he had grown up. Williams deliberately sought a middle-class life for himself — in part because of the strength of his family gathered together in New Jersey after a Caribbean diaspora, in part because he distrusted (perhaps with romantic exaggeration) his own ability to live steadily without external constraints. But he had an even more compelling reason for rejecting a garret existence. Williams was keenly aware of the difficulties of writing in America independently, without compromise: "I would continue medicine, for I was determined to be a poet; only medicine, a job I enjoyed, would make it possible for me to live and write as I wanted to. I would live; that first, and write, by God, as I wanted to if it took me all eternity to accomplish my design."[20] In this regard he closely resembled Stieglitz, who throughout his life insisted that his gallery and the art he supported were not a commercial enterprise. And he managed to avoid the severe economic straits of Stieglitz's friend Arthur G. Dove, who suffered greatly from a lack of income while trying to paint.

Yet by hanging out his shingle and joining the entrepreneurial class, Williams found himself in a contradictory position. Because he was unenthusiastic about medical politics, he was forced to seek his practice in the poorer sections of Rutherford and in the outlying industrial towns of Passaic and Paterson. These experiences he would write up in his poetry and short stories. The process sounds easier than it was, for as we shall see there were a number of social and aesthetic conflicts if not to resolve then at least to hold in abeyance or muddle through while writing. Moreover, he received little or no encouragement from his middle-class neighbors, one of whom, according to his son, inquired about the doctor, was he still writing "those shitty verses?"[21] How, then, to write in a situation that denied the writing even as it made it possible?

Williams found the dilemma compounded by the avant-garde's gravitation toward Paris in the 1920s. In a tacit way Duchamp and Picabia had been leaders of the small American coterie in New York during the First World War. When they went back to Europe afterwards other Americans soon followed. They were simply part of a larger wave of expatriates that swelled during the decade. Many Americans, especially those who had a taste of Europe in military service, apparently agreed with Harold Stearns, a journalist who compiled a case against American life and advised the "Young Intellectual" to leave these barren shores.[22] Left behind to cope with the "American carnival," as Mencken saw it, Williams was often frustrated and angry, often an oversensitive provincial when in the presence of prestigious European artists. A minor exchange with the urbane Duchamp at a party at the Arensbergs' in New York was perhaps only an imagined slight, but it was real enough to someone who characterized himself as a yokel, and salutory only in that it fueled Williams' determination to excel as a writer.[23]

Nevertheless, Williams' feelings went far beyond mere pique, for he remained deeply ambivalent toward America and Europe throughout his life. By 1920 Williams was developing a heuristic sense of the social and cultural prerequisites for the creation of an American art independent of Europe, without, however, relinquishing his avant-garde principles. He may have been making a virtue out of necessity, but then again he had set up a tall order, and so we might forgive him the paradoxes and confusions that inevitably surfaced. His ideas, which drew upon the visual arts for their modernism, were organized around the directive of "Contact," offering an alternative to the regionalist movement of the 1920s and 1930s.

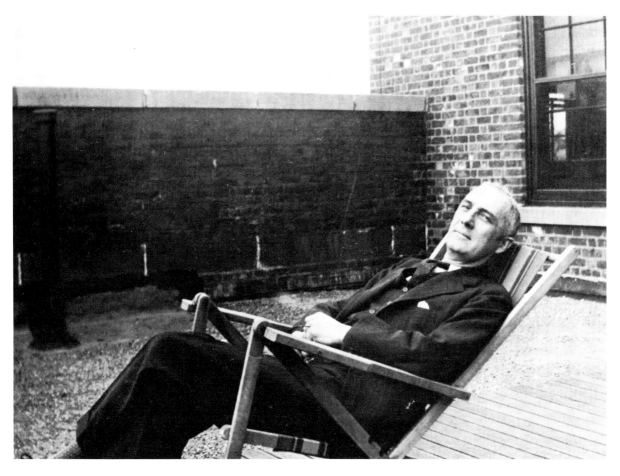

Fig. 6. Dr. Williams on the roof of the Passaic
General Hospital, 1936. Courtesy of the Rutherford
Public Library, Rutherford, New Jersey.

Fig. 7. William Carlos Williams, center, as in-
tern, c. 1910. Courtesy of the Rutherford Public Li-
brary, Rutherford, New Jersey.

# Contact with America

23

"There is to appear a new poetic monthly issue[d] December 1st to be called Contact devoted entirely to examples of new and strictly American qualities in writing. William Carlos Williams is the special light and first editor. . . ," Marsden Hartley wrote to Stieglitz in October 1920, six weeks before the magazine appeared. The idea of "Contact" was initiated by Robert McAlmon, a young midwesterner whom Williams met through Hartley in Greenwich Village. McAlmon picked up model's fees at Cooper Union while living on a barge in the harbor. Hitting it off immediately, Williams was attracted by McAlmon's straightforward demeanor: "His narrow lips and icily cold blue eyes with their direct look left no question in the onlooker's mind that he meant what he said of any situation, and if any subterfuge was to be practiced he would have none of it."[24]

Together, McAlmon and Williams decided to publish Contact as a vehicle for their views on American art. Carelessly typewritten and mimeographed on cheap paper, it had an air of poverty and spontaneity that has characterized so many little magazines since. As Hartley explained to Stieglitz, "They will waste no money on costly production as yet but concentrate entirely on quality."[25] Hartley's confidence was sustained, for although Contact could not compete with the more lavishly produced little magazines, most notably Harold Loeb's Broom, Williams and McAlmon still made an impact because their ideas offered a directive to an avant-garde seeking its own life in America as it looked to Europe.

The first issue of Contact appeared in December 1920 and was followed irregularly by four more numbers until 1923. Despite its brief existence Contact was renewed in 1932 in a second series, with Williams again as editor, joined by Nathanael West, a young novelist. Williams' entrepreneurial spirit and his fierce desire to keep his writing free from commercial compromise drew him to the publication of little magazines with the tenuous independence they afforded.[26] Thus in the early 1930s he was associated with Pagany, Blues, and Blast, a magazine of proletarian fiction. Although some magazines, like Others and Poetry, were devoted primarily to writers, and other magazines, like Art Front (Fig. 8) and Direction, to visual artists, many published both writers and painters, oftentimes concentrating on problems common to both. In this regard Contact joined the ranks of Broom, The Little Review, and transition (Figs. 9, 10, 11). By cutting across the arts these little magazines provided a crucial means of communication among the avant-garde, scattered here and abroad.

Williams and Hartley had rehearsed the Contact idea almost two years before the magazine appeared. During the summer and fall of 1919 the two friends published in The Little Review a series of short essays on the poet Wallace Gould, "a huge mountain of a man from Maine," according to Williams.[27] What began simply enough as an essay of appreciation by Hartley was soon complicated by the interjections of Margaret Anderson who drew Williams into the fray. Out of a running exchange about the nature of criticism emerged the issues raised by the idea of Contact. In his opening essay on "The Poet of Maine," Hartley implicitly stressed Gould's poetic form in lending a sense of his region. The painter read the poetry less for its literal descriptions than for its rhythmic comprehension of Maine life, which was to be found in the surface movements of the landscape.

In claiming Gould as a modern, Hartley still apparently felt the need for European validation, for he was unable to affirm unequivocally the poet's American roots: "I hear that Gould is being spoken of across the water to french moderns. Let's hope the frenchmen find a go that sounds like virility and American originality." And so toward the conclusion of his essay Hartley virtually negated his encomium to the land. "Gould was born out of place, geographically speaking," Hartley countermanded. "He needs a Russia, or an Egypt or earlier times for his playground. . . . He is wasting large material on small spaces for lack of room to make titanic gestures in. He has been tied to Maine by circumstance." Such a contradiction makes little sense without surmising Hartley's own ambivalence toward an artist's life in America. Confessing to "having lived there but little in the sense of native," Hartley would require another trip abroad in the next decade before he returned to Maine in 1930.[28] In the meantime one might praise a poet for living and writing in Maine, but the constrictions of American life also had to be recognized. So might the argument be untangled, yet the difficulties of squaring those constrictions with a "virile sense of place" suggest the persistent illogicality of Hartley's thinking.

In a postscript to Hartley's essay Margaret Anderson accurately noted that the painter had paid scant attention to Gould's writing, which she felt simply did not measure up.[29] One might readily misconstrue his omission as simply another espousal of regionalism that fallaciously emphasized subject at the expense of form. (In actuality, however, those poetic qualities that Hartley chose to admire could have been achieved only through attention to form.) Anderson's reaction served to point out a fundamental issue facing Americans who sought a unique American art: to what extent did the consideration of regional or national characteristics for the creation of a new art distinct from the European require the development of new forms as well? In 1919 the issue was buried within other critical concerns, but by the late 1920s regionalism in the arts had achieved sufficient force to bring the question out into the open.

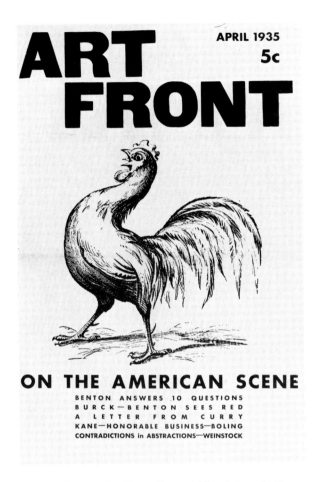

Fig. 8. Cover, *Art Front* I, no.4 (April 1935). Courtesy of The Museum of Modern Art, New York.

Fig. 9. Cover, *Broom* I, no. 4 (February 1922). Courtesy of The Museum of Modern Art, New York.

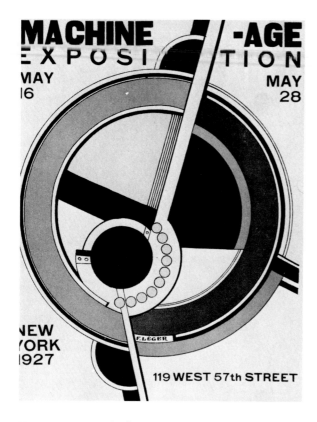

Fig. 10. Fernand Léger, cover, *Machine-Age Exposition* (*The Little Review*, May 1927). Courtesy of The Museum of Modern Art, New York.

Fig. 11. Stuart Davis, cover, *transition*, no. 14 (Fall 1928). Courtesy of The Harris Collection of American Poetry and Plays, Brown University, Providence, Rhode Island.

Williams was placed in the unenviable position of having to respond to the near-misconceived arguments of both Hartley and Anderson. In the next issue of *The Little Review*, which came out in August 1919, he was careful to praise Gould not because he was one of those regionalists "who pipe up and do conventional ditties in Wyoming or Texas or Delaware or Nebraska, taking up the ready scenery of the place," but precisely because of his form, "his immaculate craft."[30] Although Williams did not offer evidence from the poetry, his cognizance of the importance of form readily sufficed to outflank Anderson.

The more difficult task was to address Hartley's contradictory notions about regionalism. Williams was talking about Gould, but he was also referring to himself: ". . .there is an overwhelming satisfaction in feeling that a man can be a poet under any circumstances and that this has not removed him from his world but has fastened him upon it with such a deadly grip that he has transformed it in spite of himself." For Williams the writing of poetry was paradoxical. Insofar as the world resists the poet he must work against the American grain, not by ethereal escape but by immersion in that unfavorable environment. If poetry were to transcend provincialism, the poet must be able to bend adverse conditions to his art by his very commitment to the local. And hence Williams' impatience with Hartley's notion that Gould somehow needed a larger stage than Maine could provide: "Then for God's sake let us proclaim to ourselves that [poetry] isn't made out of the brains of Frenchmen, Englishmen, or dead Greeks. Poetry is fully at home in the woodsy brain of Wallace Gould as in another man's living in Teheran." The challenge to Williams was finally "to take anything, the land at your feet and use it."[31]

The image foreshadowed the metaphor of "contact" that Robert McAlmon proposed in 1920. Out of his experiences as a pilot in California he suggested "contact" as in an airplane's reunion with the ground after flight. While the term also connoted forthright commitments and social adhesiveness, to conjure a phrase from Whitman, "contact" had above all a snappy ring of the modern to it, consonant with the editors' desire "to wish above all things to speak for the present." As with most modernist ventures there was the obligatory manifesto opening the first issue of *Contact*. The introduction was marred by muddled writing, indicative, perhaps, of the editors' haste in getting the magazine out. In subsequent issues, however, their ideas would be clarified, confirming McAlmon's claim that "one writes to discover rather than to write." Discovery was central to the process of Contact, predicated on the view that American artists had cut themselves off from their local environment, which was now in need of exploration. As Williams succinctly stated in the second issue: "We, Contact, aim to emphasize the local phase of the game of writing. . . . We want to give all our energy to the setting up of new vigors of artistic perception, invention and expression in the United States."[32]

# A Matisse in New York 29

Europe was never far removed from Williams' thinking about American art. He perceived the powerful attraction of modern art from Europe upon American painters and writers, himself included. And he understood full well the legitimacy of that attraction, for it was the European avant-garde that had cast off the old, that had created an art somehow commensurate with contemporary life and sensibility. As a consequence, even the first *Contact* manifesto was equivocal about America and Europe. On the one hand, the editors disavowed a rigid commitment to a "modern traditionalism." Yet on the other, they wanted to "call attention. . . and acknowledge our debt to all importation of excellence from abroad." Such acknowledgment, however, did not necessarily provide aesthetic knowledge for the American artist. It was equally disastrous, the editors thought, to imitate either the academic *or* the avant-garde models imported from Europe. These patched together a "borrowed culture" that had little to do with authentic American life. In the second issue of *Contact*, therefore, Williams claimed that "Americans are still too prone to admire and to copy the very thing which should not be copied, the thing which is French or Irish alone, the thing which is the result of special local conditions of thought and circumstance."[33]

With these conflicting impulses at work, Williams felt challenged to write an appreciation of Henri Matisse for the second issue of *Contact* in January 1921. What better way to confound the charges of provincialism than to address the French in a magazine that declared itself for an American art? The object of the piece was *The Blue Nude*, painted in 1907 and on loan from Leo Stein at the 1913 Armory Show (Pl. I). Subsequently the painting was shown at the De Zayas Gallery in December 1920 and purchased by John Quinn, the wealthy New York collector and patron of *The Little Review*. Thus imported though it was, *The Blue Nude* was part of Williams' avant-garde environment, and he wanted to turn it to his advantage, to record his own response to it in order to make a cultural statement for his fellow American artists.

By entitling the piece "A Matisse," Williams called attention not only to a specific painting but also to the artist himself. Aside from Picasso and Duchamp (and possibly Picabia), Matisse had gained the greatest recognition in New York, due in large measure to a number of exhibitions during the years of the Armory Show. Perhaps most importantly for Williams, Matisse had been the subject of one of Gertrude Stein's pieces (the other on Picasso) for a special issue of *Camera Work* in 1912.[34] In an essay of the late 1920s called "French Painting (Its Importance, a Definition, and the Influence Upon Modern Writing Traceable to It)" Williams implicitly saw Stein as an important link between writing and painting. Thus her appreciation of Matisse in 1912 pro-

vided Williams with an instance of an experimental writer's interest in the visual arts as well as an actual example of how that interest took shape in the writing.

Yet Stein's precedent posed several problems for Williams, not the least of which were the formal ones implicit in her portrait of Matisse. Was it possible to say something new about Matisse, with Stein looking on from abroad, and not fall prey to that modernist tradition scorned by the editors of *Contact*? Williams resolved this dilemma not by using her formal means but by discerning the principles on which her form was predicated as the basis for finding other ways to consider Matisse at the outset of the 1920s. Williams' terms became explicit in his essay "French Painting." He claimed to have taken his cue as a writer from French painting, "for a hundred years one of the cleanest, most alert and fecund avenues of human endeavor, a positive point of intelligent insistence from which work may depart in any direction." Despite the confusion engendered by the past century of astonishing pictorial change and development in France, Williams incisively perceived the underlying "fundamental technical problem": "Facing it, realizing that it is pigment on surface, French painting went as far as Braque, it became a surface of paint and that is what it represented."[35] The emphasis upon surface paint rendered painting self-referential and radically presentational. In recognizing a painting as an object in its own right he implicitly recalled Braque's setting finished canvases in the fields in order to see how they competed with nature.

At this point a writer might learn from the painter: "It is the same question of words and technique in their arrangement," Williams claimed. "Stein has stressed, as Braque did paint, words."[36] Words, therefore, were construed as palpable and manipulable, just like pigment on canvas. Dislocating words from conventional usage created a self-referential opacity akin to the shallow space, the surface textures, created in, say, a Cubist painting. The discovery of these verbal principles in visual art gained mixed results in Stein's appreciations of Matisse and Picasso. While her convoluted syntax and repetitious phrasing verbally approximated the pictorial dislocations of Cubism and hence offered an appropriate verbal portrait of Picasso, the same verbal style did not evoke a sense of Matisse as derived from his painting. Her treatment tended to flatten out significant differences between Matisse and Picasso. And although her experimentation stressed words in themselves, thereby creating a verbal autonomy, her pieces verged on verbal imitations nonetheless by virtue of striving for the pictorial effect. The language has remained uniquely Gertrude Stein's, but it also has a derivative quality in being "Cubist" or otherwise identified with visual art so that verbal autonomy is ultimately subverted,

the center is shifted from the writing in itself to another, outside source.

In writing "A Matisse" Williams signaled his independence not only from Gertrude Stein but also from the subtle dominance that Matisse's *Blue Nude* could exert. The poet managed not "to ape a French manner," as he cautioned later in "French Painting," and thereby enhanced the integrity of his writing, making it his own, as part of his American experience. In keeping his distance from the painting, Williams played lightly and skillfully on description. It occurs in passing—the reclining nude, the bucolic setting are quickly sketched, while the detail of "a violet clump before her belly" suffices to identify *The Blue Nude* specifically.[37] Repeated references to the sun, along with the time of late spring/early summer, help to suggest the brightness of Matisse's palette. Yet we should not dwell too long on this economical fit between verbal and visual images, for Williams subordinated description to other concerns.

Williams imagined the original occasion for the painting as it is being viewed in a gallery on Fifth Avenue. We are given his account of the process of painting the canvas:

> So he painted her. The sun had entered his head in the color of sprays of flaming palm leaves. They had been walking for an hour or so after leaving the train. They were hot. She had chosen the place to rest and he had painted her resting, with interest in the place she had chosen.

Williams emphasized the sensuality of the situation, the subtly erotic interplay of man and woman, sitter and painter, their basking in the sun. Sensuality became the prerequisite for whatever form was to be manifested in the painting. Matisse's work became less a matter of technique alone or the selection of wild colors than of a sensibility that engaged the experience fully. The experience was finally rendered as kinesthetic: "It was the first of summer. Bare as was his mind of interest in anything save the fullness of his knowledge, into which her simple body entered as into the eye of the sun himself, so he painted her."[38]

Although Williams' account in "A Matisse" differed from the actual circumstances of how Matisse came to paint *The Blue Nude*, the poet's imaginary recreation was plausible regardless, for it conformed most importantly to his sense of the creative process informing that act.[39] But that act had a double import as an act of writing setting forth an act of painting, the two exerting reflexive forces. This doubleness begins with our double awareness of place, the movement back and forth between the French countryside and urban New York, in the mind of an observer who views *The Blue Nude* in a

Fifth Avenue gallery. Such an awareness soon leads to a sense of cultural differences. The more obvious ones are only a penultimate concern. Thus Williams immediately contrasts the imagined richness of the Frenchman's sensual experiences with "my own poor land." And he easily but ruefully scores the sexual prudery of Americans. Given his stress upon sensuality as the center of creativity, the prospects for an American art appear bleak indeed. But this pessimism is mitigated by the act of writing itself, involving as it does by implication for Williams a baring of one's senses to experience.

In the final analysis, cultural opposition is modulated in the consciousness of the narrator, who achieves a tenuous synthesis. Thus we are made aware of an apparent conflation in the opening line: "On the french grass, in that room on Fifth Ave., lay that woman who had never seen my own poor land." Until we realize (momentarily) that we are privy to a painting, we are startled by the image of a nude woman lying on "french grass" yet somehow in a room in New York City. The enclosure of the room contrasts effectively with the openness of the scene. We assume that the scene is in the painting, but it also exists as a kinesthetic impression in the responsive viewer, who provides his own cultural frame for the painting. Williams laid out the implications in "French Painting." American artists would inevitably paint a tree American by virtue of uninhibited cultural interaction with experience: the artist's "whole body (not his eyes) his body, his mind, his memory, his place: himself—that is what he sees— And in America—escape it he cannot—it is an American tree."[40]

It was, of course, impossible to make Matisse's *Blue Nude* American. But Williams did render the writing American because of his cultural place and preoccupations. Thus we have an observer who appreciates a fresh presentation of experience without aping it or feeling inferior to it. He leaves himself open to the painting and imagines the terms of its creation within the context of American poverty as an act of writing. Williams knew not to set the Matisse as a model for American artists to imitate, but he did see it as a possibility for and against American prospects, challenging us to face directly and unsentimentally our "own poor land." So the narrator insists in his concluding line upon the separateness of the painting: "In the french sun, on the french grass in a room on Fifth Ave., a french girl lies and smiles at the sun without seeing us."[41] French is French and American is American after all. Yet the largest implication is that the painting enjoys its own existence, something we must recognize, even as the narrator as an American is inevitably drawn between those two worlds, where his writing takes its ground.

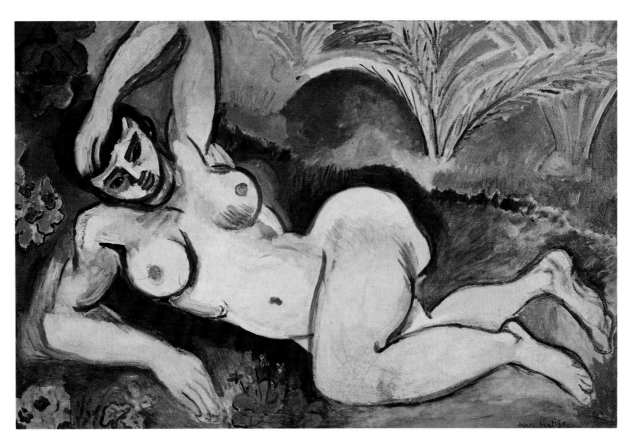

Pl. I. Henri Matisse, *The Blue Nude*, 1907. Oil on canvas, 36¼ x 55⅛ inches. The Baltimore Museum of Art; The Cone Collection.

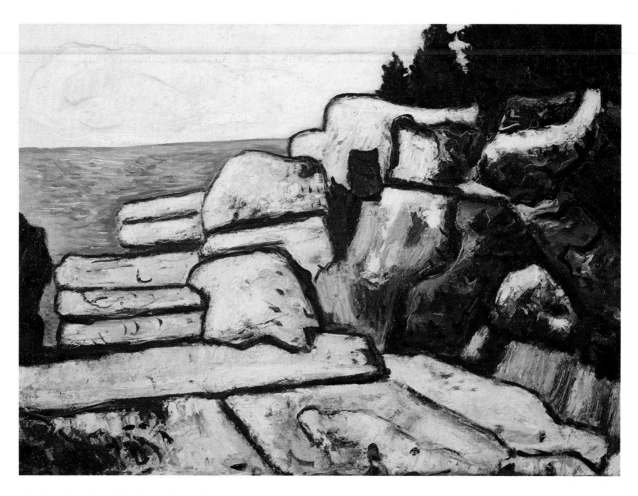

Pl. II. Marsden Hartley, *Granite by the Sea*, 1937.
Oil on composition board, 20 x 28 inches. Whitney
Museum of American Art, New York; Purchase
42.31.

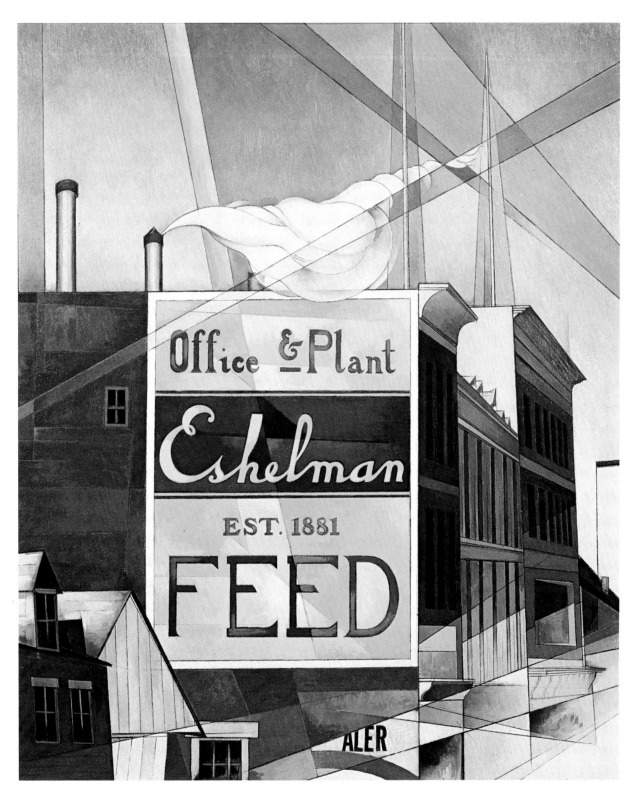

Pl. III. Charles Demuth, *Buildings, Lancaster*, 1930. Oil on composition board, 24 x 20 inches. Whitney Museum of American Art, New York; Anonymous gift 58.63.

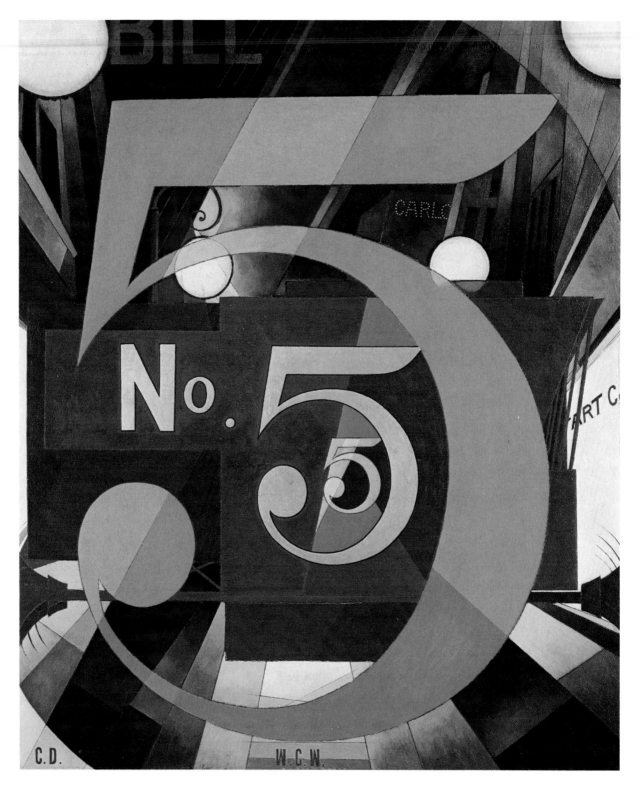

Pl. IV.  Charles Demuth, *I Saw the Figure 5 in Gold*,
1928. Oil on composition board, 36 x 29¾ inches.
The Metropolitan Museum of Art, New York; The
Alfred Stieglitz Collection, 1949.

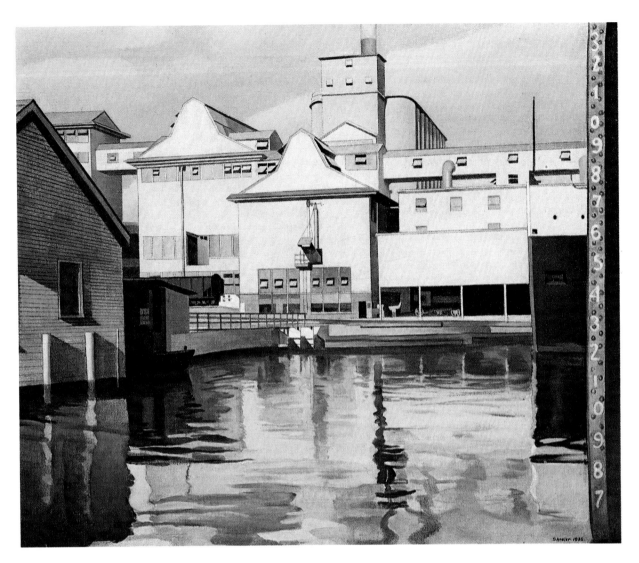

Pl. V.  Charles Sheeler, *River Rouge Plant*, 1932.
Oil on canvas, 20 x 24 inches. Whitney Museum of
American Art, New York; Purchase  32.43.

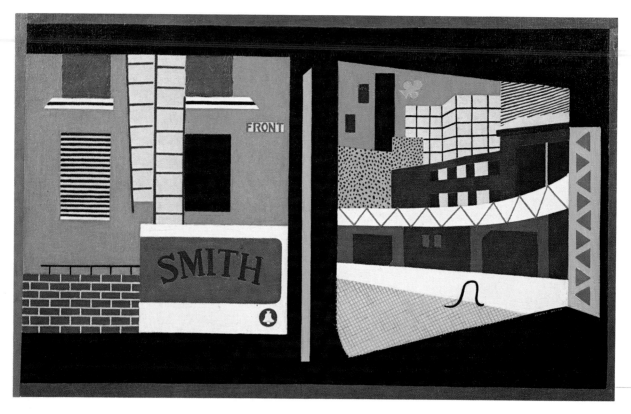

Pl. VI. Stuart Davis, *House and Street*, 1931. Oil on canvas, 26 x 42¼ inches. Whitney Museum of American Art, New York; Purchase 41.3.

Pl. VII. Henry Billings, *Lehigh Valley*, c. 1930.
Tempera on composition board, 20 x 25 inches.
Whitney Museum of American Art, New York;
Purchase 35.1.

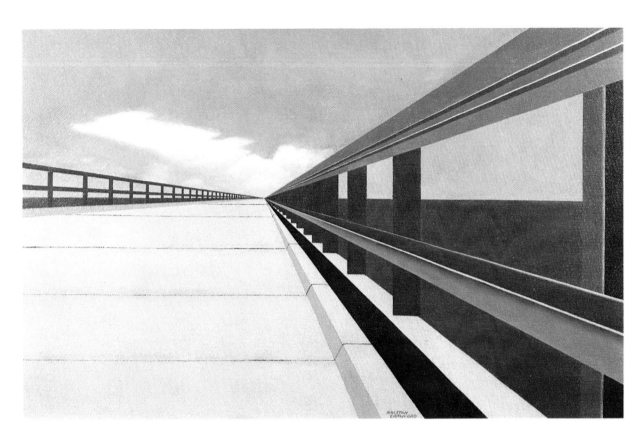

Pl. IX.  Ralston Crawford, *Overseas Highway*, 1939.
Oil on canvas, 28 x 45 inches. Collection of Charles
Simon.

Pl. VIII.  Georgia O'Keeffe, *City Night*, 1926. Oil on
canvas, 48 x 30 inches. Collection of the artist.

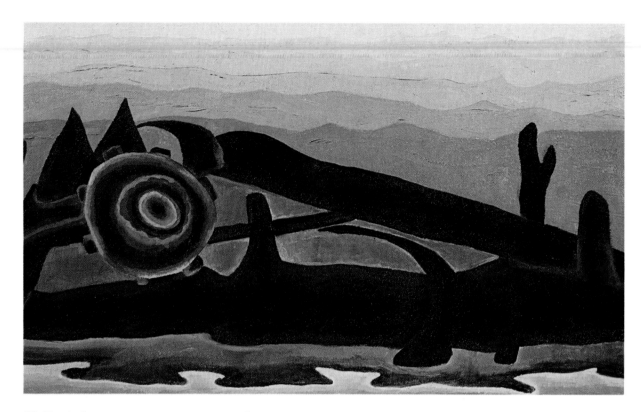

Pl. X.  Arthur G. Dove, *Ferry Boat Wreck*, 1931. Oil
on canvas, 18 x 30 inches. Whitney Museum of
American Art, New York; Gift of Mr. and Mrs. Roy
R. Neuberger (and purchase) 56.21.

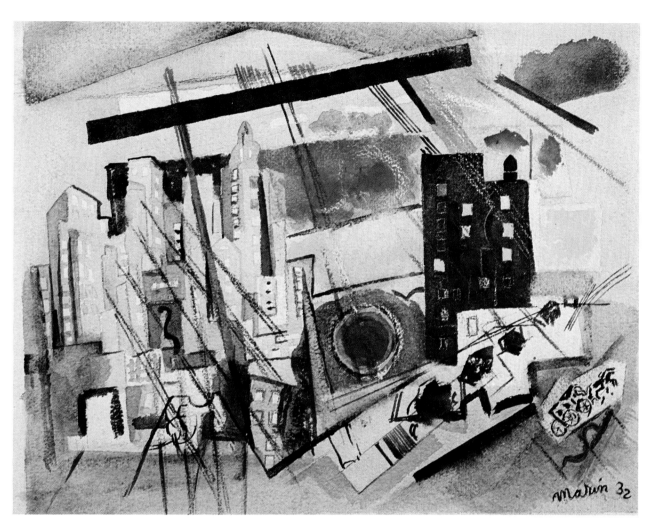

Pl. XI.  John Marin, *Region of Brooklyn Bridge Fantasy*,
1932. Watercolor on paper, 18¾ x 22¼ inches.
Whitney Museum of American Art, New York;
Purchase  49.8.

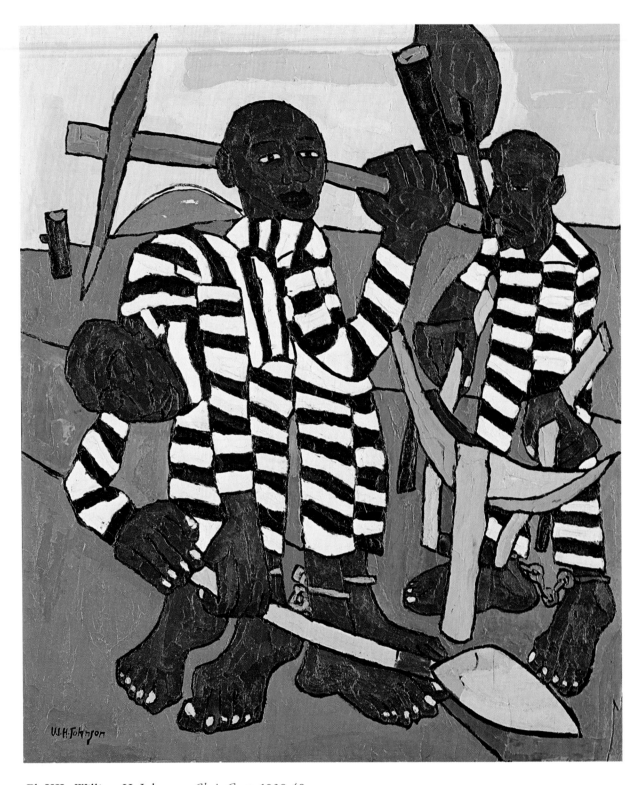

Pl. XII.  William H. Johnson, *Chain Gang*, 1939-40.
Oil on board, 45½ x 38⅜ inches. National Col-
lection of Fine Arts, Washington, D.C.; Gift of the
Harmon Foundation.

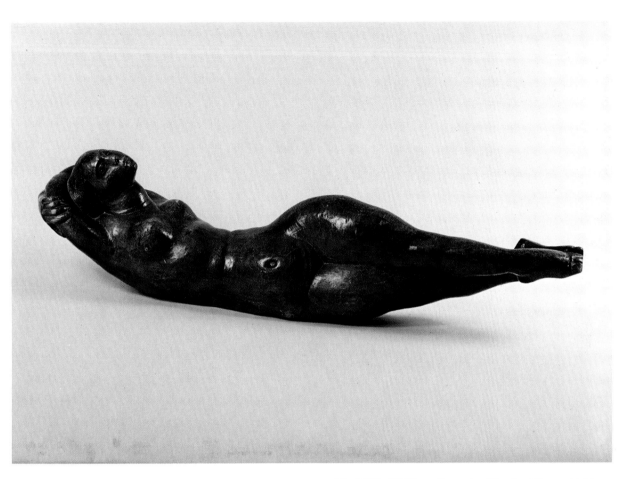

Pl. XIII. William Zorach, *Floating Figure*, 1922.
Borneo mahogany, 9 x 33¼ x 7 inches. Albright-
Knox Art Gallery, Buffalo, New York; Room
of Contemporary Art Fund.

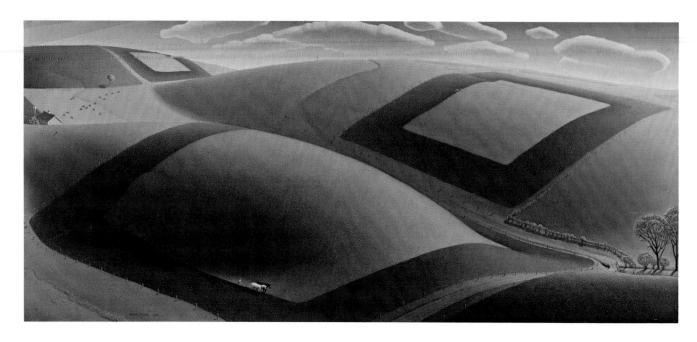

Pl. XIV. Grant Wood, *Spring Turning*, 1936. Oil
on masonite panel, 18¼ x 40¼ inches. Private col-
lection.

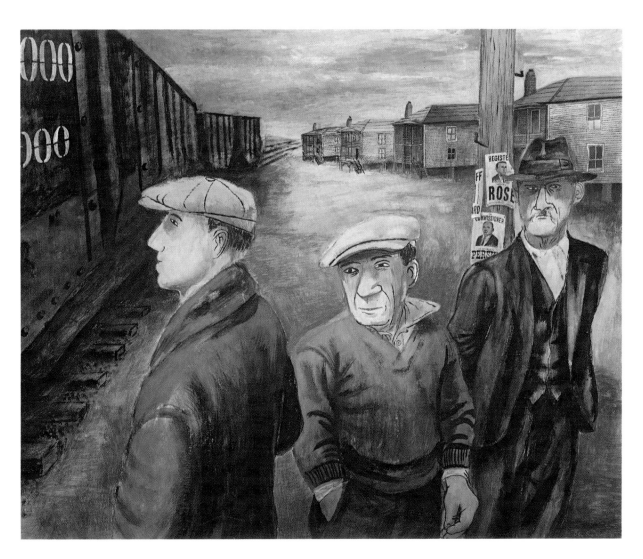

Pl. XV.  Ben Shahn, *Scott's Run, West Virginia*, 1937. Tempera on cardboard, 22¼ x 27⅞ inches. Whitney Museum of American Art, New York; Purchase 38.11.

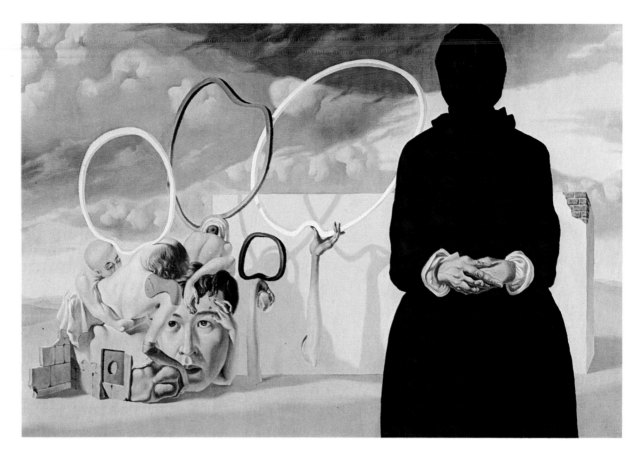

Pl. XVI.  Federico Castellón, *The Dark Figure*, 1938.
Oil on canvas, 17 x 26 inches. Whitney Museum
of American Art, New York; Purchase  42.3.

# Hartley 49
# and Contact
# with the West

While Williams tried to make a virtue out of staying in the environs of New Jersey ("That it is also Walt Whitman's state hasn't been much help," he ruefully conceded), Hartley traveled restlessly until he settled in Maine during the 1930s. During his travels he visited the American Southwest, staying in Taos and Santa Fe, New Mexico, in 1918, and then California a year later. The Southwest provided a "big sweep": "It's probably the greatest space a white person could sense — as certainly the redman knows how huge it is — having made his world out of it — his entire cosmos."[42] The space was there, and Hartley was attracted to it, as was Georgia O'Keeffe, who came to New York and the Stieglitz circle by way of Texas, and others such as John Marin and Stuart Davis. But what to make pictorially of that geographical space? O'Keeffe developed her own solutions and Hartley his. Several pictures emerged from his experience in the Southwest. Williams purchased a pastel *Mountains in New Mexico* (1919; Fig. 12) for $105 at an auction arranged by Stieglitz and Mitchell Kennerly in 1921 to finance Hartley's first trip abroad since the First World War.

Hartley's reference to native Americans was hardly an exotic tangent to his own concerns. He was preoccupied with the land's mythic possibilities and the need for modern myth. During his journey to the interior, as it were, Hartley visited Indian reservations and attended their ritual dances. Subsequently he wrote one of his most eloquent essays simply titled "The Red Man," which opened his *Adventures in the Arts* published in 1921. Throughout his appreciation ran a sensitive plea for accepting and nurturing native American culture on its own terms. Only in a peripheral fashion did Hartley touch upon the plight of the contemporary American artist. Nevertheless, native American life inevitably accentuated his own precarious situation. Faced though they were with cultural extinction from the outside, native Americans still managed to retain their ceremonial dances — rituals that affirmatively bound them to the landscape. How was Hartley to respond to this new environment? How could a contemporary American artist, stripped of religious belief and estranged from the land, comprehend the scene, especially if one further lacked — painfully lacked, according to Hartley — an "esthetic concept" to visualize it?[43]

Hartley recognized the extent of the dilemma by realizing the futility of depicting indigenous subjects, which was simply a way of borrowing mere details from native American art. Thus more successful than Hartley's attempt to illustrate a Navaho dance was the pastel that Williams bought at auction because it was addressed to formal problems that were fundamental to a modernist grasp of the American scene. *Mountains in New Mexico* (1919) abjured narrative and already owed something to Cézanne, whom Hartley would study intensively at

Aix-en-Provence in 1928 by undertaking a series of canvases reiterating Mont Sainte-Victoire so that landscape, past painting, and present effort might come together in his mind's eye

That the mountains of New Mexico eventually led to Aix-en-Provence was tacitly acknowledged by Hartley in 1928 when he followed a talk on Cézanne in Denver with a reading of "The Red Man."[44] Hartley found Cézanne to be particularly apposite because he epitomized the modernist endeavor by rejecting visual tradition and philosophy and instead yielding wholly to nature with the freshness of a child's vision. Hartley's Cézanne conformed closely to the Contact idea upheld by Williams and McAlmon. Equally significant was the way this Cézanne conformed to a prevalent notion of "primitive" peoples as childlike, in close communion with nature.

Cézanne, therefore, was a modern master for Hartley precisely because he was seen to have overcome the losses suffered by modern western society, losses dramatically pointed up by the religious rituals of indigenous groups themselves on the verge of extinction. Hartley thought that the disintegration of religion and ritual inevitably took its toll on any prevalent aesthetic or the possibility of developing one. As he concluded another fine essay on "Tribal Esthetics," written for *The Dial* in 1918, "It is a life of anciently splendid ritual, and we of this time have lost the gift of ritual. We are without the power to celebrate the simple experience. We have no ceremony for our vision."[45] Community, religion, ritual, art, and landscape all came vividly together for Hartley on the reservations of the Southwest. He must have felt that he lacked all but the art, and that as a kind of raw talent and desire which was endangered without the other necessary parts. How was he to paint in a social and cultural vacuum?

Bereft of what the native American still possessed, however tenuously, the modern artist had recourse only to Cézanne's primitivistic empiricism, "to realize the pure sensation derived from nature" in a painting that orchestrates sensations, the essential stuff of the artist's experience. In 1921, in a brief "Dissertation on Modern Painting" for *The Nation*, Hartley succinctly stated this empirical thrust in terms of "direct contact": "The thing must be brought clearly to the surface in terms of itself, without cast or shade of the application of extraneous ideas." Here was the local combined with a grasp of modernity taken to the very edge of perception. Most importantly, here was a conflation of experience (perceived sensations) and art. Hartley's pictorial metaphor translated his description of something perceived in nature, "a thing seen, heard or felt in terms of itself," to the realm of art, to the canvas surface, the picture plane, where the artist was "to reform his own sensations and ideas to correspond

to a system he has evolved, with the sensation drawn out of life itself."[46] A painting gained its autonomy as a thing apart from nature by being the objectified locus of imagery, emotion, and experience drawn through the artist.

Hartley had arrived at last at an "esthetic concept" that would serve his needs as an American artist. So long as the painting was the thing itself, requiring Hartley's focus, it could control his emotions by its own pictorial logic. Later, in an elegiac piece on Hartley, Williams noted the painter's sexual loneliness, adding, "His whole life had been a similar torment which painting alone assuaged."[47] Not simply a matter of sexual sublimation, painting the thing before him modulated Hartley's emotions, from the expressionism of his years in Berlin during the First World War to his later credo of impersonality in his work, effacing excessive feeling in deference to the image on the canvas. Painting finally became that ritual missing in modern life, the gesture that would lead the artist out of the labyrinth of the self.

In this context Williams' joke about *Mountains in New Mexico* (1919) as "Marsden's breasts" was apposite as a metaphor that transcended the cruel humor: Williams' hermaphrodite and mountains were perceived as integrated in the pastel as self and landscape, a hackneyed "Mother Earth" renewed by the artist's own painful sexuality.[48] The poet correctly saw Hartley "in" his paintings, though his interpretations occasionally drifted toward a careless allegorizing of emotional states from the canvas. More to the point were his assessments that began with concrete materials of the craft:

> The colors and the shapes he painted were for the most part seen close to the eye and positively even crudely painted, boldly and with aggressive simplicity. Their outlines whether it was two white birches broken off leaning together in the woods were distinct, dramatically conceived what it was obviously to mean . . . an inescapable tragedy to which the whole canvas pointed and nothing marginal. A mountain torrent dashing itself to pieces on the rocks was no less dramatically centered — or it might be a boulder standing alone, a split boulder the two halves eternally separated [Pl. II, Fig. 13].[49]

*Close to the eye*, contact maintained in the painting and reasserted in Williams' sight, here was the fulcrum on which meaning, in this instance "an inescapable tragedy," was poised.

This balance of form and emotion in the painting was difficult to sustain. In a letter of 27 June 1937 to Stieglitz, Williams described his adverse reactions to a recent spring showing of Hartley's work at An American Place. He found many of the paintings monotonous in tone, looking "flat and lifeless," while others were "full of mannerisms." The somber effects were misplaced, he felt. "After all death is not sad. It's life that's sad. Is that what is meant? Life takes the shape of crabs, or shell[s]—I don't know."[50]

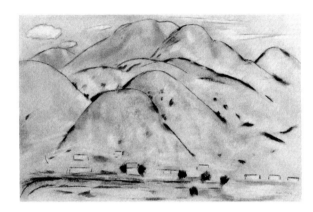

Fig. 12. Marsden Hartley, *Mountains in New Mexico,* 1919. Pastel on paper, 17 x 27¾ inches. Collection of Mr. and Mrs. Paul H. Williams.

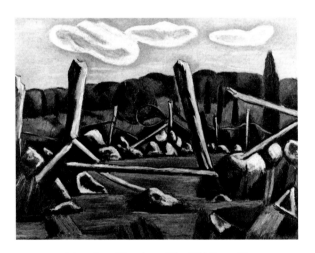

Fig. 13. Marsden Hartley, *The Old Bars, Dogtown*, 1936. Oil on composition board, 18 x 24 inches. Whitney Museum of American Art, New York; Purchase 37.26.

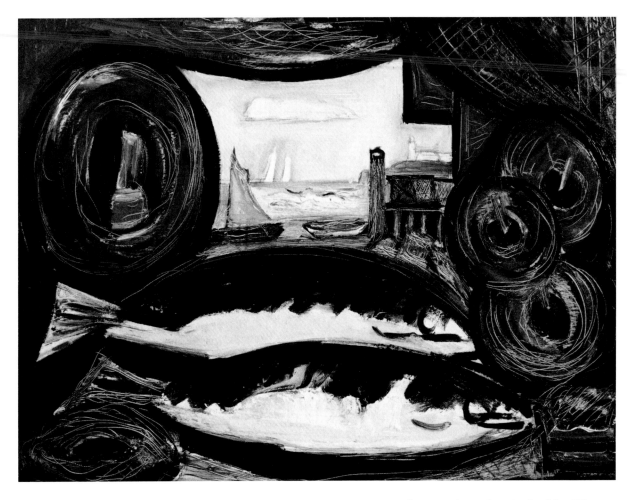

Fig. 15. Marsden Hartley, *New England Sea View—Fish House*, 1934. Oil on board, 18 x 24 inches. Collection of Ione and Hudson Walker.

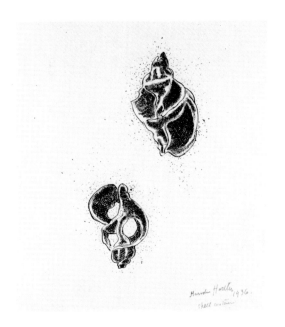

Fig. 14. Marsden Hartley, *Shell Contours*, 1936. Ink on paper, 10 x 10½ inches. Museum of Art of Ogunquit, Maine; Gift of Mrs. William Carlos Williams.

The metaphor pointed to Williams' preference for the drawings, one of *Shell Contours*, perhaps, which Hartley gave him (Fig. 14). He concluded, "Marsden has himself *too much* to heart . . . . He might better let his wit go into discovery, into showing what there *is*, with the candor of his drawings, some of them, rather than in overlooking them with emotion which, in a sense makes them sentimental." Williams admitted that his reaction may have resulted from the cumulative effect of seeing the paintings together, making a "tough session."[51] But granting that possibility, his assessments, severe as they were, were consistent with Hartley's own stated aesthetic.[52] The painter managed to realize a balance of emotion and form in *New England Sea View—Fish House* (1934; Fig. 15), which Williams liked. Since the poet could not afford the original, Hartley gave him an inscribed reproduction in 1936. The fish and the sea view in the background combine Williams' admiration of Hartley's still lifes and the requisite sense of place.

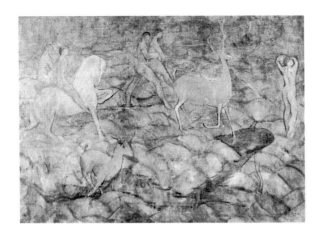

Fig. 16. Rex Slinkard, *Young Rivers*, c. 1915-16. Oil on canvas, 38 x 51½ inches. Stanford University Museum of Art, Stanford, California; Estate of Florence Williams.

The primitivistic context of Hartley's thinking that gave painting an existential imperative for the modern artist created nonetheless a lingering ambivalence toward the past. It was difficult for Hartley not to measure his contemporaries against the integrity of the vanishing native American artist. Was there an artist, preferably a westerner, one whose painting showed the promise of a simple life close to nature, unadorned by the complexities of civilization? Hartley thought that he had found one in Rex Slinkard, who had lived on a ranch in Saugus outside of Los Angeles. Although Slinkard had died in New York during the 1918 flu epidemic after having been drafted into military service, Hartley had seen his paintings in California in 1919 through the efforts of Carl Sprinchorn, a mutual friend and painter. Hartley was sufficiently impressed with Slinkard's work to write the catalogue essay for a memorial exhibition held in Los Angeles and eventually in New York at the Knoedler Gallery in 1920. Hartley idealized Slinkard as a "western ranchman and poet-painter," who felt the unity of life in himself.[53] If not the native American then certainly Walt Whitman had returned in the guise of this visionary western painter.

At Hartley's behest, Williams published Slinkard's letters in the first three issues of *Contact*, the third also featuring his photograph and four illustrations of his paintings, including his major canvas, *Young Rivers* (Fig. 16). The letters are noteworthy for their lyric sensibility combined with factual observation, exemplifying Hartley's dictum that the poet should have an "eye with brain in it." Thus in concluding to Sprinchorn, "The mountains are bathed in gold and the air is gold itself. The sun is setting. Yours O Youth, yours . . ."[54] Here was a true American artist from the Far West simply and forthrightly convey-

ing his experiences, nothing intervening between his senses and nature. It was enough to impress another poet who lived among the industrial wastes of New Jersey.

The western myth did not go unqualified, however. A brief biographical statement prefacing Slinkard's letters in the first issue of *Contact* mentioned his art training in New York. The reference prefigured Williams' main interest in Slinkard, stated in an essay further explaining the Contact idea. "What is it I see in Rex Slinkard's letters?" asked Williams. "It is all very young, this man's writing about his painting; it is what I recognized as in some measure definitely and singularly American."[55] Here the two media intersected along the coordinates of craft and technique, which always remained close to Williams' critical thinking. Yet how did this preoccupation square with his refusal, in the very same essay, to equate Contact with literature, and by extension, with art generally?

An explanation of this seeming contradiction turns on the various meanings that the Contact idea had for Williams, whose sense of "the local" had different dimensions. At the outset of the magazine, Contact suggested communal or regional experiences at the center of one's art. Such experiences were often expanded to take on a national character, as in Williams' identification of Slinkard's letters as "singularly American." The poet consistently gave the local a geographical designation and meant it in implied contrast if not outright opposition, both socially and culturally, to Europe.

In its most concentrated and basic form, however, the local resided in the individual and in one's perceptual life, celebrating "the triumph of sense." Here was Williams the arch-empiricist, staunch individualist, anti-institutional, and opposed to tradition — in sum, very much the avant-gardist. Logically, then, the Contact idea might well have little to do with existing art and its traditions, which could only hinder one's fresh perceptions of the world. The academy was anathema, as it had been for the European avant-garde for the past fifty years. Though Williams never sustained the extreme, an American Contact ultimately led to the stripping away of all culture before the primordial experience of nature seen anew. No wonder that Williams borrowed "Yours O Youth" from Slinkard to title his essay.

Short of such absolute primitivism Williams bared the aesthetic of Contact — to the extent that one can properly speak of a Contact aesthetic — to the root term: *aisthetikos*, meaning of sense perception.[56] This essential meaning complied with his insistence upon the artist's bodily commitment to experience, just as he had imagined Matisse painting *The Blue Nude* in the French countryside. By being so basic, the mean-

ing provided great latitude in the ways one might subsequently shape and qualify aesthetic values in accordance with specific experience. (Such latitude also provided tolerance for efforts that went against accepted aesthetic norms.) Williams himself emphasized those qualities he thought enhanced perception: immediacy (or spontaneity), intensity, and clarity. Though such qualities are no less arbitrary than any other set one might want to assign to the act of human perception, Williams gave his an inevitability through the force of conviction.

Those qualities became normative values as reciprocal functions of perception and ensuing work, Williams having predicated Contact as process. Drawing upon his experience as a doctor he claimed that "eyes, ears, finger tips, everything we are, everything we do, is constantly wearing out."[57] Life being what it is, no doctor can ever claim an absolute cure. So, too, art wears out, requiring new works for new situations (and hence ratifying avant-garde experimentation for the new). The act of writing or painting is as much a part of the process of experience as those experiences which motivated the artist's efforts. The immediacy of sensations, their intensity and clarity, is translated into words on a page or pigment on a canvas by virtue of the artist's efforts.

Williams celebrated the imagination as a cleansing force in *Spring and All*, which appeared with Hartley's *Twenty-Five Poems* in 1923 on McAlmon's list for the Contact Publishing Company in Paris. Like Hartley, Williams conflated perception and comprehension in "triumph of the sense," which occurs in the form of the work, in its integral structure. Craft and technique are integral to this process as part of an accomplished artist's cognitive skills in comprehending experience, adjusting its form with the formal requirements of the work. Williams thus sought to create an autonomous work, that which would be called less than a decade later "Objectivism": the poem as an object, something that is concrete, created out of the manipulable interaction of words constructed into their own reality. As he said in *Spring and All*, "The only realism in art is of the imagination. It is only thus that a work escapes plagiarism after nature and becomes a creation." In commenting on his friend's ideas to Stieglitz, Hartley called the result "pure poetry," but Williams was hardly engaged in art for art's sake, nor was the finished poem hermetic in its autonomy. Hartley tacitly recognized this paradox by adding in the same breath, "Well it's something today for a doctor of the human ills riding around in a small town circle — looking down people's throats — and at their tumours and skinspots."[58] Because of that life his poetry was open to common experience, and because of his sense of the poetic process, he imagined his poems as additions to experience by their derivation from experience.

# An
# American
# Dada

Despite having erroneously set the notion of pure poetry against the medical practice, Hartley nonetheless rightly sensed the tensions in his friend's life. Williams compounded matters by having formulated the idea of Contact, which denied escape from the problems of being a doctor and poet in Rutherford. Because Contact involved an aesthetic, Williams' art and sense of art were inextricably caught up in the cultural and social issues of American life. No wonder, then, that he was attracted to Dada. Williams could readily vent his disgust, but what it needed most was a shape, or a variety of shapes, which Dada promised subversively to provide.[59] Dada erupted in Zurich in 1916 among a number of poets and painters, deserters and refugees, who were profoundly disaffected from the senseless carnage of the First World War. Dada was a cry of nonsense aping the total bankruptcy of Europe. Nihilistic and despairing, a symbol of alienation, Dada was nonetheless idealistic in its rebellion against human depravity and stupidity. Thus it was paradoxically destructive yet affirmative in its assaults.

Williams gained an opportunity to witness Dada firsthand in New York. Marcel Duchamp arrived in 1915 amidst publicity generated by his *Nude Descending a Staircase*, which had provoked laughter at the Amory Show two years before. The newspapers had appropriately called it, among other things, an "explosion in a shingle factory," thereby looking forward to the disruptions of Dada. Williams himself later recalled, "I laughed out loud . . . happily, with relief," upon viewing the painting.[60] His laughter, however, did not partake of the public's ignorant rejection of the work but rather intimated a spontaneous awareness of new values and attitudes that the European avant-garde offered to American artists.

On a military mission to Cuba to purchase molasses for the French army, Duchamp's friend Francis Picabia also arrived in New York in 1915 just in time to contribute a series of satiric machine portraits to *291*, a review sponsored by the Stieglitz circle, signaling its commitment to Dada values and attitudes (Figs. 17, 18, 19). Picabia was sufficiently sidetracked from his mission to sit out much of the war in New York. Dada time prevailed. Duchamp precipitated a scandal at the 1917 Independents exhibition when the organizing committee rejected his *Fountain*, a urinal signed by "R. Mutt," supposedly a prominent New York plumber (Fig. 20). With the apartment of Walter and Louise Arensberg as the main center of activity, Dada continued sporadically in New York until 1921, when Duchamp and Man Ray published *New York Dada*, announcing a boxing match between Joseph Stella and Marsden Hartley and showing the Bohemian Baroness Elsa von Freytag-Loringhoven in her bald glory, the eccentric writer and sculptor who pursued Williams as her lover.

Thus Williams was caught up in the loose network of friends and acquaintances that comprised New York Dada during the decade of the First World War. In 1921 Duchamp and Man Ray followed Picabia to Paris, where a number of the younger American expatriates — Malcolm Cowley, Harold Loeb, Matthew Josephson, and Gorham Munson among them — enthusiastically joined the Dada fray in the pages of *Broom* and *Secession*, which they edited. Because he subscribed and contributed to those magazines, Williams was eager to meet the Dadaists on his 1924 sabbatical. McAlmon had the connections but didn't consider the Dadaists particularly significant, so he was lukewarm to his friend's request.[61] Extensive personal contact with the Dadaists was postponed for Williams until the outbreak of European hostilities in the late 1930s when Breton and others were forced to come to New York.

Whereas McAlmon simply misjudged the Dadaists, Williams' response was more complex, hardly that of a naive provincial dazzled by European ennui that tried to pass for significant nonsense. Dada cut across the arts and facilitated discourse for someone who

Fig. 17. John Marin, cover, *291*, no. 4 (June 1915). Courtesy of the Philadelphia Museum of Art; The Louise and Walter Arensberg Collection Archives.

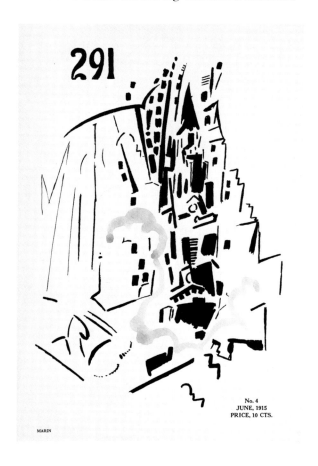

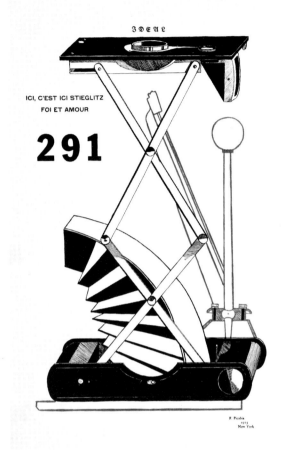

ICI, C'EST ICI STIEGLITZ
FOI ET AMOUR

**291**

Fig. 18. Francis Picabia, *Fille née sans mère*, in *291*, no. 4 (June 1915). Courtesy of the Philadelphia Museum of Art; The Louise and Walter Arensberg Collection Archives.

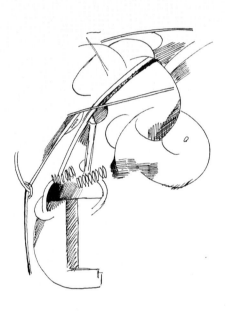

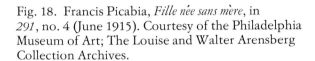

FILLE NÉE SANS MÈRE

PICABIA
New York, 1915

Fig. 19. Francis Picabia, *Ici, c'est ici Stieglitz*, in *291*, nos. 5-6 (July-August 1915). Courtesy of the Philadelphia Museum of Art; The Louise and Walter Arensberg Collection Archives.

Fig. 20. Marcel Duchamp, *Fountain*, photographed by Alfred Stieglitz, in *The Blind Man*, no. 2 (May 1917), p. 4. Courtesy of the Philadelphia Museum of Art; The Louise and Walter Arensberg Collection Archives.

58

saw poetry in the context of the visual arts. In the process it attacked American complacency and in-indifference with savage wit. Yet Williams remained ambivalent toward Dada. His essays in *Contact* were replete with scattered references to it. He suggested that it was a European phenomenon, a sign of a dying culture, that it was finally insignificant and should be ignored by American artists. He also gave the impression that he couldn't take his eyes off Dada. This ambiguity centered around the fear of losing his American identity to a foreign movement.

To allow the local to prevail required a subversion worthy of Dada. Williams' strategy remained true to what he had written earlier about Whitman, who, he claimed, had "created the art [of poetry] in America." How might an American poet — Williams, if it came to that — discharge his literary debt to Whitman? Not by growing a gray beard, not even by writing free verse, but only by assuming the cardinal American principle of individualism would a poet after Whitman build on his work. "The only way to be like Whitman is to write *unlike* Whitman," Williams insisted.[62] In a similar way he recognized that his success as an American Dada lay in being opposed to Dada. But whereas such opposition soon became the fashionable paradox, Williams knew further that he had to grasp the very essence of Dada.

In New York, Dada focused upon the tensions of art/anti-art, exploring the dialectic between destruction and creation, between accepted art forms and experimentation, which might lead to new works hitherto unrecognized as art by American culture

and society. Robert Coady's provocative photographs in *The Soil* were a case in point (Fig. 21). Duchamp's notorious *Fountain* entry at the 1917 Independents was another. Its assault upon genteel sensibilities almost obscured the disturbing questions it generated about accepted definitions of art. Could a "readymade," as Duchamp termed these objects, become a work of art simply by fiat? And did such a selection reveal the aesthetic dimensions of a mass-produced machine?

Although Duchamp harbored private reservations that were charged with intense ambiguity, his public responses were affirmative. From the moment he docked in New York in 1915, answering questions raised by reporters eager for scandalous copy, Duchamp acclaimed America as the new land of technology.[63] His praise of New York's skyscrapers as symbolic of a growing machine enviromnent was echoed in the next decade by the French Dadaists. They in turn awakened their American friends, Josephson chief among them, to the technological wonders of America. Thus in 1929, when Williams translated *Last Nights of Paris*, Philippe Soupault's Dada novel, Josephson wrote an introductory note praising the Frenchman's love of "sports, American movies, American fashions, Negro jazz…." Most significantly, Josephson saw a connection between Soupault's poetry and his appreciation of the American scene brought up-to-date: "The poems have a modern character externally; in reality, it is impossible to miss their aspects of seriousness and simplicity. They are intensely subjective; they are naked, stripped of all rhetoric; they express a vision of a

Fig. 21. Robert Coady, "The real battle of lights…" in *The Soil* I, no. 5 (July 1917). Courtesy of The Harris Collection of American Poetry and Plays, Brown University, Providence, Rhode Island.

primitive, a child-like truthfulness."[64] Using virtually the same criteria as those of the Contact aesthetic, so that his analysis could have applied just as readily to Williams' poetry, Josephson came full circle back from Europe to America.

Congenial to the Contact idea was the readymade. Duchamp's idea lingered in Williams' mind so that he recalled in *Kora in Hell* the Frenchman's excursion to a hardware store to select his first American readymade in 1915. No matter that Williams confused the snow shovel actually chosen (*In Advance of the Broken Arm*, Fig. 22) with a pickax, it was doubtless the pristine tangibility of an artifact unaltered by the artist except by his act of selection that fascinated the poet: "No ideas but in things" would be one of his principles first articulated in the poem "Paterson," which first appeared in *The Dial* in 1927.[65] Not abstractions but the thing itself as a palpable dimension of experience drew the attention of the poet.

Fig. 22. Marcel Duchamp, *In Advance of the Broken Arm*, 1945 replica of 1915 original. Wood and metal, 47¾ x 18 inches. Yale University Art Gallery, New Haven, Connecticut; Gift of Katherine S. Dreier for the Collection Société Anonyme.

Such a focus required the sacrifice of poetic effect, at the very least conventional poetic effect, to the experience itself. Williams combined a surface artlessness with an emphasis upon things that ordinarily went unnoticed, such as the rubble "Between Walls":

> the back wings
> of the
>
> hospital where
> nothing
>
> will grow lie
> cinders
>
> in which shine
> the broken
>
> pieces of a green
> bottle[66]

Trash in back alleys had been the material for Kurt Schwitters' *Merz* constructions in Hannover. Although Williams did not use in this poem a collage technique involving the juxtaposition of disparate material, he did emphasize the poem's constructed quality by virtue of word placement so that the eye sees words dislocated on a line before syntax creates the sweep of the assertion.

The detritus of urban life was brought closer to home for Williams by Joseph Stella, who probably saw the German Dadaist's collages exhibited at the Société Anonyme in New York in 1920 and 1921 and where he himself exhibited in January 1923. Not only *The Little Review* but *Broom*, and later *transition*, featured Stella's paintings of Brooklyn Bridge, which became increasingly idealized and precisely depicted after the epiphenomenal surfaces of the rendition of about 1919 (Figs. 23, 24).[67] In contrast, his collages, which were often made out of water-soaked paper and torn fragments of advertisements, suggest another aspect of urban life. And a collage such as *Macchina Naturale No.18 (Related to "The Port")*, which includes a photographic image from the five-panel *New York Interpreted* (1920-22), tries to bridge the disparity between urban decay and an idealized vision of the city through self-reflexive synthesis of the artist's media (Fig. 25). Williams would have cast a wary eye on the rhetorical sweep of Stella's later bridge paintings, but the two artists were both attracted to city junk.

Wallace Stevens identified the anti-poetic in Williams' work in 1934. Williams was annoyed by Stevens' contention that the anti-poetic was an outlet, a mask, for sentimentality. Williams argued instead that the poetic and anti-poetic were of a piece, crea-

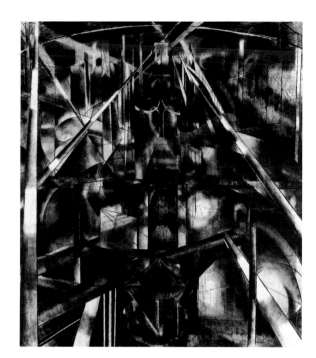

Fig. 23. Joseph Stella, *Brooklyn Bridge*, c. 1919. Oil on canvas, 84 x 76 inches. Yale University Art Gallery, New Haven, Connecticut; Gift of Collection Société Anonyme.

Fig. 24. Joseph Stella, *The Brooklyn Bridge: Variation on an Old Theme*, 1939. Oil on canvas, 70 x 42 inches. Whitney Museum of American Art, New York; Purchase 42.15.

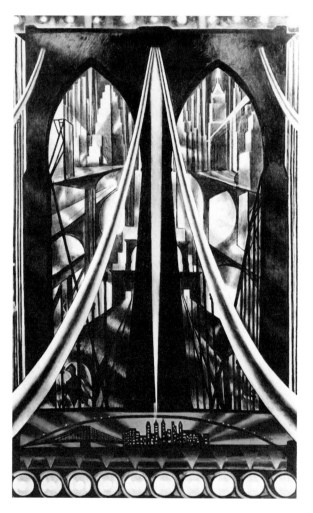

tion and destruction, art/anti-art, inextricably bound together in a dialectic.[68] Stella's collages work in such a fashion. Our attention is drawn to the material, paper stained and clotted, presumably rescued from the street. Close examination, however, of, say, *Collage, Number 21* (Fig. 26), reveals the care with which Stella folded, tore, and juxtaposed this paper, creating nuances of texture and tone. With Stella, too, we have someone who appreciated the neglected, who gained aesthetic pleasure from "the broken / pieces of a green / bottle" in a hospital back alley.

Williams never arrived at a logically consistent statement about art/anti-art. Not only was the dialectic unstable but Williams himself was volatile in constantly shifting social situations. The sweep of this process was dramatized in the sequence of books Williams published from 1920 to 1925. *Kora in Hell* (1920), *Sour Grapes* (1921), *Spring and All* and *The Great American Novel* (1923), and *In the American Grain* (1925) all share the interplay of creation and destruction. The first three works form a cycle of death and rebirth according to the natural seasons, and perhaps only with the exception of *Sour Grapes* all of them break the formal conventions separating poetry and prose, improvisation and self-conscious craft, fiction and history. Out of the despair voiced in *Kora*, the energetic defiance of *Spring and All*, the parodic novelizing of *The Great American Novel*, Williams came to terms with his "bastard country" and as a "United Stateser" was enabled to enter the American grain for the cultural texture of our past.[69] It was only a temporary truce, but it sustained him until the conflicts of the 1930s.

The visual qualities of Williams' books during the early 1920s were enhanced by the verbal and visual discourse opened by Dada experimentation. Among those works *Kora in Hell* was perhaps the most visually functional text. Not only was the improvisatory aesthetic applicable to the visual arts but the visual elements contributed to the total structure of the work. The cover illustration, conceived by Williams himself, went beyond simple decoration (Fig. 27). As Williams explained in *I Wanted to Write a Poem*,

Fig. 25. Joseph Stella, *Macchina Naturale No. 18 (Related to "The Port")*, c. 1922. Collage: newspaper, and photograph mounted on paper, 12⅜ x 9⅛ inches. Collection of Andrew J. Crispo.

61

Fig. 26. Joseph Stella, *Collage, Number 21*, c. 1920. Collage of paper, 10½ x 7½ inches. Whitney Museum of American Art, New York; Purchase 61.42.

Fig. 27. William Carlos Williams, cover for *Kora in Hell: Improvisations*, 1920. Courtesy of New Directions, New York.

"The cover design? It represents the ovum in the act of being impregnated, surrounded by spermatozoa, all trying to get in but only one successful. I myself improvised the idea, seeing, symbolically, a design using sperms of various breeds, various races let's say, and directed the artist to vary the shadings of the drawing from white to gray to black. The cell accepts one sperm — that is the beginning of life. I was feeling fresh and I thought it was a beautiful thing and I wanted the world to see it."[70]

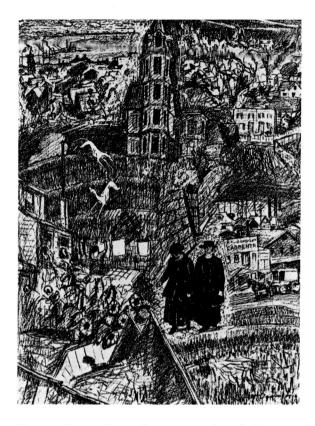

Fig. 28. Stuart Davis, frontispiece (1916) for William Carlos Williams' *Kora in Hell: Improvisations*, 1920. Courtesy of New Directions, New York.

For the frontispiece of *Kora* (Fig. 28) Williams selected a drawing by Stuart Davis, a young painter who at an even younger age had been a staff illustrator for the old *Masses*, the main Socialist monthly during the First World War. The poet's recollection is to the point: "I had seen a drawing by Stuart Davis, a young artist I had never met, which I wanted reproduced in my book because it was as close as possible to my idea of the Improvisations. It was, graphically, exactly what I was trying to do in words, put the Improvisations down as a unit on the page.... Floss and I went to Gloucester and got permission from Stuart Davis to use his art — an impressionistic view of the simultaneous." After the book was published, Davis sent Williams a note of thanks for the copy he had received and cited its originality. "I see in it a fluidity as opposed to stagnation of presentation," Davis wrote. "It opens a field of possibilities. To me it suggests a development toward word against word without any impediments of story, poetic beauty or anything at all except word clash and sequence. This may be a total misrepresentation of your motives. Best of all the work does not suggest any of the modern poets with whom I am familiar. I like the book and am glad to be associated with it."[71]

The painter need not have worried about misinterpreting *Kora*. Williams was trying to improvise a language with its own life, and the strategy of the Prologue in relation to the text of Improvisations was to draw the reader into the material with its own non-linear logic. A variation of an oil entitled *Gloucester Backyard* (Fig. 29), Davis' 1916 landscape sketch was an attempt to work toward the multiplicity developed earlier by the Cubists; it was, in Williams' words, "an impressionistic view of the simultaneous," the present moment on which the Improvisations were focused as a unit on the page.

Davis continued to explore the possibilities of his sketch in an oil of 1918, entitled *Multiple Views* (Fig. 30). From this early attempt to synthesize different views in a single work he gradually learned how to flatten interior space to the canvas surface so as to endow his painting with an inherent pictorial logic as a thing in itself. The linear composition and sparse use of color attest to his concentration on surface structure in *Windshield Mirror* of 1932 (Fig. 31). As a result Davis achieved a complex simultaneity of vision: the title places us in the driver's seat and gives us a rear view as we also presumably look ahead through the windshield. Yet our view is mediated through a mirror; indeed it has become the mirror image as a painted surface. The attendant spatial

Fig. 29. Stuart Davis, *Gloucester Backyard*, c. 1916. Oil on canvas, 30¼ x 24¼ inches. Robert Schoelkopf Gallery, New York.

dislocation, initiated by the visual cues of the title, is consummated by a pictorial reality that is finally independent of the mirror to the extent that Davis avoided a literal transcription of reflection. Davis thus successfully integrated an American urban scene, Williams' "perpetuum mobile," with the felt necessities of making a picture.[72] He was on his way toward the modernism he had vowed for himself upon seeing the 1913 Armory Show. Williams, too had resolved as much then. Although the two came together only once at the outset of the 1920s, they both sought ways to interpret the American scene through what they gained from an avant-garde education.

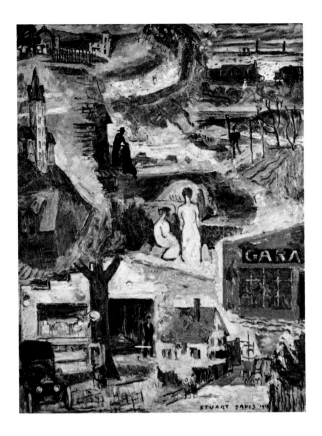

Fig. 30. Stuart Davis, *Multiple Views*, 1918. Oil on canvas, 53¼ x 40¼ inches. Collection of Mrs. Stuart Davis.

Fig. 31. Stuart Davis, *Windshield Mirror*, 1932. Gouache on paper, 15⅛ x 25 inches. Philadelphia Museum of Art; Gift of Mrs. Edith Halpert.

# Charles Demuth and the Script of Painting

Williams dedicated *Spring and All* to Charles Demuth. He later explained somewhat casually that "it was his turn for a dedication and tribute." The book, however, was more apposite than Williams might have led us to believe. Demuth had been mixed up with New York Dada, and *Spring and All* was one of Williams' major Dada gestures. Then, too, the poet's regard for plants and flowers made him especially appreciative of Demuth's elegant watercolors. In the book, of course, it was "Spring and All," when "THE WORLD IS NEW," with

> petals radiant with transpiercing light
> contending
> > > above
> the leaves
> reaching up their modest green
> from the pot's rim . . . .[73]

The lines echo Demuth's watercolor *Tuberoses* (Fig. 32), which he painted in 1922 while undergoing insulin treatments for diabetes at a sanitarium in Morristown, New Jersey. Williams used to come over from Rutherford and occasionally take him home for short visits.

After graduating from college in Philadelphia Williams and Demuth managed to keep in touch, largely because their friendship drew upon a shared apprenticeship in modernism, from which a larger network of friends and acquaintances burgeoned. Their bond went beyond nostalgic affection to a feeling of mutual respect that was based upon a grasp of what was involved in the other's writing or painting. It could hardly have been otherwise, given the divergent personalities each liked to assume. Demuth was ever the boulevardier, Williams the country doctor. Their differences extended to their hands: Demuth's were those of an aesthete, sensitively photographed by Stieglitz; Williams thought of his as "stonemason's hands." "An esthete, huh? Some esthete," so he wistfully dismissed his "stumpy fingers."[74]

Yet the two artists might be seen as mirror images of each other. Demuth seriously considered a writing career as late as 1914, just about the time that Williams gave up painting for poetry. Despite their commitment to different media, they came together on a middle ground between visual art and literature. Williams was able to see poetry from the perspective of modern painting while Demuth talked about his painting in terms of writing. Although they did not collaborate in the strictest sense of the

Fig. 32. Charles Demuth, *Tuberoses*, 1922. Watercolor on paper, 13⁹/₁₆ x 11⁵/₈ inches. Private collection.

Fig. 33. Charles Demuth, *Pink Lady Slippers*, 1918. Watercolor on paper, 21⁷/₈ x 15¹⁵/₁₆ inches. Private collection.

word, each was attracted to the other's work and was occasionally moved to use it as a basis for one of his own. The ground of their discourse was finally shaped by a mutually felt need for the creation of an American art out of their modernist preoccupations.

Williams' stress upon the local as the basis of an American art was programmatic, contrived in part out of personal economic necessity. In contrast, Demuth's family had sufficient means so that the painter managed to be independent, getting to Europe several times. He wanted to travel even more frequently and might have become an expatriate were it not for his precarious health, relegating him to the care of his mother in the family home in Lancaster, Pennsylvania. He had to adjust to the situation by various stratagems. His watercolors and still lifes were a concession to his physical weakness brought on by diabetes. Weekly excursions to New York when he was able helped to relieve a sense of isolation. But adjustment on a more profound level was necessary. Effectively cut off from Europe, Demuth took the opportunity to address the possibility of creating an American art. Yet such a prospect was not without its ironies, for it courted the danger of provincialism (anathema to an aesthete!) and thus called all of the painter's characteristic indirection into play.

On his last trip to Europe in 1921 Demuth revealed signs of a double consciousness. Writing to Stieglitz from London at the end of August he exclaimed, "I never knew Europe was so wonderful, — and, never knew, really, — not so surely, that New York, if not the country, has something not found here. It makes me feel almost like running back and doing something about it . . ." Almost, but not quite: his ambivalence, that of a pilgrim between two worlds, subverted such resolve. "But what does that come to?" he asked in the next breath. Some six weeks later in Paris his mind gravitated to America. Again to Stieglitz back in New York: "I think that I will stay on for another month or two, — and then come home. Had I stayed when I first came over [in 1904], — I was only twenty, — well, I might have gotten into it. Now it would take years, — and work would seem so only on the surface of the scene during that time."[75] Three days later on 13 October Demuth sent Williams a small book on Matisse, perhaps in tacit acknowledgment of Williams' piece on *The Blue Nude* in *Contact* the previous January. He also generously encouraged his friend with some praise from abroad and then reiterated his ambivalence toward Europe.[76] Cultural assimilation was on his mind. He had had a taste of European modernism but he was astute enough to realize how long it would take him to master the new art entirely on its own terms, that is, according to the dictates of European culture and society. Could he assimilate modernism if not on his own terms at least in response to those set by American life?

Foremost among difficulties was what Demuth perceived to be a profound indifference among Americans toward art. It was an indifference that rendered virtually invisible whatever efforts American artists made. Hence he voiced his astonishment to Williams upon discovering an American art through the French: "France thinks a great deal of our art, — of course, it all seems strange, — never knowing we had one!" Demuth's irony came with the persona of an aesthete, but it was also central to another stratagem that he developed in response to the cultural indifference around him. We glimpse this subterfuge later in the decade in his description of Washington Allston's *Self-Portrait:* "Somehow it is able to say: 'America doesn't really care' — still, if one is really an artist and at the same time an American, just the not caring, even, though it drives one mad, can be artistic material." Allston provided Demuth with the possibility of translating indifference into art. The prospect itself was reflexively ironic, highly suggestive of Duchamp's meta-irony, the irony of indifference that refuses to settle its ambiguities, for Demuth's phrasing left itself open to the artist's indifference, matching that of his public and thus creating the necessary distance for play. Here was a cultural space for the aesthete that complied with an earlier paradox. "I feel 'in' America," Demuth wrote Stieglitz from Paris, "even though its insides are empty. Maybe I can help fill them." The simultaneous presence and absence of the artist, the plenitude of emptiness, were possibilities that Demuth would explore with his mercurial wit. And so in 1921 he was prepared to join Stieglitz in a common enterprise. "Together," he declared, "we will add to the American scene. . . ."[77]

*Buildings, Lancaster*, painted in 1930, epitomizes Demuth's contribution to the local (Pl. III). The painting is firmly rooted in a sense of place, specifically referring to Eshelman's feed business.[78] Demuth portrays the visible institutions of the business community and notes in passing its history in American life. The painting thus highlights a central force in American society that is animated by the Protestant Ethic, which demands a practical life of work over and above the frivolities of play and, by extension, art. But the painting does not offer a mere record. Its commentary on the American scene emerges from the formal means that Demuth has exercised. His Cubist-Realism, as some critics have designated his style, exploits the geometry inherent in the building, thereby creating its own pictorial structure. The process moves from discovery to invention. The clarity of lines (even in the passages that characterize the lower street in the closest approximation of Cubism), the rays that unite sky and buildings, the brightness of the colors, and the elegant twists of smoke all combine to create an aesthetic experience in marked tension with the drab architectural actualities of such towns. Demuth did not idealize Lancaster, anymore than Williams was capable of sentimental-

68

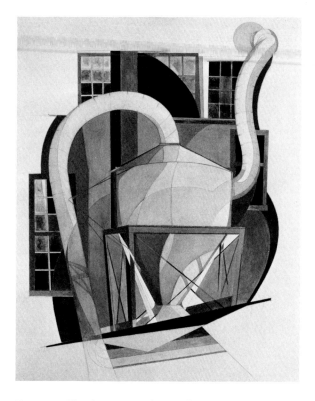

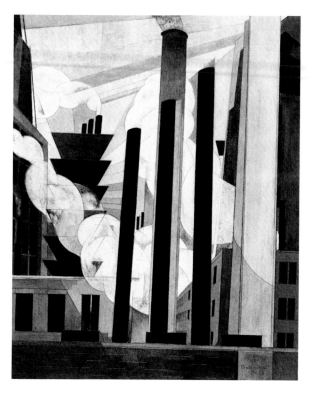

Fig. 34. Charles Demuth, *Machinery*, 1920. Tempera and pencil on cardboard, 24 x 19⅞ inches. The Metropolitan Museum of Art, New York; The Alfred Stieglitz Collection, 1949.

Fig. 35. Charles Demuth, *End of the Parade— Coatesville, Pa.*, 1920. Tempera on board, 20 x 15 inches. Collection of Mr. and Mrs. Paul H. Williams.

izing Rutherford or nearby industrial Paterson, for the painter's town is sufficiently present in the painting to suggest its discourse with the image Demuth created. Yet the painter had the vision to clarify as his own what was not realized in Lancaster itself. His assertion of that vision is the primary statement of the painting.

Demuth's awareness of the extent to which industrialization and urbanization had taken over was manifested even in a town portrayal such as *Buildings, Lancaster*. The small farmholder, that legendary yeoman of agrarian America, was replaced by agribusiness. Duchamp's private skepticism toward the machine was matched by Demuth's. It was manifested occasionally in the depiction of actual machinery, utilizing the mechanomorphic manner of Duchamp or Picabia, as in *Machinery* (Fig. 34), a sinuous complex of rooftop ventilators and watertanks, ironically dedicated to Williams in 1920, with Demuth's apparent foreknowledge of the poet's disapproval: even years later Williams still deplored "faking the psychologic appearance of the machine, making perhaps a 'woman' of it, so that it appears to be what it is not . . . ."[79]

Ordinarily, Demuth reserved his irony for the titles of his paintings, as in *End of the Parade—Coatesville,*

*Pa.*, which Williams purchased in 1920 from the Daniel Gallery (Fig. 35). The visual image set against the title generates an enigmatic irony not readily divined, though work and play are clearly at odds. While this title appears to be hermetic, others are deliberately ambiguous. Consider the indeterminate irony of the large oil entitled *My Egypt*, painted in 1927 (Fig. 36). On the one hand, the heroic conception of the grain elevators favors an affirmative intepretation of the title. Perhaps having recollected Hartley on Wallace Gould, Demuth accepted the challenge that the Maine poet (and by extension any American artist) "needs a Russia, or an Egypt, or earlier times for his playground. . . ."[80] Here, then, in this painting Demuth offered *his* Egypt, here was the playground — business as usual — in which to make the "titanic gestures" Hartley sought from the American artist. But on the other hand, the juxtaposition of grain elevators against allusions to ancient Egyptian splendors is sufficiently unsettling to cast doubt upon the value of contemporary American commerce. Demuth's skepticism lends a cerebral quality to the painting.

With his ironic titles Demuth shared Duchamp's desire "to put painting once again at the service of the mind."[81] An emphasis upon titles suggests a narrative dimension that was even more evident in

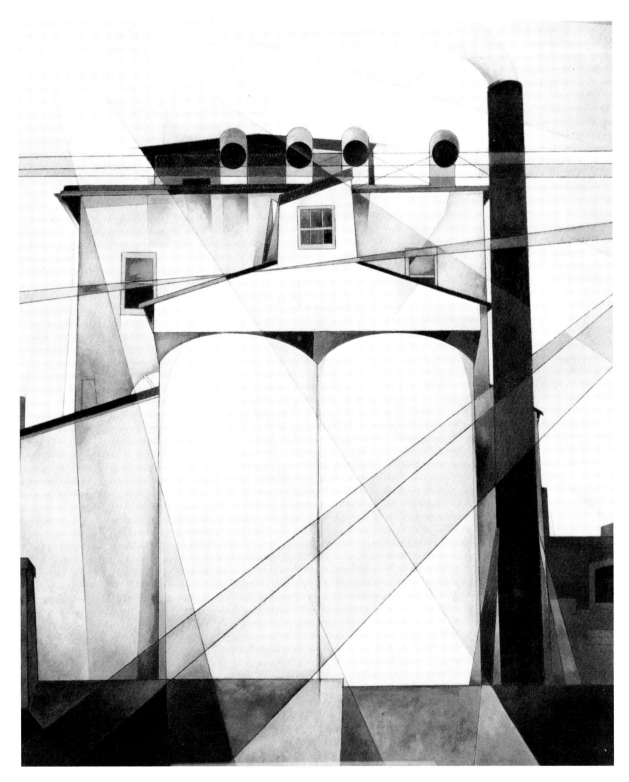

Fig. 36. Charles Demuth, *My Egypt*, 1927. Oil
on composition board, 35¾ x 30 inches. Whitney
Museum of American Art, New York; Gift of
Gertrude Vanderbilt Whitney 31.72.

his illustrations of Emile Zola's *Nana* in 1915 and Henry James' "The Turn of the Screw" and "The Jolly Corner" in 1918.[82] Nevertheless, he had no intention of getting away, in Duchamp's words, "from the physical aspects of painting." Demuth's work always retains a sensual surface, that which he called "the touchable bloom if it were a peach." In a brief essay for *Creative Art* in 1929 Demuth flatly preferred the sheer visual quality of painting: "Colour and line can say quite a bit, unaided by words, when used by one for whom they are a means of expression. Words are not to me a means. I can only paint."[83] How, then, did he manage to reconcile this statement with his literary interests?

Seen in its context, Demuth's position was not self-contradictory. The entire drift of his argument was simply that a painting existed in its own medium: any attempt to explain it by words would be at best superfluous or, more often than not, impossible. In either case, Demuth wanted little to do with written explanations. He could still say, with consistency, "Across a Greco, across a Blake, across a Rubens, across a Watteau, across a Beardsley is written larger letters than any printed page will ever dare to hold, or Broadway facade or roof support, what its creator had to say about it." The metaphor of writing for the act of painting served him well. It allowed him to integrate verbal elements into his visual design; to see words, in whatever form they took, as part of his painting, which became an extension of language as "painted sentences."[84] Thus Demuth's titles interact with the visual imagery: the sheer pictorial quality of *My Egypt* balances the cerebral effect of the title. And the words in his paintings exist as visual elements, in the manner of Cubist works, even as they retain their verbal properties. Eshelman's billboard in *Buildings, Lancaster,* for example, has a visual dimension that enhances the painting while it remains a sign on the side of a building and serves to identify its commercial use.

Although Demuth's watercolors of Zola and James maintain a narrative element drawn from the stories on which they are based, they assert a hybrid independence, existing somewhere between the cartoons of popular culture and the literary complexities that we expect from what we might call "high" culture. Their world is dream-like, dense yet fluid, comic yet menacing. The final watercolor in this vein was *Distinguished Air*, which Demuth painted in 1930 from the title story of a collection of McAlmon's fiction published in 1925 (Fig. 37). Whereas James' sensibility and Nana's sexuality struck responsive chords in Demuth, McAlmon's collection quickened his interest for its account of bohemian life in Europe during the 1920s. "Grim Fairy Tales": the sardonic title gives it away. Homosexuals, lesbians, transvestites, nymphomaniacs, drug addicts, and alcoholics populate McAlmon's fiction of postwar

Berlin, which he visited with Hartley. Williams later claimed that *"Distinguished Air* heads the list of [McAlmon's] own writing. It is a brilliant piece of work, unfortunately all but unpublishable because of the material."[85]

Williams found *Distinguished Air* reminiscent of the work of George Grosz, whose drawings he owned in a small chapbook published in 1921, and whose watercolors were exhibited at An American Place in 1935. There was, however, a distinction to be made between McAlmon and Grosz, and Williams sensed it: "All that is human, one might say all that is extraordinarily human interests [McAlmon's] mind. And that is a quality rarely lifted up today."[86] Unlike Grosz, whose Dada satire was unsparing of his countrymen, McAlmon mostly refrained from passing judgment on his characters in *Distinguished Air*: people are bored, empty, despairing—here is life as it is given. Similarly, Demuth assiduously avoided political commentary in his work. His irony was lighter than Grosz's. It afforded him a playful detachment, a fluidity of meaning commensurate with the surface flux of his watercolors.

Fig. 37. Charles Demuth, *Distinguished Air*, 1930. Watercolor on paper, 14 x 12 inches. Whitney Museum of American Art, New York; Gift of the Friends of the Whitney Museum of American Art, Charles Simon (and purchase) 68.16.

In his *Distinguished Air* Demuth brilliantly depicts that which McAlmon omitted from the title story. McAlmon's narrator sets out for Der Sturm Gallery but changes his mind at the last moment in order to avoid some obnoxious Americans who might turn up there. The narrator's decision is a minor one, of little or no consequence for what ensues, but Demuth picked up the possibility not taken and developed it pictorially for his own purposes. By inventing his own episode Demuth gained some distance from the story and expanded a theme merely touched upon by McAlmon in passing. Thus the setting for Demuth's painting is an art gallery in which two homosexuals, a couple whose heterosexuality might be questioned, and a lone woman contemplate what can be identified as Brancusi's sculpture of Mme Pogany. The "distinguished air" of McAlmon's story refers to the distinctive quality that one homosexual claims Foster Graham, a bisexual, once had but now has lost in his sexual excesses. With his elegant cane, Foster Graham was perhaps depicted in the painting as the male partner of the couple who surreptitiously looks over the sailor.

The notion of a distinguished air is not entirely without social pretense in the story but in the painting the gallery viewers' distinguished air is patently false and comic. The onlookers stand sexually exposed. In effect they act out Foster Graham's response to the narrator's invitation to go to Der Sturm: "'Goodness me, Marjorie, I just love art. I love art,' Foster minced, unable to be direct for over a moment. 'Will there be some pretty pictures of naked boys? I just love art. It's too exquisite. So glad you asked me along.'"[87] Demuth plays such campiness toward art both ways. At one with the sexual preoccupations of the viewers is the sculpture of Mme Pogany, drawn out as a phallus mimicking the top hat of the sailor's friend. By emphasizing the phallic shape of a female portrait Demuth reveals an androgenous art, making explicit the subtle eroticism of his flower and vegetable watercolors. The sculptured figure looms over the viewers, who are now seen engaged in an atavistic though comic rite, as the painting assumes the proportions of a dream.

Demuth expressed his literary interests less directly in a series of poster portraits which he began in 1923 for his personal amusement as homages to his friends, Dove, Marin, and O'Keeffe among them. Perhaps the most famous of these "stylized symbols," as the critic Henry McBride later called them, is the poster portrait of Williams in 1928 (Pl. IV). Even if the painting were an explicit likeness of the poet, it might yet portray the American scene in accordance with Demuth's broad though insightful definition. While he was still working on the painting he claimed that "in portraiture likeness is only the start, with this start the painter must in some way record his times, his own response to them. . . ." Seeing likeness as a means to an end, he argued, "All this work comes only out of the American, it could come from no other. All of it is covered; glazed with our own wit."[88]

As it is, *I Saw the Figure 5 in Gold (to W.C.W.)* is based upon Williams' poem "The Great Figure." In his *Autobiography* Williams tells us that the poem occurred to him one hot July evening in New York as he was going to Hartley's after work at the Post Graduate Clinic: "As I approached his number I heard a great clatter of bells and the roar of a fire engine passing the end of the street down Ninth Avenue. I turned just in time to see a golden figure 5 on a red background flash by. The impression was so sudden and forceful that I took a piece of paper out of my pocket and wrote a short poem about it." Williams managed to compress the experience into a succession of key words:

> Among the rain
> and lights
> I saw the figure 5
> in gold
> on a red
> firetruck
> moving
> with weight and urgency
> tense
> unheeded
> to gong clangs
> siren howls
> and wheels rumbling
> through the dark city.[89]

"Firetruck" draws together an image for us from the narrator's discrete sightings that emerge from the confusions of "rain/and lights." The engine anchors the experience, which then accelerates by "moving." As the truck passes beyond the narrator, visual perceptions give way to sounds which reach a high pitch with "siren howls" and then descend with "wheels rumbling." The fire truck fragments into its components once again as the poet's voice is overtaken by the event, *its* sounds, and then silence, the engine having passed from earshot in the urban night.

Judging from a letter Williams wrote in May 1928 to Demuth, the painter had difficulty in rendering the final design of his canvas. After congratulating his friend for "the most distinguished American painting" of the past several years, the poet went to the heart of the problem:

I like the 5 better than I did at first, but the blankness of the red in the center bothers me. It should be blackened or something. I feel in this picture that the completion that was once felt and made the composition a whole has been lost and that you have tried twenty times to recapture and that every try has left a trace somewhere so that the whole is tortured. It needs some new sweep of the imagination through the whole to make it one. It is no longer one but — not even 5. It is all shaken up. . . .

O hell, I suppose you're tired of the picture. Maybe Stieglitz's suggestions are all that are necessary: to frame the picture better and to make the gold five a *smooth* metallic figure instead of pocky as it is now.

But my own feeling, as I told you over the phone is to take the hint from the picture itself. That is, to use the overlapping of planes, one contour passing partly into the next. If that were used more through the solid red center (as it is used among the figures which surround it) the whole would gain by a unity of treatment which would cast a unity of feeling over it all. You have, in fact, done something of that with the very center of the picture but not enough.[90]

Williams was concerned about creating a unity for the painting through an interaction of planes and rays determined by color. It is impossible to ascertain the status of the painting when Williams wrote his critique, and it is equally impossible to determine the extent to which Demuth followed his advice. But it is clear that the painter did take a "hint" from the painting and made planar variations of reds in the center to override the "blankness" of red that disturbed Williams.

What was most significant in their exchange was the poet's suggestion to work out the painting according to the dictates of its own logic. Williams typically emphasized the painting as an autonomous entity in itself. The repetition of the numbers, the modulation of colors through intersecting rays and planes, and the shallowness of the picture plane all work to create a pictorial integrity. But Demuth's *Figure 5* is not hermetically sealed. It has a visual openness that is faithful to the movement of the poem. As in "The Great Figure" the painting takes the abstracted form of the fire truck as the point of reference for the picture. From it the darkened city recedes in shallow space and the figure fives project forward to the viewer. Contributing to the pictorial movement are the cropped elements along the edges of the painting lending the illusion that more is happening than we can take in.

The bright colors, the bold imagery suggest something of Williams' personality and thus contribute to his portrayal. But Demuth's is primarily a portrait of Williams as a poet since the painting is based upon one of his poems. The painter casts Williams as an urban poet, part of a cityscape. At the same time he wittily comments on his friend's relative obscurity as a poet. Williams' name is in lights, the poet is seen as a glamorous star in Times Square. Thus the painter worked ironically against the persona of the poem, "tense" and "unheeded" as the truck passes in the night. Demuth knew nonetheless that Williams was in the poem, albeit submerged by the experience, and so brought him to the surface of the painting.

*I Saw the Figure 5 in Gold* is the triumph of their friendship. On 23 August 1928 Williams wrote to Marianne Moore. Among other things he mentioned that Demuth had just finished painting "The Great Figure." He also commented on his friend's health. "Demuth is very well," he reckoned, adding the qualification, "as well as a man can be who has to have two hypodermic injections every day of his life and whose food must be weighed at every meal. His mother is a patron saint. He will live indefinitely, as long as we will." The doctor miscalculated. In seven years Demuth died of diabetes. Marsden Hartley wrote "Farewell, Charles, an Outline in Portraiture of Charles Demuth—Painter" in *The New American Caravan* of 1936, an anthology of writing edited by the friends and followers of Stieglitz. Williams, who usually tried to react matter-of-factly about death, for once found an adequate expression for his emotions. He wrote "The Crimson Cyclamen (To the Memory of Charles Demuth)." The poem fuses language, nature, and painting:

> It is miraculous
> that flower should rise
> by flower
> alike in loveliness –
> as thought mirrors
> of some perfection
> could never be
> too often shown –
> silence holds them –
> in that space. And
> color has been construed
> from emptiness
> to waken there –
> But the form came gradually.[91]

"I wanted to arrange for my older friends, William Carlos Williams and Charles Sheeler, to meet each other; and so we held a Dutch Treat dinner in a speak-easy, after which Williams, Sheeler, and their wives returned to our house, each guest bringing his own bottle of wine. We all sat on the floor not out of any Bohemian affectation, but because we had no chairs." So Matthew Josephson introduced the poet and the painter/photographer sometime during the summer of 1923. The previous spring Josephson had come home from Paris with the magazine *Broom* to welcome "the challenging American scene,"[92] machine and all: skyscrapers, jazz, dime novels, cowboy movies, and the like. He needed an expanded circulation to keep *Broom* afloat but above all he needed an energetic group of artists to help him make an assault on a moribund American art.

It was just what the doctor ordered. Williams was not above starting a fight. And incidently, he concurred with the major points of Josephson's program. The young editor's talk about the Dadaists in *Broom* confirmed his sense that they were up to something important. Although he was less optimistic about American technology and popular culture than Josephson, he readily agreed on the need to attend to artistic form. As early as 1919 he had emphasized "immaculate craft" in poetry, a distillation of what he had learned from the precise stylistic Pound had defined as Imagism earlier.[93] Thus, along with a general need of an American art, Williams had reason enough to support *Broom* with his writing.

Sheeler was equally important to gain as a friend of *Broom*. In 1921 he had collaborated with Paul Strand, whom he had met earlier through Stieglitz, on a documentary film short of New York City (Fig. 38). Entitled *Manhatta* and captioned with lines from Whitman, the film encapsulated a day in this most modern of cities, concentrating on the visual geometry of the skyscrapers. The film became a hit at a Dada festival in Paris in 1923 simply by celebrating the modern. Strand had already been featured in *Broom* with his straight photographs of machines and the city, among them *Truckman's House* of 1920 (Fig. 39), along with an essay on the prospects of photography in the modern world.[94] It was logical, then, for Josephson to seek out Sheeler, who was gaining stature as a photographer.

Prior to their *Broom* days Sheeler had moved among the same circles as Williams had for almost a decade. The painter had attended the Pennsylvania Academy with Demuth though they had not taken the same classes. Later they caught sight of one another in and out of Arensberg's apartment in New York. There, too, Sheeler first met Duchamp and became familiar with his glass construction *The Bride Stripped Bare by Her Bachelors, Even*. Its cerebral translucence, linearity, and meticulous craftsmanship impressed Sheeler

as it did Demuth. Sheeler, like Williams, worked on the fringes of Dada. While the art/anti-art ambiguities of Dada had thoroughly bewildered him, he also enjoyed its more frivolous aspects. For example, he photographed the Baroness Elsa's assemblage portrait of Duchamp for *The Little Review* (Fig. 40). (Williams recalled one of her pieces in Margaret Anderson's apartment as having the appearance of "chicken guts, possibly imitated in wax.")[95] And Sheeler joined Williams in contributing to *Aesthete 1925*, the last outburst of Dada in America. The pamphlet was a counterattack by Josephson and his friends on H.L. Mencken and Ernest Boyd, who satirized young American writers for their self-indulgence in the latest avant-garde fad. Sheeler contributed a drawing of New York skyscrapers for the cover while Williams wrote a letter scorning Mencken as a third-rate intellectual. *Aesthete 1925* was hardly a manifesto, but it did announce the arrival of a rambunctious new generation of American artists (Fig. 41).

In a more serious vein Sheeler and Williams came together in the October 1923 issue of *Broom*, which featured Sheeler's work. Two of his photographs, *Flowers* and *African Musical Instrument*, taken from his 1918 portfolio of photographs of African sculpture, graced the conclusion of "Soto and the New World," a chapter from Williams *In the American Grain* still in progress. In keeping with the essay, both photographs convey something of the primitive, nature and art combined in their fresh simplicity. Sheeler also contributed two paintings and one photograph of Bucks County barns, along with an enigmatic telephone *Still Life,* later called *Self-Portrait* (Fig. 42). The mechanomorphics of Duchamp and Picabia had made an impression on the American painter.

Fig. 38. Still from *Manhatta*, 1921, directed and photographed by Charles Sheeler and Paul Strand. Courtesy of The Stills Collection, British Film Institute, London.

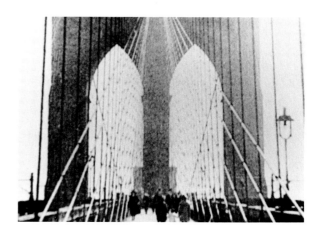

Fig. 39. Paul Strand, *Truckman's House, New York, 1920*. Photograph, 10 x 8 inches. Collection of Mrs. Paul Strand, courtesy of Aperture, Inc.

Fig. 40. Baroness Elsa von Freytag-Loringhoven, *Portrait of Duchamp*, photographed by Charles Sheeler, in *The Little Review* IX (Winter 1922).

Fig. 42. Charles Sheeler, *Self-Portrait*, 1923. Watercolor, pencil, and conté crayon on paper, 19¾ x 25¾ inches. The Museum of Modern Art, New York; Gift of Abby Aldrich Rockefeller.

Fig. 43. Man Ray, photograph of William Carlos Williams, 1924. Private collection.

Fig. 41. Charles Sheeler, cover of *Aesthete 1925* (February 1925).

At the end of 1926 Williams won *The Dial Award* for literature. He celebrated by having Sheeler take his picture. When he had been in Paris he had visited Man Ray's studio for some photographs (Fig. 43). Through some misunderstanding he ended up paying more than he had expected for the prints (in *his* memoirs Man Ray refers to a "modest bill") and then decided that he disliked them because they made him look "sentimental" and somehow not as sophisticated and as "hard" as his Parisian friends. (It was at the studio that he first glimpsed a young Berenice Abbott, who was getting her start as a professional photographer. Williams came to admire her work, so something good came out of the session.)[96] Sheeler's attempt in 1927 presented the poet in jacket and tie, face cast in shadow, brow slightly furrowed, hair touseled. Here was a public image of an urbane poet that Williams could accept. But characteristically enough, his "Lines on Receiving The Dial's Award" reveal another side to the poet:

> The sick carpenter fished up another bottle,
> empty, from his cellar
> for me last week, an old ginflask —
>
> What a beauty! a fat quartflask of
> greenish glass, *The Father of His Country*
> embossed upon one side of it
> in glass letters capping the green profile
> and on the other
> *A Little More Grape Captain Bragg*
> . . .
> An old, empty bottle in my hand
> I go through the motions of drinking,
> drinking to *The Dial* and its courtesy.[97]

Williams enjoyed being disreputable: miming the drinker's elbow during Prohibition, associating with a sick carpenter rummaging around in a cellar, finding old trash, appreciating its kitsch history. "It approaches poetry," he claimed, as did his own writing, though he kept a distance still from the likes of Eliot's *The Waste Land,* which *The Dial* had published. Williams mined instead the possibility of poetry out of his own ground. Sheeler, too, cultivated his ties with America, but he never tapped the dionysian energies Williams felt.

When Hartley met Sheeler and Morton Schamberg in 1918 he wrote approvingly to Stieglitz of their earnestness even as he was somewhat wistful of their comfortable circumstances. A moral point was called for: "I find a certain something missing," he mused, ". . . maybe they haven't suffered enough — maybe they don't know the inner significance of pain."[98] Schamberg failed to develop a capacity for suffering, or rather he suffered too much: he soon died in the influenza epidemic sweeping Philadelphia. Sheeler conformed without visible tragedy to Hartley's intuition by developing and sustaining an impersonality in his work. Years later, Henry McBride would be disturbed by the asceticism of the paintings.[99]

The visual problem of both Hartley and Sheeler involved balance. But whereas Hartley needed to recover pictorially the object from emotions that threatened to submerge it, Sheeler needed to develop a formalism that could withstand his laconic deference to the object. Almost from the start of his training, Sheeler distrusted the artist's role of actively shaping his materials and themes. At the Pennsylvania Academy he rejected the pyrotechnics of William Merritt Chase, his teacher. Coming hard upon Sheeler's disavowal of the bravura brushstroke were the visual manipulations of Cubism: its formal dislocations and surface textures disclosing the painter's presence in the work were cause for further consternation at the 1913 Armory Show. Subsequently, Sheeler could not even accept the visual compromises of "Cubist-Realism," as in the instance of Demuth's *End of the Parade* (1920; Fig. 35).

For someone who was virtually mesmerized by a commonsense visual reality yet who intuitively valued abstractionism, straight photography as advocated by Stieglitz and then Strand must have come as a godsend. When Sheeler moved to New York in early 1919 he had already been corresponding with Stieglitz about photography for several years; since 1915 he had done commercial photography for Marius De Zayas at the Modern Gallery. De Zayas was perhaps the chief theoretician on straight photography and modernism in the Stieglitz circle. Straight photography gave Sheeler an alternative to painting to which he could respond with full assent. He was attracted to its implicit positivism, which offered the illusion of recording the world directly by abjuring the manipulations of negative and print sanctioned by pictorial photographers. According to De Zayas, pictorial photography was subjective, dominated by the individual making the photography, whereas straight photography was impersonal, allowing someone like Sheeler to capture the very object itself.

Following such thinking, Sheeler decided to photograph New York, which had become a symbol of modernity. By 1920 he had discerned in the city a geometry that promised to lend form to the created image. One might become a modern artist simply by looking carefully and intensely enough. The fallacy of his wish was predicated on De Zayas' equally fallacious distinctions between straight and pictorial photography. Whereas Stieglitz upheld straight

Fig. 44. Alfred Stieglitz, *Evening, New York from the Shelton*, 1931. Photograph, 9⅜ x 7⅜. The Museum of Modern Art, New York; Gift of David H. McAlpin.

photography as an ideal for realizing the potential of photography as a medium in its own right, liberated from false comparisons to painting, Sheeler inverted the practices Stieglitz abjured. He implicitly took straight photography as a visual model for his painting.

Sheeler's departure from Stieglitz's position began with the differences in their practice of straight photography. From his genre scenes of New York in the 1890s to his photographs of skyscrapers in the 1930s Stieglitz kept technology within human scale and vision. Thus *Evening, New York from the Shelton* in 1931 is no exception, despite an emphasis on tall buildings dramatically outlined against the sky (Fig. 44). The formal quality of the scene prevails: architectural details emerge from the massive shadows which stand in contrast to a filigree of girders rising in the distance. Yet the mood and texture of the print, not to mention its composition, suggests an artist carefully making choices in the act of photography. The title itself discloses a point of view (made all the more personal because Stieglitz lived at the Shelton), a time of day, and a specific locale, thereby bringing the viewer to the photographer's side in relation to the scene taken.

By way of contrast, the title of Sheeler's photograph of *The Funnel* (1927; Fig. 45) does not establish a point of view. It simply identifies a complex of machinery on a ship's deck. *The Funnel* exists as a meta-photograph, exposing the dimensions of straight photography. The machines are bathed in light and focused with utmost clarity and precision to create a timeless scene. Sheeler thus sought that "state of perfect consciousness" that De Zayas claimed only a camera could achieve, so as to unveil the "reality of Form" of an object. Sheeler's limpid vision certainly reveals the geometry of machine elements and their shadows. Yet he could not completely disguise his point of view. It is that choice which ultimately determines the formal composition of *The Funnel* and suggests the limits of straight photography.

Although the chains bracing the funnel are reminiscent of the rays that fracture the skies of Demuth's paintings, Sheeler did not want to make photographs that looked like paintings. This allusion in *The Funnel* is rather indicative of the discourse between photography and painting that Sheeler evolved. (He eventually used photographs as studies for his paintings.) While he tried to rationalize clear

Fig. 46. Charles Sheeler, *Upper Deck*, 1929. Oil on canvas, 29⅛ x 22⅛ inches. Fogg Art Museum, Harvard University, Cambridge, Massachusetts; Purchase, Louise E. Bettens Fund.

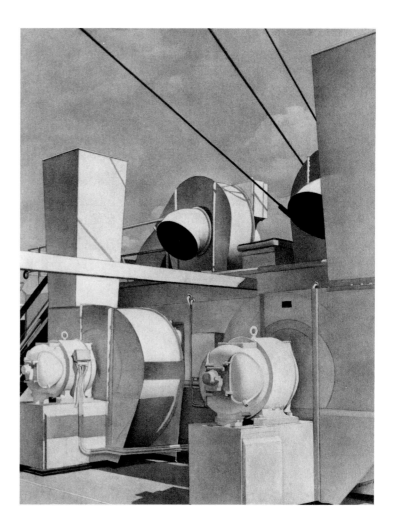

distinctions between the two media, he was nonetheless intrigued by the idea of paintings that looked like photographs. Straight photography appealed to his sensibility, which carried over to his painting. Thus his claim that the painting of the *Upper Deck* in 1929 (Fig. 46), which is related in subject to *The Funnel,* announced a new departure in his development of pictorial design, remains unconvincing.[100] An emphasis upon line, a monochromatic palette, and the careful elimination of painterly surfaces all attest to Sheeler's attempt to capture on canvas a reality he saw through the camera.

It was Williams who discerned these visual ambiguities in Sheeler. In his introduction to the Sheeler catalogue for the 1939 exhibition at the Museum of Modern Art Williams put a good face on it, reiterating the Precisionist line: "I think Sheeler is particularly valuable because of the bewildering directness of his vision, without blur, through the fantastic overlay with which our lives so vastly are concerned, 'the real,' as we say, contrasted with the artist's 'fabrications.'"[101] Privately, the poet had misgivings, which he expressed to Constance Rourke, the painter's biographer. Williams feared the influence of photography on Sheeler's painting. It detracted from the use of color and painterly texture. It allowed Sheeler to withdraw, to be impersonal, whereas an infusion of emotion was necessary.[102] Worse yet, emulation of photography could result in an empty realism, what Sheeler himself rejected in a painting as "a reduced replica...both as to literalness of form and color."[103] By those standards an oil such as *River Rouge Plant* (1932; Pl. V) looks inert in its representation. The image lacks an intensity to bring it to life because of too much detail, obscuring an inherent geometric structure that Sheeler usually sought as the basis of his composition. Only the year previous, however, *Classic Landscape* achieved a necessary balance of detail and design to stand on its own (Fig. 47). Not until the 1940s was Sheeler able to sustain consistently the structural qualities of *Classic Landscape* in his paintings.

Fig. 47. Charles Sheeler, *Classic Landscape*, 1931. Oil on canvas, 25 x 32¼ inches. The Estate of Mrs. Edsel B. Ford.

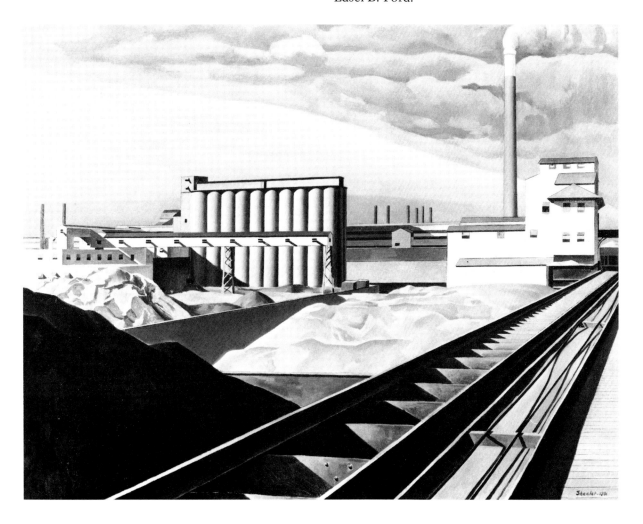

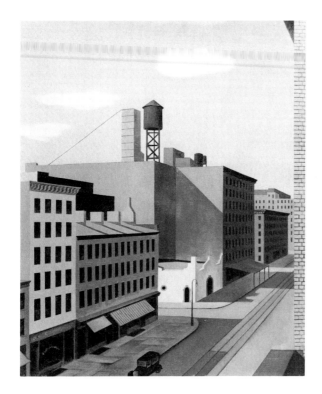

Fig. 48. George Ault, *Hudson Street*, 1932. Oil on canvas, 24 x 20 inches. Whitney Museum of American Art, New York; Purchase 33.40.

Fig. 49. John Storrs, *Forms in Space*, c. 1924. Aluminum, brass, copper, and wood on black marble base, 28½ x 5½ x 5¼ inches. Whitney Museum of American Art, New York; Gift of Charles Simon 77.58.

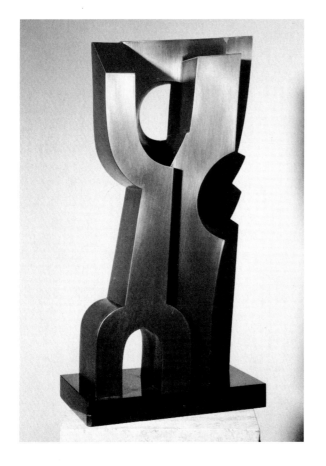

Fig. 50. John Storrs, *Composition Around Two Voids*, 1932. Stainless steel, 20 x 10 x 6 inches. Whitney Museum of American Art, New York; Gift of Monique Storrs Booz 65.34.

Despite Sheeler's long-standing difficulties in reconciling himself to the manipulative role of the artist, the Precisionist qualities of his pictorial vision were well established by the early 1920s. Precisionism was hardly a movement in the sense that a group of artists collaborated and exhibited together, issuing manifestos that proclaimed common aesthetic or political stands. In this regard Precisionism was like Objectivism in poetry, which was also elusive as a movement. Even though a group of poets, Williams among them, published together in 1931 in an issue of *Poetry* devoted to Objectivist verse, Objectivism was really the invention of a single individual, Louis Zukofsky, who came up with the idea for Harriet Monroe, the editor of *Poetry*.[104] Moreover, his commentary as guest editor was all too fragmented and eliptical to suggest a coherent manifesto upon which the contributing poets might have agreed. Without even the dubious virtue of invention, except perhaps as a descriptive label by art ctitics for their own convenience, Precisionism was mostly a matter of informal evolution among a broad range of artists.

Unlike Objectivism, which did not call for any particular subject, Precisionism was an art of urban and industrial America, whose external forms, geometric and hard edged, seemed to require a commensurate visual style. Because of these nominal stylistic elements, a varied group of artists might be called "precisionist," ranging from Georgia O'Keeffe and Charles Demuth to Stuart Davis and Louis Lozowick, from Edward Bruce, George Ault (Fig. 48), and Preston Dickinson to Elsie Driggs and Ralston

Crawford, including even a sculptor such as John Storrs, whose *Forms in Space* (c. 1924; Fig. 49) and *Composition Around Two Voids* (1932; Fig. 50) evoke urban structures.

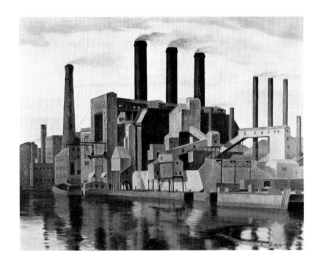

Fig. 53. Edward Bruce, *Industry*, 1932. Oil on canvas, 28 x 36 inches. Whitney Museum of American Art, New York; Purchase (and exchange) 34.4.

Fig. 52. Preston Dickinson, *Industry*, before 1924. Oil on canvas, 30 x 24¼ inches. Whitney Museum of American Art, New York; Gift of Gertrude Vanderbilt Whitney 31.173.

Fig. 51. Elsie Driggs, *Pittsburgh*, 1927. Oil on canvas, 34¼ x 40 inches. Whitney Museum of American Art, New York; Gift of Gertrude Vanderbilt Whitney 31.177.

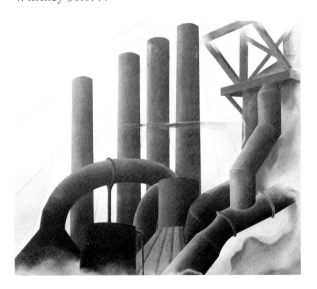

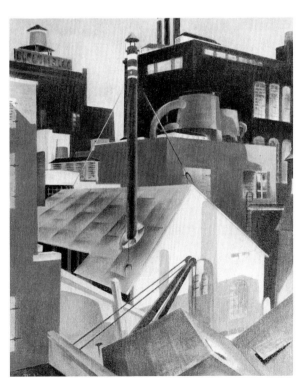

But subject matter alone fails to hold these artists together in any significant way. Neither does style. Consider, for example, Stuart Davis' *House and Street* (1931; Pl. VI), which approaches abstraction; Henry Billings' *Lehigh Valley* (c. 1930; Pl. VII), which verges on Surrealism; or Georgia O'Keeffe's *City Night* (1926; Pl. VIII), which is far more organic than geometric in form. No matter how striking, linearity and clarity of form were simply two elements of style that contributed to the diverse visions of these artists. The cropped volumetric shapes of Elsie Driggs' *Pittsburgh* (1927; Fig. 51) contribute to the bold power of the steel mill; the brilliant use of color in Ralston Crawford's *Overseas Highway* (1939; Pl. IX) is essential to the rhetorical sweep of the painting; the Cubist variants of Preston Dickinson and Edward Bruce in their renderings of *Industry* before 1924 and in 1932 respectively suggest the formal exercises that technology stimulated (Figs. 52, 53).

Among these artists Sheeler and Williams have been the most visibly associated with Precisionism and Objectivism. Despite the vagueness of those terms the two friends sensed in them a related aesthetic with which they might concur. Although Imagism in poetry was an obvious antecedent of Objectivism almost two decades before, so many paintings, photographs, and pieces of sculpture had intervened since Pound defined an image as "an intellectual and emotional complex in an instant of time" that Williams related Objectivism to a visual rather than a verbal context — a Cubist painting, he said in his *Autobiography*.[105] (Zukofsky himself, one of the more aural poets, borrowed the analogy of a focal point of a lens in an attempt to define Objectivism.)[106] Objectivism, moreover, was compatible with the idea of Contact, whose implicit aesthetic values were drawn from felt cultural imperatives into service for a poetic.

Both artists thus came to stress the painting or the poem as an autonomous object, a work that was taken objectively rather than subjectively, impersonally rather than emotionally. These essential qualities pointed to the work of art as a machine, with efficient, interlocking parts. (One can see the camera-machine, in Sheeler's mind's eye.) To state the matter schematically fails to reveal the nuances of ideas modulated by each artist. Williams consistently held to the first tenet, for in regarding the poem as an object he could concentrate on its form by manipulating language. Although he advocated the other tenets at the time of Objectivism, he clearly did not find them so important as the first.

Sheeler on the other hand abided by all the tenets of this aesthetic. He held to the machine as a basic model for the painting: "Forms created for the best realization of their practical use may in turn claim the attention of the artist who considers an efficient working of the parts toward the consummation of a whole, of primary importance in the building of a picture."[107] The building of a picture suggests the possibility of its autonomous existence, but Sheeler had the most difficulty in working toward such pictorial autonomy. Here we gain the full ambiguity of setting the artist's "fabrications" against the "real," as Williams did in speaking of Sheeler. The painter's preoccupation with direct presentation was aimed at the real, but it also undercut the fabrications so necessary for a work to become autonomous and not simply be a window to the world.

The paradox often eluded Sheeler during the 1930s. Yet *Classic Landscape* of the Ford plant in Detroit successfully took the machine as both formal model and subject for the canvas. "There I was to find forms which looked right," the painter claimed, "because they had been designed with their eventual utility in view and in the successful fulfillment of their purpose it was inevitable that beauty should be attained."[108] The image of the Ford plant became an apt metaphor for the pictorial form that Sheeler sought.

Perhaps for that reason Williams may have recalled *Classic Landscape* when he wrote "Classic Scene":

> A power-house
> in the shape of
> a red brick chair
> 90 feet high
>
> on the seat of which
> sit the figures
> of two metal
> stacks — aluminum —
>
> commanding an area
> of squalid shacks
> side by side—
> from one of which
>
> buff smoke
> streams while under
> a grey sky
> the other remains
>
> passive today—[109]

What is significant about the relationship between the poem and the painting is the way that the poem does not depend upon the painting for its imagery. They are bound together by their aesthetic presuppositions.

The key term in both works is "classic" even though on the face of it there is little that appeared classic in a factory scene. Hadn't advanced machine technology cut America off from the past? *Classic Landscape* and "Classic Scene" both attempted to bridge the gap at a time of great social and economic upheaval. Of the two works Sheeler's painting more readily evinces classical form. The painter established geometric relationships from the buildings. The meaning of an industrial "order" is thus rendered explicit in the painting. Balance, harmony, and reason contribute to this classic landscape. Moreover, we see the painting as a painting because Sheeler restrained photographic detail.

Williams' poem is the more problematic of the two works because he would not pander to poetic tradition, especially the English, as a source of American writing. A modern classic had to exist on its own terms. "Classic Scene" is not even a complete sentence; it amounts to a descriptive phrase qualifying "powerhouse." The poem is thus laconic and abstracted, precisely focused on a building in the landscape with "squalid shacks" in relation to it. This sentence fragment, which nonetheless has an illusion of wholeness about it, joins the meticulous placement of words on a line to suggest the poem as object, as a construct of words.

Paradoxically, this simplicity and clarity of description, which are classical qualities, almost obscure the poem's connection with the past. Williams uses words that can be taken to describe the powerhouse literally but that also extend a submerged conceit likening the smokestacks to monolithic figures, ancient sculpture of the gods on their thrones perhaps. The ambiguous language verging on the anthropomorphic calls attention to the age-old way we ascribe human identity to large-scale forces and things, machines in our instance. The powerhouse dominates the landscape with an elemental quality, rivaled only by the sky. The powerhouse becomes a mysterious icon of the twentieth century, an "occult mechanism" according to Henry Adams in describing his responses to the dynamos at the Paris Exposition of 1900, rendered all the more mysterious by Williams' matter-of-fact description.[110] (Williams had read Adams on the recommendation of Zukofsky, who saw Williams as a post-Adams poet.)[111] Sheeler, of course, had photographed the Chartres cathedral in 1929, two years after he had been commissioned to photograph the Ford plant. The latter finally commanded his attention, for Chartres, he realized, "is the flower of the culture and a tradition of people of which one is not a part."[112]

Fig. 54. Charles Sheeler, *Industry*, 1932. Photomural; first panel $7^7/_8$ x $2^3/_4$ inches, second panel $7^{15}/_{16}$ x $6^3/_8$ inches, third panel $7^7/_8$ x $2^3/_4$ inches. Reproduction of the original in the Julien Levy Collection at the Art Institute of Chicago.

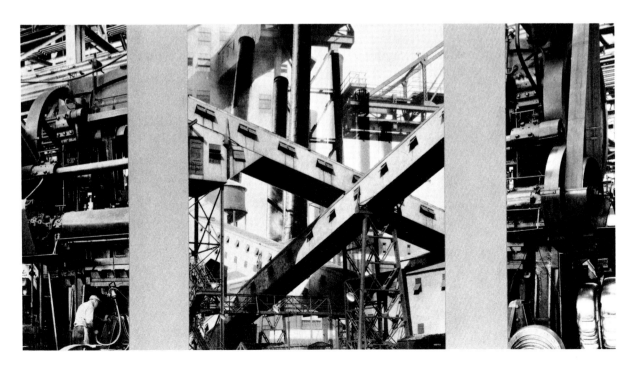

Unlike Williams, Sheeler was deeply committed to a celebration of American life. Despite the Depression he never felt alienated from the large-scale technological forces at work in American society. In 1932 he entered an invitational exhibition of murals at the Museum of Modern Art with a triptych photo-mural entitled *Industry,* its center panel a double exposure montage of the Ford plant pictures (Fig. 54). (In *transition* these Ford plant photographs were published under the heading of an "Industrial Mythos.") Sheeler located the American Dream in the industrial process. In an essay in the catalogue Lincoln Kirstein stressed the need for American artists to develop cultural symbols for a public art. Sheeler's entry belonged with those that celebrated modern American life as opposed to those that took up social issues and causes. Some of the latter were sufficiently controversial that Ben Shahn, William Gropper, and Hugo Gellert were asked by the museum to modify or withdraw them. After the inevitable squabble, the entries were allowed to remain in the exhibition.[113]

Sheeler's Precisionist aesthetic was finally predicated on an ideological acceptance of modern technology at the heart of industry and urban life. Such a position was controversial at a time during the 1920s when intellectuals and artists were debating the social value of technology. Williams sided with Sheeler. In a note to John Riordan he mentioned wanting to see an exhibition of Sheeler and Louis Lozowick's paintings (Fig. 55), which "refute the stupid dicta of the bellyaching end of the worlders."[114] Temperamentally, Williams wanted little to do with apocalyptic predictions about American society. Sheeler and Lozowick must have appeared refreshing to him.

But with an acceptance of technology came the question of its political implications as a prime resource of modern society. Lozowick was committed to a new order based upon the Soviet Revolution. His position was diametrically opposed to Sheeler's and suggests the range of interpretation that Precisionism could bear. Like Sheeler, however, he also minimized labor exploitation. He preferred to concentrate on the affirmative possibilities of technology, not to maintain the status quo but to envision what would be possible under a new, more equitable social order for the workers.

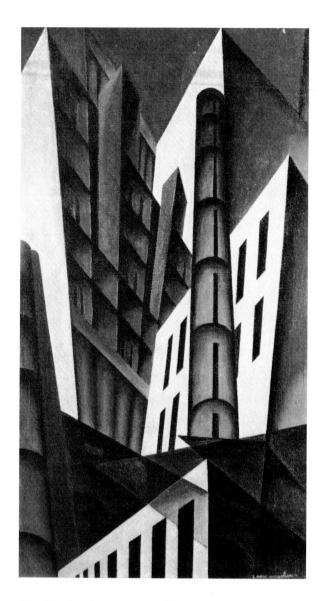

Fig. 55. Louis Lozowick, *Pittsburgh*, 1922-23. Oil on canvas, 30 x 17 inches. Whitney Museum of American Art, New York; Promised gift of Mr. and Mrs. Joe Wissert 1.78.

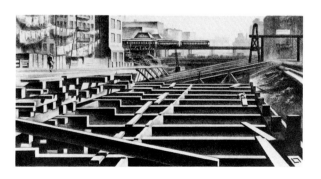

Fig. 56. Louis Lozowick, *Subway Construction*, 1931. Lithograph, 6⅝ x 13¹/₁₆ inches. Whitney Museum of American Art, New York; Gift of Philip Morris Incorporated 77.8.

In *The New Masses* in 1930 Lozowick argued that caricature was an effective though negative weapon. The artist should also make a positive contribution to proletarian culture. A year later he expanded on the idea:

> The American worker inevitably lives and works with cities and machines. But instead of portraying the apocalyptic city of the German expressionists or the mad and inhuman city of the Italian Futurists, the American revolutionary artist pictures it more as a prognostication than as a fact. He departs from realistic appearance and paints the city as a product of that rationalization and economy which must prove allies of the working class in the building of socialism. The revolutionary artists are gradually working towards the acquisition of a synthetic style. They insist on the highest technical quality, not however at the expense of the message but only as something that can best help the effective delivery of that message. They have profited by the experiments in the art of the last twenty-five years. Thus they utilize the clear cut laconic precision of certain younger artists; they take liberties with natural appearance whenever their theme requires it. They strive towards a style which must develop and mature as the revolutionary movement grows.[115]

Lozowick was describing himself and implicitly defending his art against the charge that a move toward nonrepresentation was reactionary, obscuring the revolutionary message of art from the masses. The lithographs that regularly appeared in *The New Masses* attest to a modernist vision which was essentially utopian though no less valid for that. He offered a radical view in contrast to Sheeler's at a time of great stress in American society. Somewhere between the two moved Williams.

Fig. 57. Louis Lozowick, *Excavation*, 1930. Lithograph, 15⁷⁄₈ x 6³⁄₁₆ inches. Whitney Museum of American Art, New York; Gift of Gertrude Vanderbilt Whitney 31.945.

Fig. 59. Louis Lozowick, cover, *The New Masses* I, no. 6 (October 1926). Courtesy of the Museum of Modern Art, New York.

Fig. 58. Louis Lozowick, *Tanks Number 2*, 1929. Lithograph, 14⅝ x 9 inches. Whitney Museum of American Art, New York; Gift of Gertrude Vanderbilt Whitney  31.946.

An 89
American
Place

Because of his friendship with Demuth, Hartley, and Sheeler, Williams was inevitably drawn to the galleries of Alfred Stieglitz: first "291" until it closed in 1917, then the Intimate Gallery, opened in 1925 on the premises of the Anderson Galleries (Stieglitz had held several exhibitions there during the hiatus), and finally An American Place, inaugurated in 1929. By the turn of the century Stieglitz had achieved preeminence among American photographers. With the opening of the Little Galleries of the Photo-Secession at 291 Fifth Avenue in 1905 he soon became the leading champion of modern European art in America as well. By the time of the Armory Show a partial list of his exhibitions included the drawings of Rodin and Matisse, the paintings of Rousseau, and the watercolors of Picasso and Cézanne. During this decade "291" was consistently the New York gallery in which Williams could see works of European modernism along with children's paintings and African art.[116]

Like the Arensbergs' apartment in midtown Manhattan Stieglitz's galleries became meeting places for visual artists and writers to discuss modern art. A charismatic figure, the photographer attracted a close circle of followers. He emphatically denied being a commercial art dealer. The role he implicitly claimed for himself was that of an "American Seer," as in the words of his friend Dorothy Norman. Upon his death in 1946 Williams saw him as "a profound prophet of real values as opposed to the murderous falsity of cash over everything else."[117] The galleries existed as a place for artists to exhibit their work and incidentally to educate Americans visually. It had to be achieved by looking, no amount of telling would do, as Williams himself was willing to admit.

The poet, however, remained on the periphery of the Stieglitz group. He was gradually drawn into its literary activities during the 1920s and 1930s by Hartley and Demuth. Hartley had been a regular with Stieglitz since 1909, and Demuth beginning in 1925. Although Hartley had steadily praised Williams' poetry to Stieglitz, the photographer was not particularly impressed. In a letter of 27 October 1923 he wrote to Hartley, "Enjoyed your feelings about Williams and his writings. I have never quite warmed up to most of his writings but have always liked him when I met him."[118] This came a year after Williams had contributed two poems to *Manuscripts,* another of Stieglitz's magazines.[119] Demuth's enthusiasm probably tipped the scales in the poet's favor. In 1929, just prior to the opening of An American Place (Fig. 60), Stieglitz wrote Williams in praise of "The Somnambulists," an essay published in *transition,* saying that it had touched him deeply.[120] After that the poet wrote "The American Background," the lead essay for *America and Alfred Stieglitz,* which appeared in 1934 in honor of the photographer. By 1937 Dorothy Norman approached him to become an editor of *Twice a Year,* a magazine of the arts that

Miss Norman was planning. Williams demurred on the grounds of a busy practice (as usual), citing several maternity cases pending, but he did manage to contribute some essays to the magazine.[121]

There were some good reasons why Williams kept his distance from the inner circle. He was probably put off by all the talk about "Spirit" with its mystical overtones. Capitalized words made him nervous. Williams was much more at home philosophically at "291" as a laboratory, which Stieglitz once called it, than as a place with ineffable "spirit," which was a typical characterization in many of the responses to the question "What is 291" posed in *Camera Work* in 1914. (Williams was not invited to give his views, though Hartley and Demuth were.) The heights of lyrical prose that attended such thinking were reached in *Port of New York* by the critic Paul Rosenfeld, an unabashed admirer of Stieglitz who alluded to the photographer's "complete obedience to the imperative of the unborn stuff of worlds in his bosom." (He claimed that Williams' poems "writhe with the movements of bodies vainly twisting to loose themselves from fixed scorching points.")[122] Although Williams liked Rosenfeld, his prose was anathema; the poet joined Josephson and his friends in scorning such imprecise language passing for mystical communication.

These differences in sensibility were accentuated by personality conflicts. Both Williams and Stieglitz had healthy egos. The poet simply could not have tolerated being in the shadow of the photographer. He was finally ambivalent toward Stieglitz. A "profound prophet," yes, but also someone who "wanted to be God and in his shitty little hole of an office building he was God." (Williams' portrayal of An American Place was most spiteful in view of the pride Stieglitz felt for its clean, bare walls.) In the next breath, however, Williams claimed that Stieglitz "was the only god any decent person in his right unsold mind could ever take seriously."[123] The unpublished eulogy, such as it was, was a strange performance made all the more deplorable by anti-Semitic overtones, as we shall see later. If nothing else, the piece indicated many of the tensions the poet felt while Stieglitz was still alive.

Williams' account of the naming of An American Place reveals the source of his mixed feelings toward Stieglitz. In *The Autobiography* he erroneously claimed that the photographer cited *In the American Grain* as the inspiration for the name of his new gallery about to be opened.[124] Williams' memory was somewhat faulty by the time he wrote *The Autobiography,* so he might have mistakenly recalled Stieglitz's letter about "The Somnambulists," to which was appended a postscript that "there is to be a new Place." Williams was sufficiently pleased by Stieglitz's approval to write back three days later, "Many thanks for your good word. When the new 'place' is

in operation I want to be one of the witnesses."[125] Too much shouldn't be made of Williams' error in *The Autobiography*. His lapse was minor, one which at least had the virtue of casting the photographer in a favorable light, unlike the unpublished eulogy. Yet the poet's account served to exaggerate his own importance to the avant-garde. It suggests that Williams was aroused not so much by any personal animosity toward Stieglitz (as in the eulogy) than by a need to feel wanted, to be at the center of events. That this should have happened toward the end of Williams' life suggests the fragility of his self-confidence after years of public neglect.

Despite this sorry advertisement for himself, there is no reason to doubt Williams' sincerity in wanting to bear witness for An American Place. By the 1920s Stieglitz had shifted from an espousal of internationalism in the arts to an emphasis upon American art in his galleries. Eventually his regulars devolved to O'Keeffe, Demuth, Hartley, Marin, Dove, and Strand, although other painters and photographers were also occasionally exhibited at An American Place. Its very name concurred with Williams' Contact idea and held forth the promise of an American art as an outgrowth of European modernism. This does not mean that the Stieglitz group formally espoused Contact even though Hartley had been instrumental in helping Williams develop the idea. Nor were these artists dependent upon Williams for their aesthetic presuppositions. To the contrary, the poet's Contact idea was gradually corroborated by the work of Stieglitz and his group. Contact is thus especially helpful for understanding the common endeavor of these diverse artists.

As we might expect, Williams knew some members of the group better than others. Besides Demuth and Hartley, he was apparently on good terms with O'Keeffe. The poet has left no indication of his response to Dove or Strand, but he had to be familiar with their work, which was regularly on display at An American Place. After Marin's death in 1953, Williams wrote a short appreciation for a memorial exhibition catalogue. He waxed enthusiastically over their efforts in the common cause of modernism: "I always thought John Marin a flaming expression of the ground from which we both sprang. He was an affirmation of all that I felt of it that comforted me in times of stress, which I need in my daily life. I could count on him to back me up." The poet stopped short from making large personal claims. "We were born within a half mile of each other [in Rutherford] and never moved over a few miles apart all our lives. [Marin lived in Cliffside, New Jersey.] We knew of each other towards the end of our later years, even met and understood each other completely but never grew intimate," he admitted.[126]

Fig. 60. Dorothy Norman, *American Place*, 1936. Photograph, 8½ x 11 inches. On extended loan from Dorothy Norman to the Philadelphia Museum of Art.

91

Intimacy with members of the group was difficult to achieve or sustain. While Williams was rooted in Rutherford, the group itself was often scattered beyond the confines of New York. It was precisely this outward movement, however, that dramatized Williams' Contact idea. Although they were all urban artists interested in rendering the New York scene (Hartley, and perhaps Dove, the lone exceptions), they all felt a need in their art to seek other locations. Stieglitz and O'Keeffe went summers to the photographer's family home at Lake George, New York. It was there that Stieglitz began his Equivalents project and captured his sense of the place so magnificently in *Lake George* (1932; Fig. 61). O'Keeffe began going regularly to the Southwest in 1929. Marin went to Taos and Santa Fe the same year, though dating back to 1914 his principle summer residence was in Maine. Strand visited O'Keeffe in New Mexico (Fig. 62) and Marin in Maine.

Of all the artists in the group, Marin was the most theatrically committed to a sense of place. In his published *Letters,* privately printed for An American Place in 1931 (Stieglitz sent Williams a copy), Marin assumed the pose of a Yankee with the garrulous expansiveness of a Whitman.[127] Despite his longstanding affinity for New York, Marin decided upon an agrarian persona as a metaphor for his Americanness. Though some of his vernacular sounds strained, Marin evidently managed to gain the trust and friendship of reserved Down Easters. The disparity between the man and the pose only emphasizes the extent to which it was a metaphoric identity that linked the artist to an American place.

Fig. 61. Alfred Stieglitz, *Lake George*, 1932. Photograph, 9⅜ x 7⅜ inches. The Museum of Modern Art, New York; Gift of Georgia O'Keeffe.

Fig. 62. Paul Strand, *Church, Buttress, Ranchos de Taos, New Mexico*, 1932. Photograph, 10 x 8 inches. Estate of Paul Strand and Hazel Strand, courtesy of Aperture, Inc.

Fig. 63. Arthur G. Dove, *Fields of Grain as Seen from Train*, 1931. Oil on canvas, 24 x 34 inches. Albright-Knox Art Gallery, Buffalo, New York; Gift of Seymour H. Knox.

Dove deserves special mention in this regard. He lived most of his life orbiting New York City: first on a farm in Westport, Connecticut, then on a houseboat in the Harlem River, on a yawl on Long Island Sound, finally back on a family farm in upstate Geneva. He lived wherever he could to live inexpensively so as to be able to paint. But despite the stringent economic necessities, he enjoyed being on the water. A sense of place was extremely important to his art. O'Keeffe insightfully observed that "Dove comes from the Finger Lakes region. He was up there painting, doing abstractions that looked just like that country, which could not have been done anywhere else."[128] Her point has been often lost in our eagerness to claim Dove as our first abstractionist. Yet he always painted from nature, requiring a special ground for his landscapes, abstract though they were.

On Madison Avenue, during the bleak years of the Depression, An American Place provided some financial sustenance but most importantly a focal point for the group. Stieglitz brought together the work of these artists from their disparate regions around the country and gave them common cultural ground.

The work of these "Seven Americans," as Stieglitz called his group, ranged in imagery from urban scenes to landscapes. While photographing skyscrapers from his window at the Shelton in the early 1930s, Stieglitz was still engaged in making his Equivalents of the sky and clouds at Lake George. O'Keeffe painted her canvases of enlarged flowers and New York buildings during the mid-1920s and later New Mexico landscapes. Strand also turned from New York scenes to landscapes of New England and New Mexico. Marin, of course, was one of the first American modernists to do watercolors of New York and then seascapes along the Maine coast. While Dove never really painted the city, his work often alluded to an urban environment as in *Ferry Boat Wreck* (1931; Pl. X) or *Fields of Grain as Seen from Train* (1931; Fig. 63).

The vision of these artists was not split. The polarities of city and country that have generated one kind of primitivism did not exist in their work. There was instead a remarkable consistency of vision. Stieglitz's straight photography led not only to powerful images of the city but also to the Equivalents. What greater challenge for a straight photographer than to see evanescent clouds through a lens and then to print

Fig. 64. Alfred Stieglitz, *Mountains and Sky, Lake George*, 1924. Photograph, 9³⁄₈ x 7³⁄₁₆. The Museum of Modern Art, New York; Gift of David H. McAlpin.

95

an untouched, uncropped image that matches the initial viewing experience. According to Stieglitz, "the true meaning of the *Equivalents* comes through without any extraneous pictorial factors intervening between those who look at the pictures and the pictures themselves."[129] Williams with a camera. Thus *Mountains and Sky, Lake George* (1924; Fig. 64) is no less a formal statement than *The Steerage* (Fig. 69) or *Evening, New York from the Shelton* (Fig. 44), but its moral strength comes from our knowledge of the sheer discipline of sight Stieglitz invested in its making. Perhaps even more subtly than *Evening, New York from the Shelton*, we are invited to share the photographer's point of view as we become aware of the process of seeing that the print demanded.

Throughout the variety of her paintings, O'Keeffe remains O'Keeffe — not simply because of her brilliant use of color ("Flowers and flames. And colour. Colour as colour, not as volume, or light,—only as colour," Demuth wrote in 1927),[130] or her unerring line, nor because she stayed aloof from European moderns. The images of *The Mountain, New Mexico* (1931; Fig. 65), *The White Calico Flower* (1926; Fig. 66), and *City Night* (1926; Pl. VIII) — different as they are — share in common a visual structure that is organic in quality. The contours of earth in the New Mexico landscape and the sensuous folds of the flower are reiterated in quality in *City Night*. As a consequence New York's machinescape is rendered at one with the moon and evening sky. The manmade is brought within a larger natural order.

If the machine gave Sheeler — and occasionally Williams — a metaphor for his aesthetic values, the flower in its organic glory has been O'Keeffe's. In the 1939 exhibition catalogue at An American Place she talked about flowers, how familiar they are to us all and how they are often passed unnoticed: "So I said to myself — I'll paint what I see — what the flower is to me but I'll paint it big and they will be surprised into taking time to look at it — I will make even busy New Yorkers take time to see what I see of flowers."[131] Like Williams she appreciated that which often goes unseen. To enlarge the flower on the canvas allowed a magnification and intensification of its formal qualities. It also brought flowers to the attention of busy city dwellers. *The White Calico Flower*, therefore, should be seen next to *City Night* or *New York* (Fig. 67), just as her flowers and skyscrapers had been juxtaposed at the Intimate Gallery in 1925. There is no abrupt leap from nature to cityscape, for O'Keeffe's sensibility facilitates our passage.

Dove's vision was also organic. He began from nature in applying his eye to the abstraction of images. *Ferry Boat Wreck* thus assiduously avoids narrative in taking a motif otherwise fraught with story. The scene is distinctly urban, what with a debris-polluted harbor or river, yet Dove brought the constituent elements together into an overriding organic pat-

Fig. 65. Georgia O'Keeffe, *The Mountain, New Mexico*, 1931. Oil on canvas, 30 x 36 inches. Whitney Museum of American Art, New York; Purchase 32.14.

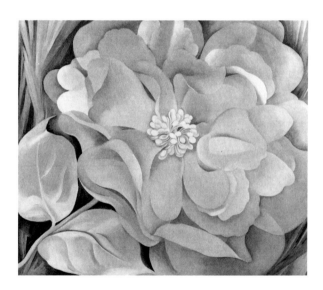

Fig. 66. Georgia O'Keeffe, *The White Calico Flower*, 1931. Oil on canvas, 30 x 36 inches. Whitney Museum of American Art, New York; Purchase 32.26.

tern. Similarly, *Fields of Grain as Seen from Train* draws on abstract design from a motif of cultivated fields. A vivid sense of linear movement is reinforced by the title: the window of a speeding train provides a frame for the passing scene.

From city to seascape Marin enjoyed making the surface flow of his watercolors. The medium was perfectly suited for Marin's eye, which was strongly attracted to the surface movement of things both in the city and country. In his early paintings of New

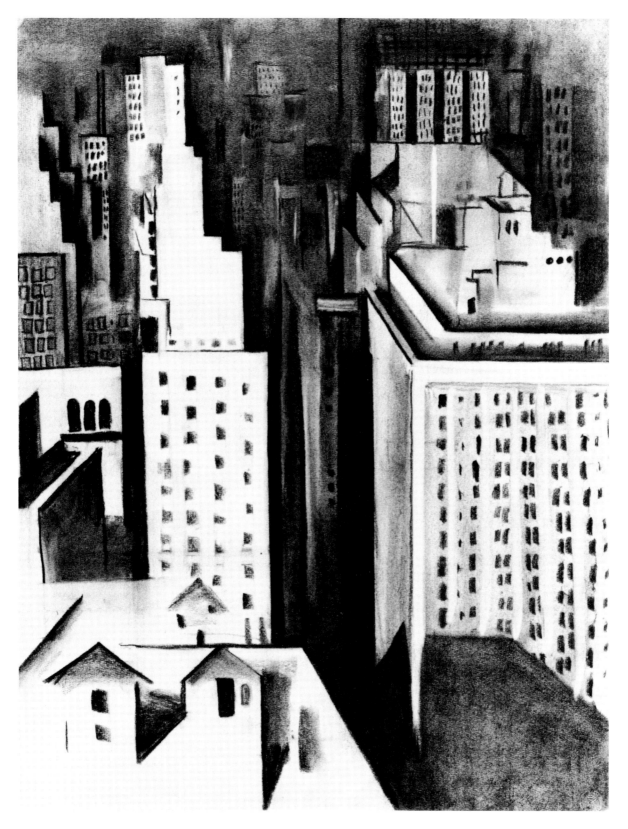

Fig. 67. Georgia O'Keeffe, *New York*, c. 1920.
Charcoal on paper, 24⅞ x 18⅞ inches. Courtesy of
Doris Bry.

York at the time of the Armory Show he spoke of the forces he felt in the modern city. Almost two decades later he continued to portray the energy of New York in such a watercolor as *Region of Brooklyn Bridge Fantasy* (1932; Pl. XI). Here was Marin's "sky-scraper soup" that Williams had facetiously discerned earlier.[132] A similar play of pictorial surfaces also dramatized the epiphenomenal movements of sunlight, sky, and water along the Maine coast. *Deer Isle, Maine,* a watercolor of 1923, is a difficult painting (Fig. 68). There isn't an ease of entry for the eye as there might be in a more representational work. The eye has to make its way as it might with an unfamiliar view of nature. Sea, sky, rock, and trees gradually become discernible. But the watercolor remains true to its medium as a tight calligraphic structure. As Williams quoted Marin in another context, "The painter should follow his *paint.*"[133]

With the exception of O'Keeffe and Strand, who entered the group *in medias res,* these artists were all first-generation modernists. By the mid-1920s they had achieved a mature and hence consistent vision. And they all implicitly recognized the need to assimilate European avant-garde forms and techniques with their individual sensibilities and American lives. Otherwise, their modernism would remain derivative and shallow. Their move toward the creation of an American art by the 1920s was in direct response to such needs. It was hardly a reactionary development. Williams' Contact idea provides a clue to their regionalism, and in the process it helps us assess what otherwise appears to have been their anomalous avant-garde status during the period between the two wars.

Williams explained it clearly in "The American Background" for *America and Alfred Stieglitz:* "The thing that Americans never seem to see is that French painting, as an example of what is meant, is related to its own definite tradition, in its own environment and general history (which, it is true, we partly share), and which, when they have done with some one moment of it and have moved on to something else [the avant-garde process], they fatly sell where they can — to us, in short. And that American painting, to be of value, must have comparable relationships in its own tradition, thus *only* to attain classic proportions." The poet shared this insight

with Stieglitz and his group. The essay was a condensation of *In the American Grain,* which Stieglitz had apparently admired, and which Williams tailored to him. "The effect of his life and work," Williams concluded, "has been to bend together and fuse, against whatever resistance, the split forces of the two necessary cultural groups: (1) the local effort, well understood in defined detail and (2) the forces from the outside."[134]

Contact had a dual meaning, as these artists realized. It called attention to the local scene and suggested a direct exposure of one's self to the immediacy of experience (which necessarily involved place). Because sensibility took precedence in their work, their regionalism was not anecdotal. (Marin saved his stories for his letters to Stieglitz.) Their paintings and photographs were statements of (not about) an area. At their best the scenes presented existed as objects in themselves, with an inevitability of pictorial logic abstracted from experience. Therein lay their modernism.

Fig. 68. John Marin, *Deer Isle, Maine*, 1923. Watercolor on paper, 17 x 13¾ inches. Whitney Museum of American Art, New York; Gift of Gertrude Vanderbilt Whitney 31.589.

# Ethnic 99
# and Folk
# Identity

In 1907 Alfred Stieglitz photographed *The Steerage* (Fig. 69). Published in *291* in 1915, it was later included in Stieglitz's exhibition of his own work at An American Place in 1932. Williams recommended the show and its counterpart at the Julien Levy Gallery to Louis Zukofsky.[135] *The Steerage* is striking for its textures and composition. As Stieglitz himself described it:

> The scene fascinated me: A round straw hat; the funnel leaning left, the stairway leaning right; the white drawbridge, its railings made of chain; white suspenders crossed on the back of a man below; circular iron machinery; a mast that cut into the sky, completing a triangle. I stood spellbound for a while. I saw shapes related to one another — a picture of shapes, and underlying it, a new vision that held me: simple people; the feeling of ship, ocean, sky; a sense of release that I was away from the mob called "rich."[136]

It matters little that the event took place three days out to sea, on Stieglitz's way *to* Europe. The photograph still gives visual form to what Americans have perceived as a central social and cultural experience, the passage from another country to the United States. Thus the image of the steerage is powerfully evocative, as it was that day on board ship to Stieglitz, himself a second-generation Jewish American.

Among the many artists who immigrated to the United States this century, Louis Lozowick recalled the point of landing at Ellis Island: "It was a critical moment for everyone. There was an air of foreboding, apprehension, hope. . . . To me America would be the beginning of a new life; to others a final resting place, to all a plunge into the unknown. This was the great divide in our lives, our lives split in two." A divided consciousness suggests that there was no longer a simple answer to the famous question raised by the French emigré J. H. St. John Crèvecoeur, perplexing even in 1782: "What then is the American, the new man?" And how much more complex was this question for Williams, whose ethnic identity was thoroughly splintered, even obscure in its origins. As late as 1943 he could hardly disentangle the threads for Fred Miller, a former co-editor of *Blast* in the 1930s: "My mother's father was a Jew so I have been told. He may have been wholy Jew or he may have had an admixture of Spanish or Dutch or both in his veins. He lived as a Catholic, a converted Jew, then. He was left an orphan by his father at a very early age and his mother married again, definitely a Spaniard or Puerto Rican on her second marriage (so I am told) so very little, really, is known about the details. My mother's mother was a French catholic from Martinique."[137] His father was English, he might have added, whose history also faded a few generations back.

By professing a belief in the powers of environment, both physical and political, Crèvecoeur tendered the melting pot idea. Europeans would be almost magically transformed into Americans by virtue of their new situation, so favorable to their nurture. Yet nativism and racism, almost intrinsic aspects of our cultural baggage, have made assimilation difficult if not impossible for minorities, especially for those who deviate from Anglo-Saxon norms. And for all that we like to imagine ourselves a classless society, or a middle-class society, which often amounts to the same illusion, immigrants have always been exploited as a source of cheap labor for our industrial centers. The dark side of technology was evident in the factory towns of Passaic and Paterson, neighboring Rutherford. On his daily rounds Williams was privy to the disease and poverty of first-generation immigrants recently cast off from Ellis Island. Blacks, too, had begun their migration from the South and joined other minorities to be exploited for their labor. First Paterson in 1913 and then Passaic in 1926 were scenes of tumultuous and bitter labor strife, as had been the rest of the nation from the latter part of the nineteenth century through the 1930s.[138] With the onslaught of the Depression Williams began to write sympathetically about these people in a series of short stories and vignettes.

Whereas Crèvecoeur believed that immigration came on the smooth wave of progress in science and industry, the very forces that brought minorities to the United States and generated internal migration have placed stress upon if not fractured the family and disrupted traditional behavior. As a consequence, ethnic and racial identity in America has been fraught with ambiguity; it has been a hybrid affair, determined by deeply mixed perceptions of appearances, attitudes, and behavior — perceptions inventoried by the individual himself as well as by others. Such identity has thus not been without its ironies and cruel paradoxes, more often a matter of conflict than agreement. Understandably, then Williams was profoundly ambivalent about his Jewish ancestry, sometimes preferring to ignore it, and at other times disparaging it.[139]

Marsden Hartley perceived these tensions within Williams. In writing to Stieglitz in 1923 the painter made his case for the poet: "Williams as you know is a very lovely fellow for himself and he certainly has made a splendid struggle to plasticize all his various selves and he is perhaps more people at once than anyone I've ever known — not vague persons but he's a small town of serious citizens in himself. I never saw so many defined human beings in one being. That's because he's latin and anglo-saxon in several divisions and he being an artist has to give them all a chance." Whereas Eugene Jolas, editor of *transition,* offered the conventional wisdom that

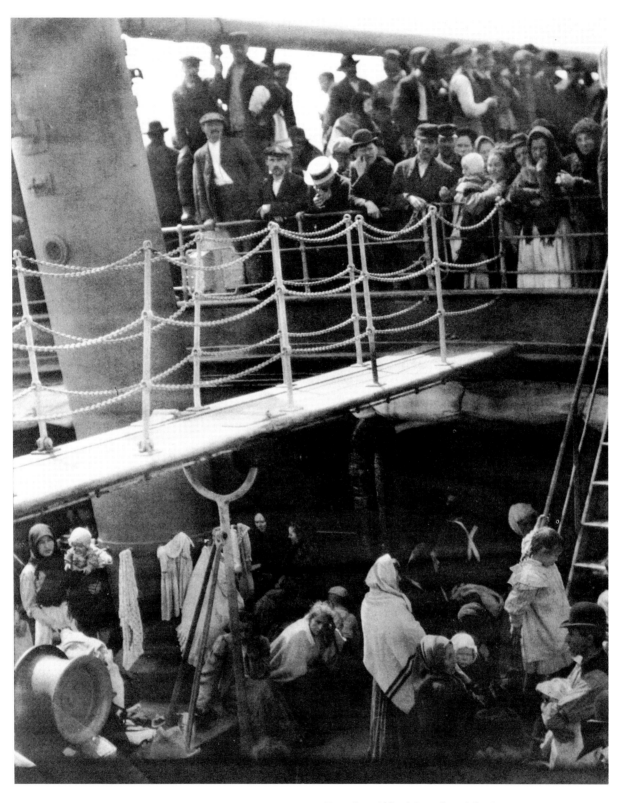

Fig. 69. Alfred Stieglitz, *The Steerage*, 1907.
Photogravure, 13⅛ x 10½ inches. Whitney Museum
of American Art, New York; Gift of Michael E.
Hoffman 77.106.

Williams was working towards an American poetry *despite* his mixed background, Hartley saw that Williams had to give his heritage play as an artist, indeed that his artistry and ethnicity were bound together in the multiple guises that the poet could entertain.[140]

Pressures to resolve one's identity were particularly intense upon those who embraced modern art. Since the 1913 Armory Show modernism has often been viewed as foreign and "un-American." The conservative critic Royal Cortissoz compared avant-garde art at the Armory Show to an "invasion" of "aliens," "thousands of whom constitute so many acute perils to the health of the body politic." Because modernism originated abroad, his bigotry logically extended to "types not yet fitted for their first papers in aesthetic naturalization — the makers of true Ellis Island art." Cortissoz's argument went beyond simple analogy to assume the guise of a literal equation. It was such flawed thinking that later allowed Thomas Craven, a critic who championed Thomas Hart Benton, to scorn Stieglitz as a "Hoboken Jew."[141] Anti-Semitism became a weapon against modernism.

Craven's slur against Stieglitz (who he still conceded was an important figure in American art) was inconsistent with his forthright condemnation of anti-Semitism in France.[142] The critic's insensitivity was similar to Williams' in the poet's ambiguous commemoration of Stieglitz upon his death in 1946. The distortions mounted into an anti-Semitic portrait: "So there was Stieglitz the Jew." Yet no sooner uttered than Williams shifted the anti-Semitic implications to the photographer's detractors. "What did that mean to him?" asked the poet. "Nothing whatever — except a hard drive into the guts of the living bastards he had to battle. . . . He belonged to New York City and he should (as he knew) have been given power, POWER. No! No power." At this point Williams could identify with an underdog. Hence: "as a friend, as a lover of peace, and as a fighter, principally, I deeply honor his memory."[143] The rhetorical pattern of the writing, seen in conjunction with scattered references elsewhere, suggests that the poet's ambivalence toward Jews was derived from unsettled feelings about his own mixed heritage. His portrayal of Stieglitz was exacerbated by personality conflicts compounded by a fear of death and a distaste for memorials. These circumstances, however, do not make it any less reprehensible, coming as it did after the Holocaust. Yet Williams never evinced a pathological hatred of the Jews as did Ezra Pound, his life-long friend. This affair, distasteful yet sad because of Williams' generosity and openness, points to one of the ways that modernism could cannibalize itself.

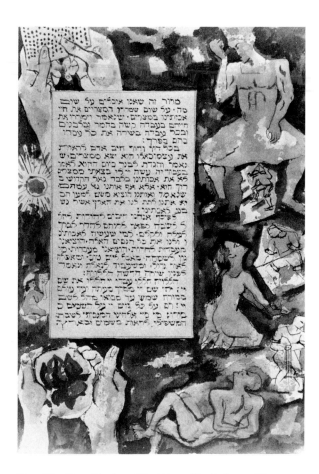

Fig. 70. Ben Shahn, *The Bitter Herbs* from *Haggadah for Passover*, c. 1945. Ink and watercolor on paper, 11¾ x 8½ inches. The Jewish Museum, New York; Gift of Mr. Edward M. Warburg.

Jewish-American artists who aspired to modernism were thus caught in difficult crosscurrents. Not only were they vulnerable to bigoted attacks but they also had to overcome ghetto poverty and the weakness of a visual tradition in their past. Many first- and second-generation Jews in the United States had families originally from Russia, where they had been denied access to the arts. Moreover, many who desired to pursue a career in the arts in America had to go against their parents' objections to graven images. Ben Shahn, an impoverished young painter in the 1920s, was often at odds with his family whose strong sense of tradition was intensified by an alien environment. But far from abandoning his Jewish heritage, he brought it within a larger social ambience. Ethnicity and politics merged for Shahn as he began illustrating the *Haggadah* in 1931 (Fig. 70), a narrative of the Passover celebration and hence symbolic of "the everlasting struggle against oppression."[144] This project came at a time when he was also illustrating the Dreyfus case reeking with anti-Semitism.

crucifixion. Here was something to paint." Twenty-three gouaches exhibited at the Downtown Gallery in April 1932 were the result. *The Passion of Sacco and Vanzetti* (Fig. 71), framed in a religious metaphor, shows the two in their open coffins sanctimoniously presided over by those whom Williams called "pimps to tradition," a "triumvirate of inversion, the / New England aristocracy...."

As Shahn's integration of the pictorial values of modernism with his strong narrative interests in politics and social issues suggests, Cortissoz's identification of modern art with something foreign and ultimately subhuman was but an inverted view of "aesthetic naturalization." Whereas he conjured the process merely for the sake of a mean-spirited chauvinism, modern art and artistic identity came together in an entirely different fashion that was essential for growth and productivity. Because most American artists were confronted by new art forms from without, that is to say, because most Americans were not firsthand witnesses to such experimentation as it developed out of the social and cultural contexts of the European avant-garde, they had to undergo aesthetic rites of passage from the old to the new. Although immigration required actual geographical movement, both processes involved symbolic transformation. The one demanded if not assimilation at least accommodation to a different society and culture while the other necessitated an assimilation of new aesthetic forms and precepts to the experiences of American society. Both processes were disruptive and required a reintegration of self, but obviously a self (and art) changed in passage.

A graphic example of these two rites joined together can be seen in Arshile Gorky's portrait of *The Artist and His Mother* (Fig. 72), begun in 1926, some six years after he and his younger sister Vartoosh landed at Ellis Island, and possibly finished in 1929, a decade after his mother starved to death in his arms in Turkish Armenia.[146] The flattened space and simplified forms have long been recognized as part of Gorky's eclectic visual evolution toward his own style. But the expressive eyes of the mother and her son, their spatial relationship, the hieratic posture of the woman, and the pale colors all contribute to a dream-like quality suggesting that artistic development was inextricably at one with Gorky's sense of self and past.

In 1925 he had changed his name from Vosdanik Adoian to Arshile Gorky, a transformation that was hardly a renunciation of family but rather an intensification of heritage, Arshile having been taken from the Armenian Arshak, a royal name, and Gorky meaning "bitter" in Russian. The symbolic implications cannot be ignored. The following year Gorky began a series of family portraits, *The Artist and His Mother* chief among them. It was based upon a pho-

Fig. 71. Ben Shahn, *The Passion of Sacco and Vanzetti*, 1931-32. Tempera on canvas, 84½ x 48 inches. Whitney Museum of American Art, New York; Gift of Edith and Milton Lowenthal in memory of Juliana Force 49.22.

It was with Sacco and Vanzetti, however, that Shahn found a contemporaneous cause to visualize. In 1921 Nicola Sacco and Bartolomeo Vanzetti were convicted of murder in a South Braintree, Massachusetts, payroll robbery. The two Italian anarchists were tried as much for their ethnicity and political views as for any crimes they might have committed. Their eventual execution in Boston in 1927 tragically climaxed protests in this country and abroad on their behalf. Shahn witnessed impassioned street demonstrations in Paris. "Ever since I could remember," he claimed, "I'd wished that I'd been lucky enough to be alive at a great time — when something big was going on, like the Crucifixion. And suddenly I realized I was. Here I was living through another

Fig. 72. Arshile Gorky, *The Artist and His Mother*,
1926-29. Oil on canvas, 60 x 50 inches. Whitney Mu-
seum of American Art, New York; Gift of Julien
Levy for Maro and Natasha Gorky in memory
of their father 50.17.

tograph taken in 1912 and sent to his father, who had migrated to the United States to escape the Turkish draft, a particularly cruel way of having Armenians murder their own. In Gorky's hand, the photograph documented the original sitting and gave evidence of his present dislocation, for it had traced in advance his own exile to the United States. The photograph generated highly charged feelings: it reminded Gorky of his family and its diaspora; most crucially, it disclosed their rehearsal for genocide: *she* became the votive offering of the son. Gorky tried to exorcise his painful past by the act of painting. On the other side of her death he renewed her in art. The canvas became his locus for a ritual enactment of a family reunion; mother and son created once again in the New World. And *that* act, *those* preoccupations, made Gorky's art American.

Williams' attachment to his family, especially to his mother and grandmother on his father's side, was dramatized in the act of translation. It was one way of identifying with the literature of his mixed heritage and synthesizing it with his present Americanness. Thus in the late 1930s he collaborated with his mother in translating *The Dog and the Fever*, an obscure seventeenth-century novella by the Spaniard Don Francisco de Quevedo. Out of this project, devised in part to amuse his bedridden mother, came his biographical compilation of conversations with his mother, a sort of oral history, portions of which were published in 1941 as "Raquel Hélène Rose" in *Twice a Year*.

*"Neither one thing or the other, grotesques were drawn on the walls of grottos, half human, half leaves — whatever the fancy made obligatory to fate. So in her life, neither one or the other, she stands bridging two cultures, three regions of the world, almost without speech — her life spent in that place completely out of her choice almost, to her, as the Brobdignigans to Gulliver. So gross, so foreign, so dreadful to her obstinate spirit, that has neither submitted nor mastered, leaving her a* neant *of sounds and sense — Only her son, the bridge between herself and a vacancy as of the sky at night, the terrifying emptiness of non-entity."*[147] So Williams wrote about his mother, dislocated in Rutherford, approaching death yet groping through the past with her son. Like Gorky, with whom he would have been familiar during the 1940s when both were associated with the Surrealist emigrés, Williams acknowledged his mother but in this instance in the very process of translation, an act that replicated in language itself her own experience between two worlds.

While the metamorphosis of one language into another was at the heart of translation, metamorphosis also played a thematic part in Williams' poetry. At the outset of "The Wanderer," published in 1914 but written earlier, perhaps during the 1913 Paterson strike, the narrator asks, "How shall I be a mirror to this modernity?" He is guided in this task by an old woman, whom Williams later identified as his grandmother. She has him baptised in the "filthy Passaic." Out of this symbolic immersion, interpenetration actually, comes identification of self with place: "And I knew all — it became me."[148] Williams would eventually assemble *Paterson*, his testament to the local. But experience would have to overtake this early declaration, necessary as it was for someone described by Pound as a "blooming foreigner."[149]

Whereas ethnicity was often falsely viewed as "unAmerican," a folk designation appeared to validate American origins. Because of a growing concern for the identification of a unique American art, distinct from the European, American folk art gained visibility during the 1920s and 1930s. First to hold an exhibition of American folk art was the Whitney Studio Club in February 1924. Among the works in the show Charles Demuth lent a nineteenth-century lithograph of Noah's Ark and Charles Sheeler *The Temple of Egina* by H.M. Ware. Sheeler also photographed the works which were illustrated in the Whitney catalogue. In 1931 Edith Halpert, who had already come to represent Sheeler and Stuart Davis in her Downtown Gallery, started an American Folk Art Gallery where she held several shows during the course of the decade. In 1932 Holger Cahill, who was to become national director of the Federal Arts Project in 1935 and conceive the Index of American Design, organized at the Museum of Modern Art an exhibition entitled "American Folk Art: The Art of the Common Man in America 1750-1900."[150]

The identification of an American "folk" was never very clear, largely because the term itself has remained elusive. However, certain characteristics emerge from its usage in those early exhibitions. In as much as the Whitney Studio Club entitled its show "Early American Art" and the Museum of Modern Art cut its selection of artifacts at 1900, both exhibitions located the folk in the past, thus offering an American tradition in the visual arts outside the mainstream of American academic art, which took its cues from Europe. The uniqueness of American folk art resulted from its rural origins, as part of eighteenth- and nineteenth-century agrarian America. This implied definition set American folk art at a problematic distance from the twentieth century. Living on the far side of an industrial revolution all but severed the "folk" from the present, which was accelerating into an increasingly complex future. As a brief review of the Whitney exhibition recognized, a contemporary interest in folk art of the past threatened to become a form of escape, antiquarianism at its worst.[151]

How, then, was an artist of the 1920s and 1930s to profit from this revelation of an American scene past? How was a contemporary American artist to remain faithful to a complex and bewildering present

Fig. 73. Marcel Duchamp, *Nude Descending a Staircase, No. 3*, 1916. Watercolor, ink, pencil, and pastel over photographic base; 5⅞ x 35½ inches. Philadelphia Museum of Art; The Louise and Walter Arensberg Collection.

while assimilating folk art? By sponsoring a folk art exhibition in 1932 the Museum of Modern Art acknowledged the interest shown in folk art by the avant-garde, both European and American, over the past decade. The lack of academic training (turned into a positive virtue), the creation of simplified form, the naiveté of folk art, its affiliation with the "primitive," often taken as a synonym for the "folk," all these characteristics appealed to the values of the avant-garde.

Understandably, then, Williams' interest in folk art was inextricably related to modern art and extended back to the First World War. In his Prologue to *Kora in Hell* he recalled a luncheon conversation with Walter Arensberg about the nature of modern art. Arensberg stressed innovation as the hallmark of modern painting. He cited Duchamp's interest in chance and mass production. Back at Arensberg's apartment Williams saw Duchamp's latest version

of the *Nude Descending a Staircase*, which was a retouched photograph of the notorious painting that hung in the Armory Show (Fig. 73). Through mechanical reproduction Duchamp ironically made a work unique even as he cast doubt on the uniqueness of art done by hand.

Williams was not to be outdone by Arensberg's exposition of a Duchampian modernism based on the anonymity of chance and mass production. In making his daily rounds Williams had glimpsed art that would never gain recognition. "I wish Arensberg had my opportunity for prying into jaded households where the paintings of Mama's and Papa's flowertime still hang on the walls," he said. These "abortive paintings," these "queer products. . . might be housed to good effect in some unpretentious exhibition chamber across the city from the Metropolitan Museum of Art," a bastion of conservatism.[152] Williams might have added that his own mother had had aspirations to paint and had studied in Paris as a young woman until the family money ran out. He did suggest that the anteroom of his fancied "exhibition chamber" show photographs of prehistoric rock-paintings. Years later Williams recalled the image of primitive wall paintings in association with his dying mother in reminiscence with her son while they struggled over the translation of a Spanish novella. The recovery of an obscure fiction, the care for a few of his mother's paintings, these were not unlike the ancient pictographs: what would survive from our primordial past? Williams took the primitive literally. It was not the exotic but something direct and fundamental running through our lives, a form that would be worth keeping if happenstance allowed.

History and form: Williams kept these in mind when he was asked by *Art News* in 1954 to comment on a collection of American folk paintings presented by Colonel and Mrs. Edgar W. Garbisch to the National Gallery.[153] In keeping with the felt tenor of the paintings Williams offered direct impressions of what he saw before him, hence the discursive and anecdotal nature of the essay. The paintings acknowledged his sense of the past. As a consequence he entitled the essay "Painting in the American Grain" echoing the history he had written in 1925. At the center of *In the American Grain* the poet explained the need for Americans to gain an identity from history. To discover their historical ground was to discover the local once again. And so *In the American Grain* explored how Americans in the past took to the local: did they come to it with fresh perceptions or did they apply outworn European ideas and attitudes to their new experiences? At the outset of this history Williams explained his selection and transcription of old documents: "Everywhere I have tried to separate out from the original records some flavor of an actual peculiarity denoting shape which the unique force has given."[154] He said as

Fig. 74. Artist unknown, *The Cat*, c. 1840. Oil on canvas, 16 x 20 inches. Collection of Edgar William and Bernice Chrysler Garbisch.

Fig. 75. Artist unknown, *Adam and Eve*, c. 1830. Oil on cardboard, 24¼ x 18½ inches. Whitney Museum of American Art, New York; Gift of Edgar William and Bernice Chrysler Garbisch 69.143.

Fig. 76. Artist unknown, *Bowl of Fruit*, c. 1830. Oil on canvas, 31 x 39 inches. Collection of Edgar William and Bernice Chrysler Garbisch.

much, later, when the original records were American folk paintings.

Here, then, was the intersection of American art and that "unique force" exerted by the new land. "How *not* to begin an article on American primitives in painting," we are told. "You don't begin speaking about Giotto and Fra Angelico or even Bosch, but of a cat with a bird in his mouth — a cat with a terrifying enormous head, enough to frighten birds [Fig. 74]...." European antecedents simply did not exist for these painters. Their work suggests "a yearning in the new country for some sort of an expression of the world which they represent." Thus *Adam and Eve* was the first painting to draw Williams' full attention (Fig. 75): "There is no serpent here, no sign even of God, just the garden and its bountiful blessing. Wild beasts are at Adam's feet or at least one panther is there. The sky is luminous, this was not painted in a potato cellar. The vegetation is luxuriant, huge grape clusters hang from the trees and there at their ease sit together our primordial parents, naked and unashamed, bathed in sunlight. Who shall say the plenty of the New World so evident about them was not the true model that had been recorded?"[155] The painting thus offered to Williams a double vision. The prelapsarian Eden the painter depicted was drawn from his imagination of an Edenic world about him.

The means of such expression was direct. "As you enter the gallery...," Williams observed, "the first thing that hits your eye is the immediacy of the scene. I should say color! They were putting down what they had to put down, what they saw before them. They had reds to use and greens and flesh tints and browns and blues with which they wanted to surround themselves in shapes which they recognized."[156] It was this direct use of material, paint as paint, vivid in its application, that appealed to Williams' modernist sensibilities.

The situation, however, was not entirely Edenic. Human needs were centered around death, the family, communal activities, property, anything that might hold back the encroaching wilderness. Thus the striking colors and simplified forms of the painted representations served as "a record, something to stand against, a shield for their protection, the savage world with which they were surrounded ...." Williams detected this essential purpose even in the still lifes. "One group symmetrically arranged on an oblong table, recognizably Shaker, particularly fascinated me," the poet said. "Curtains hang, always symmetrically, across the top. At either side are plates, with fruit knives. A bowl ... stands in the exact center of the picture making of it an obvious decoration, with melons, grapes, apples, perhaps an orange, peaches and pears [Fig. 76]." As Williams summarized, "their paintings remained always things."[157]

108

Although there is some question that the table de-
picted in the painting was not Shaker, the poet's
identification of it was conditioned by his long asso-
ciation with Sheeler.[158] Williams was fully aware of
the painter's attraction to Shaker artifacts, which
furnished his home in Ridgefield, Connecticut. But
how was the Sheelers' nineteenth-century domes-
ticity reconciled with Sheeler's depiction of modern
technology, the heavy industry of a Ford River Rouge
Plant, or the skyscrapers of New York? We can cite
*Shaker Detail*, a close-up exterior of a white clap-
board structure, as simply another instance of the
painter's interest in architectural forms (Fig. 77); we
can suggest that Sheeler painted simply what was at
hand in *Interior*, a canvas with recognizable Shaker
tables (Fig. 78). In neither case would we be incor-
rect, but these explanations strike at the obvious.
Williams divined the apparent paradox of Sheeler's
fascination with modern technology and his attrac-
tion to the preindustrial handicrafts of the Shakers.
A functional aesthetic that attended to materials
and emphasized the formal clarity of their construc-
tion provided a model out of the past that Sheeler
found consonant with modern technology but more
important that he could appropriate for his own art
as he lived it.[159]

*Interior* of 1926 was a significant effort in the interior
series Sheeler undertook during this time for it stands
midway pictorially between the ambivalence he felt
toward abstraction and representation alike. *Interior*
depicts the Sheeler household — a Shaker trestle
table with a pewter platter, another small Shaker
table with pitcher and fruit, a quilted bed, rag rugs,
pine floors. Sheeler was clearly interested in the
geometric qualities of these artifacts but only in so
far as they could be exploited for a pictorial design.
His treatment in this instance fulfulls the notion of
"Cubist-Realism," for the objects retain their repre-
sentational dimension though they are distorted or
modified according to Cubist premises. Thus the
painterly surface of the trestle table (Sheeler ordi-
narily preferred the invisible brushstroke) plays with
the surface of the canvas. Shifts of perspective cul-
minate in the small scale of the bed, which takes on
an air of fantasy. Although the strength of *Interior*
lies precisely in these formal and spatial disloca-
tions, the painting remains tentative, almost uncon-
vincing, in its composition.

The Shakers had developed their aesthetic sensibili-
ties out of their deeply held religious convictions.
Perhaps inevitably, then, their aesthetic implied a
way of life to Sheeler. In a remarkable passage from
*The Autobiography* Williams disclosed the full di-
mension of such an aesthetic by integrating, not by
metaphor or even analogy but out of a common
necessity of structuring the mind, the "reconstruc-
tion of the poem," a present-day aesthetic necessity,
with the painter's reconstruction of a domestic life.

Fig. 77. Charles Sheeler, *Shaker Detail*, 1941. Oil
and tempera on masonite, 13¼ x 14¼ inches. The
Newark Museum, Newark, New Jersey.

Fig. 78. Charles Sheeler, *Interior*, 1926. Oil on
canvas, 33 x 22 inches. Whitney Museum of Ameri-
can Art, New York; Gift of Gertrude Vanderbilt
Whitney 31.344.

His wife dead for nine years, Sheeler remarried and moved from Ridgefield to New York, where he bought "a wilfully destroyed Hudson River estate." How was his domesticity, an organization of the mind, to be regained? Williams seized upon the organization of Shaker furniture: "It is a past, totally uninfluenced by anything but the necessity, the total worth of the thing itself, the relationship of the parts to the whole. The Shakers made furniture for their own simple ritualistic use, of white pine, applewood, birch — what they had. Sheeler has a remarkable collection of this furniture. He has quilts, rugs, glass, early paintings in use about him." Not an inert collection of artifacts nor, for that matter, a futile resurrection of Shaker religion, but living with the furniture, "to transfer values into a new context, to make a poem [or a painting] again"—*there* was the interaction of mind and object that created a way of life.[160] Sheeler's paintings of domestic interiors served that very purpose.

In 1916 Marius De Zayas mounted an exhibition of African sculpture at his Modern Gallery in New York. It was only the second such exhibition in the United States, the first having been held at "291" in 1914 upon the urging of De Zayas, who had seen African art in Paris as early as 1911. Charles Sheeler worked as a photographer for De Zayas at his various galleries. In 1917 he photographed twenty African sculptures owned by De Zayas and in January 1918 published a portfolio, *African Negro Sculpture*, in a small edition of twenty-two (Figs. 79, 80). De Zayas wrote a short preface to the portfolio. It was not without misconception. He viewed African art as being "without history, without tradition and without precedent," a notion that had nothing to do with Africa and everything to do with a modern artist's desire to escape from the dead tradition of academic art. De Zayas also reduced the art to fetishism and implied the racial stereotype of Africans as "natural" beings. But he was also not without appreciation. "Negro sculpture had been the stepping stone for a fecund evolution in our art," he claimed.[161]

Sheeler's assignment was hardly onerous. As a painter keenly interested in the formal developments of European modern art and as a photographer attracted to the Stieglitz circle, he must have been eager to photograph De Zayas' collection. The twenty photographs that comprise the portfolio were mostly of wooden figures. Sheeler made the prints in sepia tones which today might be thought to lend the pieces an arty appearance but which were perhaps then rationalized as a way of approximating their warm polished wood. Otherwise, Sheeler abided by the tenets of straight photography. He kept the objects in clear focus, photographed them against a plain background, and generally avoided dramatic lighting. The figures stand-

Fig. 79. Charles Sheeler, photograph no. 2 in *African Negro Sculpture*, 1918. Courtesy of the Robert Goldwater Library of Primitive Art, The Metropolitan Museum of Art, New York.

Fig. 80. Charles Sheeler, photograph no. 13 in *African Negro Sculpture*. Courtesy of the Robert Goldwater Library of Primitive Art, The Metropolitan Museum of Art, New York.

ing or seated are shot frontally or in profile. The photography itself is thus laconic: Sheeler draws our attention to the artifacts and not to the photographic process.

The project serendipitously integrated Sheeler's concerns as a photographer and as a modern painter, working as he did in earshot of De Zayas' aesthetic theories. Because Sheeler was a straight photographer, De Zayas saw him as one who caught the unadulterated form of nature or sought a "plastic verification of fact" with his camera.[162] By this view Sheeler's photographs of African sculpture verified the form of an art that was in itself, De Zayas claimed, a mental conception that had become an aesthetic model for the European avant-garde to draw upon. Sheeler's photographs thus allowed him to explore the form of these artifacts so important to the development of European modernism and which might give him some clues to his own artistic course. Instead of relying upon Stieglitz's position that the camera relieved the painter of representation, Sheeler was able to approach form in modern painting according to the tenets of straight photography. Here were artifacts already given a formal value that he could explore "objectively" with a camera.

In the meantime African sculpture was also gaining an intense personal significance among some black Americans. Alain Locke, one of the leaders of the Harlem renaissance in the 1920s, thought it strange that despite a strong and vital African heritage black Americans lagged behind in the visual arts even as they advanced in music and poetry.[163] The reason lies in the social effects of slavery. Cruelly stolen from their land, those Africans who survived had endured a brutal "middle passage" to North America that surpassed even the hardships of later, some more voluntary, immigrants. The enforced journey was less transformational than profoundly dislocative in intent. Africans were not supposed to become Americans but were to be reduced instead to the status of chattel property. Whereas someone like Williams freely turned from painting to poetry, blacks had little or no choice: writing and singing did not require the apparatus of painting. Under slavery they were denied the necessary institutional opportunities to move into the "fine" arts of the dominant society, which relegated them in the main to craft activities that were of profit to their masters. With few exceptions this denial was systematically extended well after the Civil War. Only with the development of alternative black educational institutions and with the migration north into their own urban communities in Chicago and Harlem during the decade of the First World War did blacks slowly gain momentum in the visual arts.[164]

Thus in 1925 Locke explored the vital self-consciousness among blacks of his generation in a collection of essays entitled *The New Negro*. The anthology coincided with a growing interest in African art in New York.[165] Prompted by an exhibition of the Blondiau-Theatre Arts collection at the New Art Circle, Locke wrote an essay on African art for *The Arts* in 1927 in which he acknowledged the importance of the De Zayas exhibition over a decade before.[166] While De Zayas' categories of analysis centering around the concept of primitivism were implicitly racist, Locke sedulously avoided using the term "primitive" to describe African art.[167] Unlike De Zayas, he recognized the importance of tradition in the creation of African art and sketched its various social and cultural functions. Locke's essay was remarkable for its sensitive insights but no more than what one might expect from a black man who had a vital interest in his heritage as a way of inspiring a renaissance among black Americans.

The process took place slowly and painfully, requiring in part educational institutions that blacks might attend. Otherwise, in a segregated society they lacked even the academicism of white artists who aspired to modernism. The lack was occasionally an advantage, as in the case of William Edmondson, a black handiman from Nashville, Tennessee, who in the early 1930s decided to take up the carving of limestone blocks. His rough-hewn, directly carved volumetric forms approach abstraction in their simplicity. Edmondson was able to turn to sculpture by virtue of his evangelical faith. "This here stone and all those out there in the yard come from God," he declared. "It's the work in Jesus speaking His mind in my mind. I must be one of His disciples. These here is miracles I can do. Can't nobody do these but me. I can't help carving. I just does it."[168] His works were usually freestanding forms like *The Preacher* and *Jack Johnson* (both c. 1935; Figs. 81, 82), a hero among black Americans for his boxing prowess and defiance of white dictates. The iconography of the preacher was related to the American scene by having been carved from a black man's religious experience: the very carving process itself as well as the subjects chosen was informed by spiritual metaphors whose reality has remained a vital part of black culture in America.

That *Vogue* magazine should have been attracted to Edmondson's work indicates the aura of high fashion and exoticism to which some blacks were prey during the Harlem renaissance. But because the magazine refused to publish a black in its pages then, Edmondson came to the attention of the Museum of Modern Art, which gave him a one-man show in 1937. The exhibition was part of the ongoing interest among the avant-garde in primitive and folk art. In 1941 Sheeler's friend Edward Weston photographed the sculptor in his workshop (Fig. 83).[169] He is frontally seated with an air of forthright confidence. Nowhere is there a sense of condescension. We meet the sculptor on his own terms.

By way of contrast Richmond Barthé studied at the Art Institute of Chicago during the early 1920s. He remained academic even when he turned to the sculpture of black figures such as *The Blackberry Woman* in 1932 and *African Dancer* the following year (Figs. 84, 85). Both figures are naturalistic and in the instance of the *African Dancer* idealized as well. The pieces have a rhetorical quality if not symbolic overtones, as though Barthé began work with a preconceived idea. Yet the idea is an interesting one, especially if the two figures are seen in tandem. *The Blackberry Woman* is, of course, rural Southern. She strides barefoot, wearing a simple dress and carrying her basket of blackberries. Her African counterpart is nude except for a loin covering and headgear. She stands poised, enraptured for a moment by music and dance. Her obvious sexuality is muted in *The Blackberry Woman* but evident nonetheless. Although domesticated she remains close to nature. If her bare feet don't indicate as much, Barthé's title does. He thus played back and forth between the two figures in suggesting the transformation of an African dancer into an American black woman of the South.

Fig. 81. William Edmondson, *The Preacher*, c. 1935. Limestone, 17 x 7½ x 6¾ inches. Collection of Edmund L. Fuller.

Fig. 82. William Edmondson, *Jack Johnson*, c. 1935. Limestone, 16½ x 8 x 8 inches. Collection of Edmund L. Fuller.

Fig. 83. Edward Weston, *William Edmondson, Sculptor, Nashville*, 1941. Photograph, 7½ x 9½ inches. The Museum of Modern Art, New York; Gift of Thomas J. Maloney.

Fig. 84. Richmond Barthé, *The Blackberry Woman*, 1932. Bronze, 34 x 11½ x 14 inches. Whitney Museum of American Art, New York; Purchase 32.91.

Fig. 85. Richmond Barthé, *African Dancer*, 1933. Plaster, 42½ x 16¾ x 14 inches. Whitney Museum of American Art, New York; Purchase 33.53.

As Williams insisted time and again, however, subject matter alone does not create an American art. The virtue of Barthé's sculpture lies not in its naturalism, which required a certain technical skill, but in the way he tried to incorporate African form into it. The results are subtle, related to the posture of the two figures. African sculpture belongs within the context of tribal dance and ritual, which involve the aesthetic (and ethical) norms of posture and physical movement related to dancers and carved figures alike.[170] The sculpture Sheeler photographed dramatize those norms, some of which gain play in Barthé's figures. Both *The Blackberry Woman* and *African Dancer* take an erect stance combined with a supple form indicated by their flexed knees and in the *African Dancer* by her relaxed wrists as well. *The Blackberry Woman* especially has her feet planted firmly on the ground as she balances a basket on her head, a characteristic act of grace among Africans. The *African Dancer* is uncharacteristically moving up on her toes but she too displays a tensive balance. By African standards these figures are ultimately related to the gods through their posture. Neither piece, however, was ever intended for ritual or dance use. In that respect they are firmly tied to western sculptural tradition. Yet each bears traces of those postural qualities that echo African aesthetics. Barthé, therefore, varied the double vision of those moderns who sought the primitive. Unlike them he remained a sophisticated academic who tried to integrate Africanisms with a naturalistic tradition. That these two figures do not entirely succeed comments on the difficulties of his task.

The formal problems raised by the concept of the primitive for academics and modernists alike were compounded by the social and political issues concerning blacks. It was impossible to pursue the primitive and its counterpart the folk in aesthetic terms alone. To associate black Americans with the "folk" was particularly ironic because of its democratic and egalitarian connotations. ("Art of the Common Man in America," the Museum of Modern Art called it.) Were not blacks, once they were designated as supposedly a true, some might say *the* true, American "folk," condemned to an inferior status that had little to do with the economic and social realities of twentieth-century America? Blacks endured cruel hardships and terror on both urban and rural fronts. Artists black and white were inevitably drawn to the intolerable situation of their fellow American citizens systematically denied their rights.

The circumstances demanded perhaps propaganda but more than that an unsentimental attitude to channel anger into an effective aesthetic statement dramatizing the situation. Thus Paul Cadmus' large drawing *To the Lynching!* (1935; Fig. 86) captures the full violence and animalism of that despicable act. The sculptor Isamu Noguchi (who eventually worked with Brancusi in Paris because of a serendipitous meeting with McAlmon at the Café Flore in 1927)[171] entered his powerful *Death* of 1934 (Fig. 87) in an exhibition at the A.C.A. Gallery in 1935 entitled "The Struggle for Negro Rights." When reviewed in *The New Masses*, the exhibition was praised for its "undeniable anti-lynch propaganda value,"[172] yet Noguchi's metal sculpture gains its power precisely from its modernist form. This grim figure, its limbs in grotesque tension, actually swings from a rope — a searing "mobile" of our shameful time.

Finally, William H. Johnson's large oil entitled *Chain Gang* (1939-40; Pl. XII) is the work of a black painter who cultivated the primitive through the tenets of modernism. After studying in Paris Johnson returned to his hometown in South Carolina in 1930 only to be harassed and arrested by the local authorities.[173] He did not require much imagination to foresee *Chain Gang*, a common enough experience for black southerners. Even so, the painting is not a simple recording. The expressive contours of the prisoners' awkward bodies create an intricate visual pattern as intricate and close as that relationship among men painfully chained together. The exhausted trio, the center figure staring at us, indict American justice while the bright colors suggest the indomitable spirit of those who manage to survive.

Fig. 86. Paul Cadmus, *To the Lynching!* 1935. Pencil and watercolor on paper, 20½ x 15¾ inches. Whitney Museum of American Art, New York; Purchase 36.32.

Fig. 88. Howard Lester, *An American Beast of Burden* in *The Negro Anthology*, ed. by Nancy Cunard (London, 1934), p. 2. Courtesy of The Harris Collection of American Poetry and Plays, Brown University, Providence, Rhode Island.

113

Fig. 87. Isamu Noguchi, *Death*, 1934. Monel metal, 36 x 33 x 18 inches. Collection of the artist.

*Chain Gang* is a reminder of the infamous Scottsboro case of 1931, when nine young blacks were tried and convicted of raping two white girls while they were all riding freight cars in Alabama. Their case received widespread publicity and was taken up by many groups on the left. Among them was Nancy Cunard, British heiress of the steamship lines. On his Paris trip in 1924 Williams had met "that tall, blond spike of a woman" probably through McAlmon.[174] Four years later she bought William Bird's Three Mountains Press, which had published *The Great American Novel*. Her assistant Henry Crowder, a black jazz pianist and composer, whetted her interest in social conditions in the United States. By 1931 Cunard was determined to edit what was to become *Negro*, a

magnificent anthology of materials on blacks throughout the world. With unflagging energy she brought together history, biography, music, poetry, folklore, and fiction for an unparalleled account of black life. *Negro* was also a stunning, often shocking visual record: photographs throughout the text documented black achievements and tragic scenes of oppression (Fig. 88).

In the summer of 1931 Cunard and Crowder arrived in New York and lodged in Harlem. Their stay was not without racial tension though it wasn't until their return the following year that hostilities were provoked by a yellow press. The Williamses invited the couple to Rutherford during their first visit. It was not an uncourageous gesture on their part for they risked being ostracized by their neighbors. Williams responded enthusiastically to Crowder — almost too enthusiastically, in the manner of someone who wanted to be open about blacks. Cunard asked him to contribute something to her anthology and he submitted "The Colored Girls of Passenack — Old and New," a semi-autobiographical short story that romanticized black women as natural, sexual creatures.[175] The story's appearance in *Negro* perhaps indicates Cunard's sense of friendship more than an enlightened attitude on Williams' part. But the story was intended to be generally affirmative, and Williams was to be exposed to more militant and less stereotyped views of blacks in *Negro*, which appeared in 1934, and in the interim, in issues of *The Negro Worker* along with Nancy Cunard's *Black Man and White Ladyship*, a pamphlet giving her caustic account of the break with her mother and the British aristocracy she represented. Cunard's inscription to the Williamses announced that she was returning to the United States in the spring of 1932.[176] The poet's contacts were becoming increasingly political.

In the final issue of *The Little Review* Williams offered "A Tentative Statement" about the future: "I intend a construction, something at least wrong, from the senseless world of American writing."[177] This was in the spring of 1929. The senseless world was announced with the stockmarket crash in October, unraveling the 1930s chaotically and tragically for the American people. Here was a nation with great resources going to waste. Men and women without work found themselves in psychologically debilitating circumstances for a country that prided itself on the Protestant Ethic. The United States was caught up by devastating economic forces seemingly beyond governance. In such a widespread social crisis perhaps all that could be asked of American artists were constructions that were "wrong." Certainly little else was right.

As a witness to the daily troubles of his patients, Williams himself was affected in his dual role. To Zukofsky during the winter of 1933 he wrote, "Practice is plumb shot to hell. Hardly a call anymore. And when there is it's: I can't pay you today, doctor."[178] A dwindling practice gave him more time to write but with little satisfaction. Yet to write seemed the only way to muddle through a profound sense of disorientation. He was fortunate to have one kind of work left. These domestic problems pointed to larger issues. How was the United States to regain its proper economic course? Were the traditional political parties adequate instruments for resolving the country's ills? Or was a new economic and political system necessary? (Revolution seemed imminent.) While American artists had to confront these issues along with everyone else, they were also burdened with another fundamental question: what was the social and cultural role of the American artist? Was his economic marginality symptomatic of a deeper alienation or was the artist to take a central role in American society?

Williams' idea of Contact inevitably led him as a poet to a consideration of the issues that surfaced in his life and in the lives of those about him. In 1929 he rededicated his poetry to life: "It lives where life is hardest, hottest, most subject to jailing, infringements and whatever it may be that groups of citizens oppose to danger." Williams knew the dangers of writing firsthand. In 1926 for the first issue of *The New Masses* the poet had submitted "The Five Dollar Guy," a short story about a workingclass woman. Williams neglected to change the names of the people on whom he had based the story. His writing cut too close to the bone of reality. Sued for libel, Williams was saved by *The Dial* Award, which covered a portion of the out-of-court settlement. As he said a few years later, "In this country if you write, Hallelujah, I'm a bum — and mean it, you get put up against a wall for one man out of twelve to shoot a blank cartridge at."[179]

For Williams language was intimately associated with action. In 1921 he tried to publicize the cause of John Coffee, who had been confined as insane for stealing openly in civil disobedience. Williams took the reaction of the authorities as evidence in itself of the bankruptcy of a legal system that would deny a man responsibility for his actions. The poet was equally concerned about Coffee's argument, an "atrocious mode" of "abstract philosophical jargon"—"bad writing," in short, which he still felt should not cloud Coffee's "logic and human devotion." The incident stuck with Williams. In 1935, at the height of the Depression, he managed to have printed *An Early Martyr and Other Poems* in honor of Coffee. The title poem laconically set forth the case once again. Its only image draws the episode to the workers: "Let him be / a factory whistle / That keeps blaring —/ Sense, sense, sense!"[180]

Coffee's dissent was in the anarchistic tradition of Henry David Thoreau. Anarchism appealed to Williams for it vouchsafed individualism underlying his entrepreneurial efforts as an artist. In contrast Communism offered another model on the left that required attention because of the successful Bolshevik Revolution of 1917. The Soviet Union appeared to be building a new society based on collective endeavor. Could the American artist submit to the authority of the Communist Party both in one's personal actions and in one's art? The question was difficult but made all the more urgent by the Depression, which seemed to signal the imminent downfall of American capitalism.

By deploring Coffee's inadvertent split between act and written word, Williams implied that he wanted to be enlisted as a poet in politics. Yet he shied away from such a position as he imagined it was available to him. In writing for a subscription to *The New Masses* in 1930 he felt constrained to explain the "false position" in which he found himself. "How can I be a Communist," he asked, "being what I am." The doctor was a poet above all. "Poetry is the thing which has the hardest hold on me in my daily experiences. But I cannot," he protested, "without an impossible wrench of my understanding, turn it into a force directed toward one end, Vote the Communist Ticket, or work for world revolution." Poetry engaged him diversely, pluralistically. But at the same time he could see the "social injustices" surrounding him even as he tacitly (most crucially for CP members) rejected a Marxist explanation of their cause. "I would give my life freely if I could right them," he claimed. "But who the hell wants my life? Nobody as far as I can see. They don't even want my verse, which is of more importance." Nevertheless, Williams managed to conclude, "I'm for you. I'll help as I can. I'd like to see you live. And here's to the light, from wherever it may come."[181]

At this juncture Williams qualified as a fellow traveler. In 1932 he was editor of *Contact* once again, a short-lived second series of three issues the first of which included the Mexican muralist Diego Rivera on "Mickey Mouse and American Art" (entertainment for the masses).[182] A year later he served as advisory editor for *Blast: A Magazine of Proletarian Fiction* run by Fred Miller, an independent leftist, "a tool designer living precariously over a garage in Brooklyn."[183] The light, however, was eventually to come from the Social Credit Movement in England and advocated by Ezra Pound as early as 1921 in the first series of *Contact*.[184] By 1935 Williams was writing occasional pieces for *New Democracy*, a magazine edited as a sounding board for Social Credit by Gorham Munson, a friend from the Dada days of *Broom* and *Secession*. Social Credit involved an economic theory that centered on monetary control to balance the production and consumption of goods equitably throughout society. Munson formed his own American Social Credit Movement in 1938 and in a manifesto espoused democracy, opposed Fascism and Communism as totalitarian, and explicitly denounced anti-Semitism. Social Credit had been in danger of being discredited by one such as Pound, who had come to support Mussolini. Williams became a charter member of Munson's party. It was one way of disengaging himself from the vicious and irrational politics of Pound. It also gave him a new political outlet after he had renounced Marxism in *Partisan Review and Anvil* in 1936 as a "static philosophy" in conflict with the "deep-seated ideals" of American democracy.[185]

Running throughout this political odyssey was Williams' concern about the relationship between art and politics. He was not interested in writing propaganda in the guise of art as did so many who wrote proletarian fiction. By acknowledging the inadequacy of present efforts, the better writers looked forward to a proletarian art. Hence "Worker Find Your Poet" was the apposite title for an otherwise inept poem by a contributor to *Dynamo: A Journal of Revolutionary Poetry*, or as Williams' friend Norman Macleod wryly noted, "Poems are sometimes asinine / in the face of industrialism." His irony was lost upon those political radicals who in the extreme viewed art as a mere superstructure resting upon economic realities at the base of social problems. Short of that position, radicals were willing to enlist poetry and visual art in the cause of revolution. As Williams himself declared, in what was rapidly becoming a cliché of the left, "The artist holds a weapon. . . ."[186]

Although their weapons were occasionally blunt-edged, illustrators such as Hugo Gellert and William Gropper among others were often pointed in their drawings and cartoons for *The New Masses* (Figs. 89, 90). Williams was also capable of writing caustic

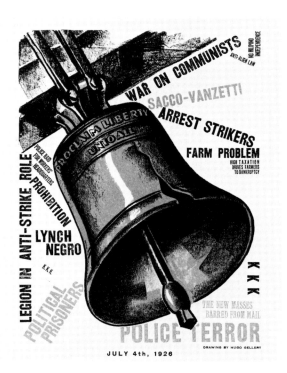

Fig. 89. Hugo Gellert, "July 4, 1926," *The New Masses* I, no. 3 (July 1926), p. 8. Courtesy of The Museum of Modern Art, New York.

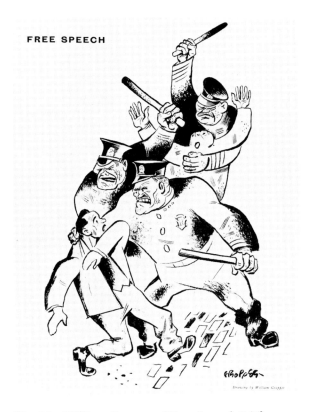

Fig. 90. William Gropper, "Free Speech," *The New Masses* III, no. 4 (August 1927), p. 14. Courtesy of The Museum of Modern Art, New York.

poetry in response to the pressure of events. Like Shahn, Williams responded powerfully to the Sacco and Vanzetti case. In a bitter indictment of his own, he wrote "Impromptu: The Suckers": "Americans, you / are the suckers, you are the ones who will / be going up on the eleventh to get the current / shot into you, for the glory of the state / and the perpetuation of abstract justice —" Although a rhetorical outburst might temporarily assuage his anger, Williams realized that a more subtle approach was necessary to sustain his art. In a lengthy attempt to state his editorial position for *Blast* in 1933 the poet asserted the individual primacy of artists over and above the state. He claimed that Communism and the present social/economic crisis challenged the artist not to write "communistically" but to "retreat to essentials," to develop a "more simple organization of social materials" through close observation.[187] As he said earlier in 1928 in his "Democratic Party Poem," "Poetry is accurate statement," and "that sort of thing is dangerous."[188] This argument was drawn from the tenets of Objectivism made compatible with his social sympathies. Thus Williams described the artist as an "artisan," a "practical man working with materials which he knows from the first," who is kin to the worker.[189]

Objectivism itself, however, was attacked from the left as a movement merely preoccupied with technique; and Williams was brought under pressure to produce socially relevant themes in an explicit fashion.[190] The subtleties of his position can be seen in his collaboration with the sculptor William Zorach on a small pamphlet in 1937. In *I Wanted to Write a Poem* Williams was casual about the matter. "We were theatre pals," he reminisced, "and somehow it came about that we combined our works, his two drawings, nudes, and my two poems, 'Advent of Today' and 'The Girl.'"[191] Even though neither contribution served to illustrate the other in any obvious way, the pamphlet shared some aesthetic presuppositions that bore political implications.

Zorach was one of the first Americans to promote the revival of direct carving. Having begun in 1917 with a simple exercise in whittling, an act perhaps born out of an admiration for folk art, he soon gave up painting for sculpture. He preferred to carve away the block of stone or wood to discover the essential forms he envisioned. It was with such an emphasis on material that Zorach purchased a long piece of African mahogany to carve *Floating Figure* in 1922 (Pl. XIII).[192] While the material related him symbolically to African sculpture, the voluptuous

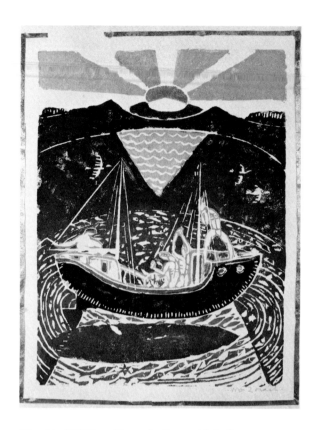

Fig. 91. William Zorach, *Boat with Sailors*, c. 1915. Linoleum block, 16 x 13 inches. Museum of Art of Ogunquit, Maine; Gift of Mrs. William Carlos Williams.

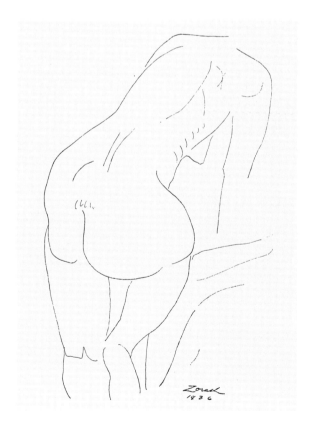

Fig. 92. William Zorach, *One Nude*, 1936, in *William Zorach: Two Nudes/William Carlos Williams: Two Poems* (Stovepipe Press, 1937). Courtesy of The Harris Collection of American Poetry and Plays, Brown University, Providence, Rhode Island.

lines of the figure, the graceful distortions of its neck, face, and arms, had more to do with a modernist interpretation of African carvings than with any imitation of African form.

The sensibility that preferred direct carving for an emphasis on material also dictated Zorach's use of the block print and style of drawing. In *Boat with Sailors*, which Williams once owned, the sculptor worked with linoleum block, cutting away the superfluous surface to reveal the simplified shapes that would make a direct imprint (Fig. 91). In his collaboration with Williams, Zorach chose two simple sketches of nudes (Fig. 92). Their economical lines suggest spontaneous drawing which calls attention to itself as a fluid process. Likewise, Williams' poem entitled "The Girl" involves laconic description: "The Girl" / with big breasts / in a blue sweater / was crossing the / street bareheaded / reading a paper / held up close / but stopped, turned / and looked down / as though / she had seen a coin / lying / on the pavement —" The sentence is straightforward and abstracts a brief moment in an urban situation. Yet the placement of the words according to line stresses the palpable quality of words. The poem is a construction, Williams reminds us.

At first glance this collaboration seems to have little to do with politics or social problems. And while Zorach was indeed class conscious (ever since he saw a boy shot to death during a streetcar strike in Cleveland), he abstained from political statements in his sculpture. Williams, however, commented on "The Girl" at the time in a little magazine of a local college. In order to achieve the classic, he claimed, the poet must attend to his own time. "The Girl" was his example: "This girl is caught in the economic embarrassments of the age.... But there is a dignity in this girl quite comparable to that of the Venus [de Milo].... Why not imagine this girl Venus? Venus lives! She thought she saw a dime on the pavement and leaned—or turned around to pick it up. But being short sighted she was mistaken. It wasn't a dime it was a gob of spit." The poem was similar in kind to "Proletarian Portrait," which appeared in *Direction* in 1935. Williams again described a robust young woman on the street holding her shoe: "She pulls out the paper insole / to find the nail / That has been hurting her." The understatement of both poems served as an antidote to overt commentary extraneous to art. Williams rested his case on the assumption that "particular meaning is complex. It takes up the whole philosophical, ethical, economic complexion of the day. A day like no other day."[193]

"Proletarian Portrait" was originally called "Study for a Figure Representing Modern Culture." The two titles taken together suggest the tensions Williams felt in trying to reconcile a long-standing split between the avant-garde and the political vanguard on the left. The poet implicitly subsumed "modern culture," ambiguously contemporaneous and avant-garde, into a "proletarian portrait," which intimated a class culture that had to be nurtured. In the spring of 1935 when "Proletarian Portrait" was published, Williams had attended the Writer's Congress in New York and singled out the speech of Waldo Frank to Zukofsky. Not only did Frank reject propaganda in the arts but also directed the artist to condition the "proletarian mind, making it ready for revolution."[194] Already skeptical about the possibility of a new American revolution, Williams nonetheless committed his poetry and fiction to the urban poor. The best conditioning he could imagine was to portray their essential worth without sentimentality or idealization.

Exactly such portrayals can be found in the work of Raphael Soyer, Katherine Schmidt, and Isabel Bishop — artists who maintained studios in the Fourteenth Street area of Manhattan. In *Reading from Left to Right* (Fig. 93) we see Soyer's claim of being "absorbed in painting the unemployed and [discovering] the joy of being able to represent accurately and in detail all those men on park benches and in missions." Even though the three men are clearly of a social class, they are rendered as individuals not types. Soyer

Fig. 93. Raphael Soyer, *Reading from Left to Right*, 1938. Oil on canvas, 26¼ x 20¼ inches. Whitney Museum of American Art, New York; Gift of Mrs. Emil J. Arnold in memory of Emil J. Arnold and in honor of Lloyd Goodrich 74.3.

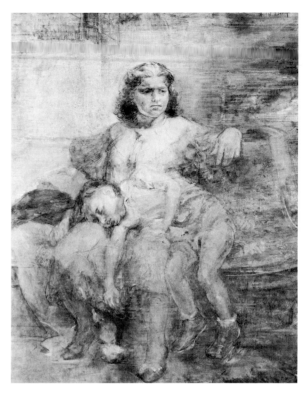

Fig. 94. Katherine Schmidt, *Broe and McDonald Listen In*, 1937. Oil on canvas, 30 x 24 inches. Whitney Museum of American Art, New York; Purchase (and exchange) 50.15.

Fig. 95. Isabel Bishop, *Waiting*, 1935. Ink on paper, 7⅛ x 6 inches. Whitney Museum of American Art, New York; Purchase 36.31.

changed the title of the painting from *Bowery* to *Reading from Left to Right*, perhaps because of a literal reading suggested by a menu on the rear wall, but more likely because he was aware of the "danger of naturalism."[195] The new title gives us a formal directive. We read sequentially the bleak faces of these men and discover a human text of poverty. This text is also apparent in the psychological vignette offered by Katherine Schmidt in *Broe and McDonald Listen In* (1937; Fig. 94) and Isabel Bishop in *Waiting*, a small pen and ink sketch of 1935 (Fig. 95). Here is a young girl asleep across her mother's lap, herself a young woman vigilant yet tired, with a worried look in her eyes. The scene is a poignant encapsulation of two generations simply awaiting what the future has in store for them.[196]

Stieglitz had vividly reenacted the split between the avant-garde and a political vanguard. In *Twice a Year* (1940-41) he recounted an episode that occurred at "291" probably around the time of the 1913 Armory Show and the Paterson strike of textile workers. (The Armory Show set against a large-scale pageant for the strikers at Madison Square Garden suggests an existing split.) Stieglitz was visited by Big Bill Heywood, leader of the IWW in town to support the strikers. Heywood deplored the "dinky little place"

of a gallery, ignored the paintings on the walls, scorned "pseudo-workers," and invited the photographer to join him in the "real fight" for "true workers" everywhere. Stieglitz refused, and as he told it, Heywood "shook [his head] and said two single words, 'Too bad', and with his friend he left 291."[197]

Yet to include the story in *Twice a Year*, devoted to art, politics, and social issues, suggests that the photographer wanted to state his own political apologia. "When the day arrives and what you are doing proves to be true and what I am attempting to do proves to be equally true we'll be standing shoulder to shoulder where-ever we meet," he reassured the Wobblie leader.[198] Stieglitz's reputation for political aloofness stems in part from his antipathy toward labor unions, which he believed went counter to true workmanship. In 1934 he quickly withdrew from any affiliation with the newly-formed Artists' Union on the grounds that he was an anarchist committed to the worker.[199] Preferring to maintain his autonomy, Stieglitz opposed the need for organization and collective action.

While An American Place turned out to be a gallery for those artists who did not participate in politics (Demuth, when asked what he really disliked by *The*

*Little Review*, responded, "Anything concealing a 'cause!'"),[200] Stieglitz did on one occasion show the watercolors of George Grosz, the German Dadaist who migrated to the United States in 1933. In the brochure for the exhibition, Hartley observed, "If Grosz is perhaps kinder in these American satires than he was in his scalpel-like incisions into the coarse flesh-crust of obtuse and vulgar humanity as he knew it in Berlin . . . there is doubtless a reason, for Grosz likes us, he entertains the hope of being one of us and all our droll behaviour is to him fresh with vital energy." "Droll behavior" hardly describes some of Grosz's depictions of American life. His drawing for *Americana*, a satiric magazine of the early 1930s, catches an old bum rummaging through a garbage can in an alley (Fig. 96). "Mother was right," he says, "the first million is always the hardest."[201] Deflating the "Proven Proverbs" of a capitalist society, in this instance the widespread credence still given to the Protestant Ethic despite hard evidence to the contrary, was matched again by his ironic portrayal of *The Hero* in a lithograph for a portfolio of six prints depicting the American scene in 1933-34 (Fig. 97). With this powerful image of a cripple Grosz suppressed anecdotal elements that surface in Thomas Hart Benton's *Mine Strike* or John Steuart Curry's *Manhunt* for a subsequent portfolio (Figs. 98, 99).[202]

Fig. 96. George Grosz, "Mother was right . . ." in *Americana* I, no. 10 (August 1933), p. 31. Courtesy of The Harris Collection of American Poetry and Plays, Brown University, Providence, Rhode Island.

Fig. 97. George Grosz, *The Hero*, 1934, from *The American Scene No. I*. Lithograph, 13 x 9 inches. Whitney Museum of American Art, New York; Purchase 33.83d.

## PROVEN PROVERBS

Fig. 98. Thomas Hart Benton, *Mine Strike*, 1934, from *The American Scene—Series 2*. Lithograph, 9¾ x 10¾ inches. Whitney Museum of American Art, New York; Purchase 34.37a.

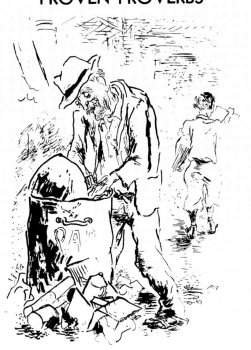

"Mother was right, the first million is always the hardest"

Although Stieglitz tried to maintain a low political profile, he was inevitably drawn into the thick of cultural politics. The photographer was attacked in 1935 by Benton, a former modernist turned leader of an "American Wave" movement espousing regionalist art. Benton used the publication of *America and Alfred Stieglitz* as the occasion for his attack in *Common Sense*. Benton viewed the book as "extravagant and windy," matching the personality of Stieglitz, who has a "mania for self-aggrandizement, and his mouth is never shut." Although he praised Stieglitz's photography, he left little else uncriticized. He dismissed the painters and writers of the Stieglitz circle as "New York cultists" who were sadly out of touch with the realities of American life. The painters' move toward abstraction resulted only in an "empty purity." The intellectuals engaged in "mere language pattern" with no meaning. (Benton singled out Williams' essay "The American Background" as an example of "linguistic balderdash.") Ultimately the painter attacked the afflatus which cast a pall over the writing and thinking of the group. Against these "dilettantes" Benton set the "rising power" of the regionalists.[203] The essay became his valedictory address to New York, which he left for the Midwest later in 1935.

Stieglitz, of course, was upset, though in a letter of response to Benton he tried to shrug off the article as a joke, "contortions similar to those in your paintings and murals."[204] In fact Benton's assault was simply a verbal version of a mural he had been commissioned to do by the Whitney Museum for its library in 1932. A ceiling panel was entitled *Political Business and Intellectual Ballyhoo* (Fig. 100), which took cartoon swipes at *The New Masses*, "literary playboys,"

Fig. 99. John Steuart Curry, *Manhunt*, 1934, from *The American Scene—Series 2*. Lithograph, 9¾ x 12⅞ inches. Whitney Museum of American Art, New York; Purchase 34.37b.

Fig. 100. Thomas Hart Benton, *Political Business and Intellectual Ballyhoo*, 1932. Tempera with oil glaze on linen canvas, 56½ x 113 inches. New Britain Museum of American Art, New Britain, Connecticut; Alix Stanley Foundation.

Fig. 101. Thomas Hart Benton, *Arts of the South*, 1932. Tempera with oil glaze on linen canvas, 8 x 13 feet. New Britain Museum of American Art, New Britain, Connecticut; Harriet Russell Stanley Fund.

Fig. 102. Georgia O'Keeffe, *Cow's Skull — Red White and Blue*, 1931. Oil on canvas, 39⅞ x 35⅞ inches. The Metropolitan Museum of Art, New York; The Alfred Stieglitz Collection, 1949.

and "Greenwich Village proletarians." An atrocious painting, it nonetheless delineated in crude fashion the political animosity Benton felt toward the American avant-garde, which as early as 1921 he thought of as "little maggot noodle moderns," and the political vanguard, which he claimed viewed "art as propaganda."[205] An antidote was prescribed in other panels for the Whitney which depicted *The Arts of Life in America*, a celebration of popular and folk arts — crapshooting, burlesque, bronco busting, and the like in various regions of the United States.

In 1935 Stuart Davis, serving on the editorial board of *Art Front*, a magazine of the Artists' Union, denounced the murals as "dime novel American history," replete with "regional jingoism and racial chauvinism," especially *Political Business and Intellectual Ballyhoo*, which he thought "shows a Jew in vicious caricature holding the *New Masses*," and *Arts of the South* (Fig. 101), with its "caricatures of crap shooting and barefoot shuffling negroes."[206] Visual counterattacks against Benton's way of thinking had already been mounted. As early as 1931 Georgia O'Keeffe had made her own subtle gesture toward the "Great American Painting." Her attraction to the countryside beyond New York City made her aspire to an American art as she railed against the "city men" who were so mesmerized by Cézanne that "the Great American Painting didn't seem a possible dream." But the idea was also a parody of the Great American Novel, rendering her intentions ambiguous: "So as I painted along on my cow's skull on blue I thought to myself, I'll make it an American

124

Fig. 103. Thomas Hart Benton, *The Lord Is My Shepherd*, 1926. Tempera on canvas, 33¼ x 27¼ inches. Whitney Museum of American Art, New York; Gift of Gertrude Vanderbilt Whitney 31.100.

Fig. 104. John Steuart Curry, *Baptism in Kansas*, 1928. Oil on canvas, 40 x 50 inches. Whitney Museum of American Art, New York; Gift of Gertrude Vanderbilt Whitney 31.159.

Fig. 105. Photograph of Grant Wood in France, 1924. Courtesy of James Dennis.

painting. They will not think it great with the red stripes down the sides — Red White and Blue — but they will notice it."[207] *Cow's Skull—Red White and Blue* (Fig. 102) testifies against the rank chauvinism latent within regionalism even as the painting offers a sublime image of the American landscape.

The underlying conflict generated by regionalism involved competing ways of life. Regions finally devolved into city and country, each attracting its own constellation of cultural values. Benton identified his true Americans in *The Lord Is My Shepherd* in 1926 (Fig. 103). Here is an older agrarian couple, full of Christian piety, gathered around the kitchen table at the center of their home. John Steuart Curry presented essentially the same ideals in *Baptism in Kansas* in 1928 (Fig. 104). A Christian ritual gathering a rural community together was a valid theme, but the idea took precedent over the conception, what with the doves and celestial rays.

Of those painters who claimed the American scene for an agrarian vision Grant Wood was perhaps the most sensitive and talented spokesman. Like Benton, Wood had been attracted to modernism as a young painter, but he soon returned home to Iowa. This *rite de passage* can be visualized in some photographs and a pastel entitled *Return from Bohemia* (1935). One photograph shows Wood in 1924 sporting a goatee and hoisting a stein in a French cafe (Fig. 105). Less than a Bohemian, Wood showed all the markings of a tourist. *Return from Bohemia* is a self-portrait of Wood facing outward at an easel while interested neighbors look over his shoulder at his work (Fig. 106). The tableau is framed by a barn in the background. Here is the artist, hair now shorn, at the center of a rural community. Another photograph

Fig. 106. Grant Wood, *Return from Bohemia*, 1935. Pastel on paper, 23¾ x 20 inches. IBM Corporation.

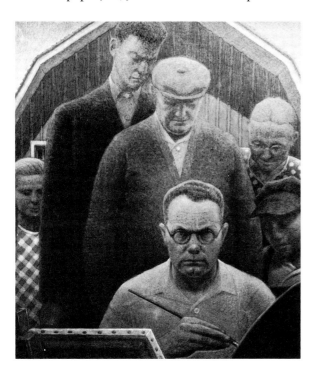

Fig. 107. John Steuart Curry visiting Grant Wood at Stone City Colony and Art School, Stone City, Iowa, Summer 1932. Courtesy of the Cedar Rapids Art Center, Cedar Rapids, Iowa.

shows Wood and Curry at the Stone City Colony and Art School in Iowa (Fig. 107). Dressed in coveralls, the two are seated while Curry works on a sketch of Wood. "Pose an aesthetic question to a plowman": so Wood might have paraphrased Jefferson. The metamorphosis from expatriate to rural citizen has been completed.

In 1935 Wood summarized his agrarian preferences in *Revolt Against the City*, a pamphlet whose contents were moderately couched despite its title. Concentrating on the Midwest the painter charted the growth of regionalism in the arts. He argued that the Depression necessitated a return to fundamental values, especially to the self-reliance of rural Americans. Wood had begun to dramatize those "old frontier virtues" in planning murals for the Iowa State University Library.[208] For one he drew a triptych tableau, the center panel showing farmer and wife taking a break in the field with horses and plow, the two side panels capturing the swing of an ax as a husbandman clears the land for tillage (Fig. 108). The farmer had already become Wood's heroic fig-

ure, one whose life called for artistic interpretation. And so Wood skillfully portrayed agrarian rituals based on a close relationship with the earth in such works as *Dinner for Threshers* (1933; Fig. 109) and *Seed Time and Harvest* (1937; Fig. 110).

Williams remained skeptical about regionalism. It was not simply because some of his favorite artists were under attack. Although regionalism could easily be extrapolated from Williams' emphasis upon the local, it did not conform entirely to the poet's standards. He found some regionalists all too often interested only in narrative and subject matter without an attendant concern with form. Thus in 1929 he claimed that "[Carl] Sandburg should quit the false local of 'these states', 'the prairie', etc., and be actually local in his finer sense of the words and metric of which I have spoken above." And in 1930, when Williams had the opportunity to contribute to the short-lived *USA: A Quarterly Magazine of the American Scene* (Benton appeared in the second issue), he submitted "The Flower," a poem that begins with the immediacy of "A petal, colorless and without form," moves to the sweep of an urbanscape, and concludes with the resolve "when / my mind is clear and burning — to write."[209]

Fig. 108. Grant Wood, *Study for Breaking the Prairie*, c. 1935-39. Colored pencil, chalk, and pencil on butcher paper; triptych, 22¾ x 80¼ inches overall. Whitney Museum of American Art, New York; Promised gift of Mr. and Mrs. George D. Stoddard 2.76.

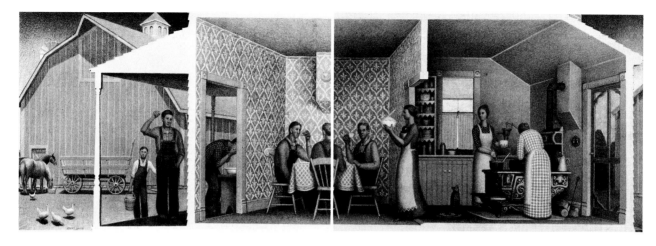

Fig. 109. Grant Wood, *Dinner for Threshers*, 1933,
studies for the left and right sections of the painting.
Pencil and gouache on paper, each 17¾ x 26¾
inches. Whitney Museum of American Art, New
York; Purchase 33.79 and 33.80.

Fig. 110. Grant Wood, *Seed Time and Harvest*, 1937.
Lithograph, 7⅜ x 12 inches. Whitney Museum of
American Art, New York; Gift of Arthur G. Altschul
72.77.

128

At their best, however, as in the instance of Benton's *Cradling Wheat* (1938; Fig. 111) or Wood's *Spring Turning* (1936; Pl. XIV), the Regionalists went beyond representation to achieve an intensity of vision and design. This was particularly true of *Spring Turning*, which has a pictorial reality that matches the patterned Iowa fields themselves. Williams himself recognized this agrarian artistry. In the context of declaring the poem's autonomy in *Spring and All* years before, Williams had enlisted the farmer, "in his head / the harvest already planted." Elaborating on this mental activity Williams concluded with the "artist figure of / the farmer — composing /— antagonist."[210] Just as the farmer must struggle with the land in order to "compose" his fields in the spring so too the artist composes one's poem or canvas. The imagination in contact with palpable materials thus makes something that rivals nature. As anyone who has driven through Iowa can attest, Wood became

that "artist figure of / the farmer" in making *Spring Turning*, no less a triumph than *Fields of Grain as Seen from Train*, painted by his abstractionist rival Arthur Dove.

Although Wood preferred to idealize the Midwest, he was not entirely blind to the forces of mechanization that had come to dominate agriculture during the 1920s. His painting of *The Old J. G. Cherry Plant, Cedar Rapids* (1925; Fig. 112), a manufacturer of dairy equipment, or his commissioned renderings of its workers — *The Shop Inspector* (1925; Fig. 113) for example — indicates an awareness of industrialization in arcadia. Even so, he portrayed the machinists as skilled craftsmen not as proletarians who had little stake in their work. Wood's whimsical assemblage of *Lilies of the Alley* (1922-25; Fig. 114) out of machine odds and ends hints at the detachment the painter was able to sustain from technology.

Fig. 111. Thomas Hart Benton, *Cradling Wheat*, 1938. Tempera and oil on board, 31 x 38 inches. The St. Louis Art Museum.

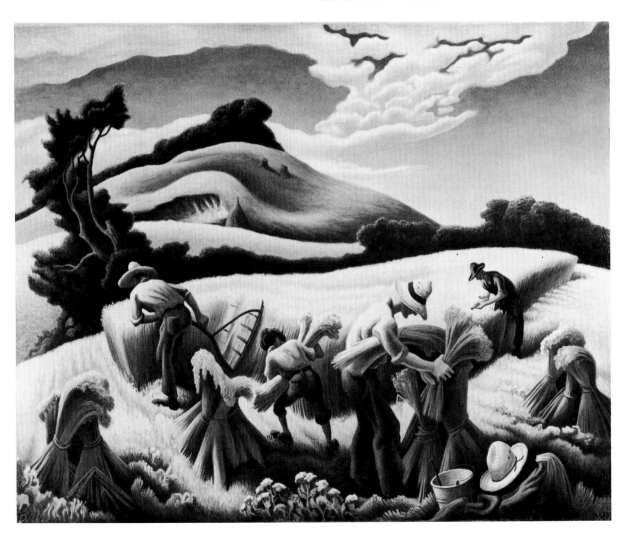

Fig. 112. Grant Wood, *The Old J. G. Cherry Plant, Cedar Rapids*, 1925. Oil on board, 13 x 41 inches. Cedar Rapids Art Center, Cedar Rapids, Iowa.

Fig. 113. Grant Wood, *The Shop Inspector*, 1925. Oil on canvas, 24 x 18 inches. Cedar Rapids Art Center, Cedar Rapids, Iowa.

Fig. 114. Grant Wood, *Lilies of the Alley*, 1922-25. Assemblage, 11 x 11¼ x 7 inches. Cedar Rapids Art Center, Cedar Rapids, Iowa.

In a mixed review of Wood in *Art Front* in 1935 Lincoln Kirstein concluded that the painter should try "to gain some trace of insight into the real weather of his Middle West — dust storms and drought, slaughtered pigs, unsown crops or crops ploughed under." Devastation of the countryside was to be seen in the work of other artists, who had different ideological perspectives. Aaron Bohrod's *Landscape Near Chicago* (1934; Fig. 115) reveals the overflow of urban junk into the Midwest countryside. Joe Jones' *American Farm* in 1936 shows to the point of explicit symbolizing a terrain ravaged by drought and erosion (Fig. 116). (Jones was reviewed in *Art Front* alongside Wood and was described in contrast as socially committed. He was also featured in *Direction* as a proletarian artist though not dogmatic, one eager for experience, "to express his own contact with life simply and directly." While centered in St. Louis he traveled throughout the Midwest on a government commission to sketch drought areas. Williams was to champion another Missouri artist, H. H. Lewis, a "dirt farmer and song maker," in *The New Masses*.)[211]

The desolation of human life was poignantly captured by Ben Shahn in *Scott's Run, West Virginia* in 1937 (Pl. XV). Because of his own impoverished circumstances Shahn felt virtually imprisoned in New York City until he was offered a job in 1935 by the Resettlement Administration (later the Farm Security Administration) to travel around the country and record conditions. One of his first destinations in the South was Scott's Run, a river region in northern West Virginia notorious for its poverty, disease, and mining strikes. (Scott's Run was also known as Bloody Run because of labor violence.) According to Eleanor Roosevelt, who visited the area because of the pilot resettlement project in Arthurdale in 1934, "some of the [mining] company houses, perched on hills on either side of the Run, seemed scarcely fit for human habitation."[212] (Shahn himself decided to live in a resettlement project at Jersey Homesteads, later renamed Roosevelt, in New Jersey, about fifty miles south of Rutherford.)

At the outset of the 1930s Shahn had shared a studio in Greenwich Village with Walker Evans, who was to become perhaps the best-known photographer employed by the Farm Security Administration.[213] In 1938 Evans had an exhibition of "American Photographs" at the Museum of Modern Art (Figs. 117, 118, 119). Lincoln Kirstein wrote an essay for the catalogue of the exhibition. In October the book was reviewed in *The New Republic* by Williams, who

Fig. 115. Aaron Bohrod, *Landscape Near Chicago*, 1934. Oil on composition board, 24 x 32 inches. Whitney Museum of American Art, New York; Purchase 34.13.

Fig. 116. Joe Jones, *American Farm*, 1936. Oil and tempera on canvas, 30 x 40 inches. Whitney Museum of American Art, New York; Purchase 36.144.

Fig. 117. Walker Evans, *Part of Phillipsburg, New Jersey*, 1936. Photograph, 7¼ x 9¼ inches. Courtesy of the Library of Congress, Washington, D.C.

had seen Evans' photographs earlier in the decade in *Hound and Horn*, a little magazine that Kirstein helped edit. The two writers concurred in their view of Evans. Kirstein placed the photographer among those who —and here he cited Williams —"have turned. . .to attack the subject matter of their own country in their own time." The poet, of course, stressed that "in a work of art place is everything," an assertion which he thought was corroborated in the

Fig. 118. Walker Evans, *Joe's Auto Graveyard, Pennsylvania*, 1935. Photograph, 4⅝ x 6¹³/₁₆ inches. Courtesy of the Library of Congress, Washington, D.C.

Fig. 119. Walker Evans, *Alabama Cotton Tenant Farmer's Wife*, 1936. Photograph, 9⅝ x 7¹³/₁₆ inches. Courtesy of the Library of Congress, Washington, D.C.

photographs. Both praised Evans as a straight photographer who, they agreed, had surveyed a country that was in bad shape. Kirstein spoke of Evans' "records of an age before imminent collapse," Williams of "social upheaval."[214]

Kirstein was not put off by the "puritanism" of Evans' "way of looking." "The view is clinical. Evans is a visual doctor, diagnostician rather than specialist," he thought. "But he is also the family physician, quiet and dispassionate, before whom even very old or very sick people are no longer ashamed to reveal themselves." The verbal doctor was even more explicit: "The artist must save us. He's the only one who can." Williams restored the artist to a central role in American society. His task was to make us "see what we have not heretofore realized ourselves made worthy in our anonymity." For Williams the artist uniquely worked with the particulars of experience abstracted by the medium so that "it is ourselves we see, ourselves lifted from a parochial setting." In this "particularization of the universal" the artist was to avoid both artiness and propaganda. Ultimately, Williams saw the photographs at hand as "works of art having their own identity," and that was a relatively rare observation about photography at the time.[215]

Despite his approval of Evans' photographs, Williams withheld full assent. Although he praised the eloquence of *American Photographs* he allowed that there might be better books of photographs recording American life. His reservation centered around the mildness of the images. He stated the case more forcefully in a paragraph deleted from the final draft:

> There is a pointed reference in Mr. Kirstein's notice to the work of Brady during the war between the states. In Evans' pictures also we are seeing fields of battle after the withdrawal of the forces engaged. The jumbled wreckage, human and material, is not always so grim in the present case but for all the detachment of the approach the effect is often no less poignant.[216]

Perhaps Evans' laconic vision was at the heart of the matter, but Williams took almost literally the metaphor of "jumbled wreckage" for the social crises of the past decade.

The martial metaphor derived from American history appealed to Williams in part because it implied class warfare but mainly because he was increasingly preoccupied by American violence and the grotesque in daily life. What had seemed simply idiosyncratic in his mother, with a "grotesque turn to her talk, a macabre anecdote concerning a dream, a passionate statement about death," had gradually become the dominant mood of the Depression — or so it appeared to Williams. His co-editor of *Contact*

Nathanael West claimed in 1932 that "in America violence is idiomatic," accounting for the high incidence of stories concerning violence the editors received. West's own apocalyptic novel *Miss Lonelyhearts* corroborated what Williams had observed several years before. "Most Americans are emotionally illiterate," he wrote. "Their principal joy is smashing their heads together."[217]

What was the artist to do under those circumstances but to avoid artiness and propaganda so as to encounter directly the rawness of American life. Hartley had captured the idea earlier in describing the doctor on his rounds, "looking down people's throats — and at their tumours and skinspots."[218] If America were "sick," to borrow Kirstein's metaphor of the artist as doctor, then Williams was convinced in his most depressed moments that the national "disease" involved a particularly gruesome epidemic. Ironically, Evans' photographs were some of the best documents of America's "disease" that Williams was to see, and he knew that, but the poet's sensibility — both social and aesthetic — occasionally demanded the extreme. Williams would have countered that the circumstances themselves were extreme, perhaps surpassing whatever "cure" the artist might have. Although he shied away from such nihilism by affirming above all his own faith in art as in his review of Evans, such a disturbing notion ran strong among the undercurrents of his feelings.

In 1932 Williams and West proclaimed that "Contact will attempt to cut a trail through the American jungle without the use of a European compass." Yet Williams was tempted to take Surrealism as his "European compass." (At virtually the same time that he was declaring independence from Europe he was recommending a little magazine called *Fifth Floor Window* to Zukofsky for "a readable article on Surrealism in it.") If art could not arise to the devastating circumstances of the times, then perhaps Surrealism with its denial of art was the only recourse. Williams had been attracted to the Surrealists from the early 1920s. After all he too had engaged in a kind of automatic writing with the improvisations for *Kora in Hell*. In 1936 for the first *New Directions* anthology edited by James Laughlin, Williams' publisher, the poet offered a prescription on "How to Write" that echoed André Breton's account of automatic writing in the first *Manifesto of Surrealism* of 1924. And in 1941 Williams translated from the French "Wrested from Mirrors," a poem by Nicolas Calas, a young Greek emigré whose essay on Surrealism he had read earlier. The Nierendorf Gallery in New York published the translation in a limited edition along with an etching by Kurt Seligmann.[219] Williams was at the height of his involvement with the Surrealists, many of whom had recently migrated to New York to escape the Nazi occupation of France.

Salvador Dali, of course, had visited the United States as early as 1934, and later decorated two windows at Bonwit Teller and designed a pavillon at the New York World's Fair. The Julien Levy Gallery held its first Surrealist exhibition in 1932. Levy was to provide the New York avant-garde with a window to Surrealism during the 1930s. In addition to the exhibitions he regularly mounted, he published an important anthology of Surrealism in 1936. It appeared at the time of the large exhibition entitled "Fantastic Art, Dada, Surrealism" held at the Museum of Modern Art. Little magazines that printed the Surrealists included *This Quarter*, with a special Surrealist number edited by Breton himself in 1932, *transition*, with its polyglot avant-garde roster, a *New Directions* anthology in 1940, and *View*, which was begun in 1940 by Charles Henri Ford, who had previously been editor of *Blues*, for which Williams had been a contributing editor.

Surrealism gradually gained momentum in the United States during the 1930s. But what did it have to do with the American scene? Nothing, thought many on the political left. They vigorously attacked those interested in Surrealism as extreme avant-gardists. The political radicals accused them of being fantasists but even worse escapists incapable of facing social reality and hence allied with the decadent bourgeoisie and wealthy capitalists who wanted to maintain the status quo. "Some of my best friends are surrealists," assured the anarchist Adolf Wolf, "but any flight from life is a retreat, any commerce with mysticism is surrender, and to lie down with obscurantism is to beget confusion."[220] This sort of argument ran through the pages of *The New Masses* and *transition*.

While such an artist as Federico Castellón deployed a Surrealist repertoire of images to good advantage in creating an enigmatic and ominous dreamscape in *The Dark Figure* (1938; Pl. XVI),[221] other artists tried to synthesize Surrealism and American life. One strategy taken by Eugene Jolas in *transition* was to reinterpret existing American art according to his own version of Surrealism, which heavily stressed myth and dream. Thus Joseph Pickett's *Coryell's Ferry, 1776* (probably between 1914-18; Fig. 120) was illustrated as an example of naive art presumably tapping the cultural unconscious. Sheeler's photographs of the Ford plant were taken as examples of "magic realism" and identified as "The Industrial Mythos."[222] With a different emphasis the pages of *Americana* were replete with illustrations and cartoons lampooning the grotesque often at the risk of bad taste for the sake of political and social commentary. "Americana Fantastica" was the logical culmination, a special issue of *View* for January 1943.

The cover for "Americana Fantastica" was made by Joseph Cornell, who also did the cover for the catalogue of the first Surrealist exhibition at the Julien

Levy Gallery. (In 1940 he designed the cover for Charles Henri Ford's *ABC's for the children of no one, who grows up to look like everyone's son* and early in the year he had his first one-man exhibition of "Surrealist Objects" at the Julien Levy Gallery that Williams may have seen.)[223] Cornell has been considered one of the "purest" Surrealists, a recluse of dreams on Utopia Parkway in Queens. Yet from one of his earliest collages of an engraved schooner in full bloom to his enigmatic boxes, Cornell sought an American culture and its detritus from which to elicit the marvelous. Thus an untitled collage of the 1930s shows a view of Manhattan and Brooklyn, the great bridge between them straddled by a Father

Fig. 120. Joseph Pickett, *Coryell's Ferry, 1776*, probably between 1914-18. Oil on canvas, 37½ x 48¼ inches. Whitney Museum of American Art, New York; Gift of Gertrude Vanderbilt Whitney 31.316.

Fig. 121. Joseph Cornell, *Untitled*, c. 1930. Collage, 6⅛ x 8 1/16 inches. The Estate of Joseph Cornell, courtesy of Castelli/Feigen/Corcoran, New York.

Knickerbocker sort of figure floating amidst birds and a hot-air balloon (Fig. 121). Here was the city imaginatively recreated out of the dreams of its history just as Williams conceived his Paterson as a man, a "Mr. Paterson," whose "thought is listed in the Telephone / Directory."[224]

These attempts were predicated on Breton's theorizing that surreality was not simply an "unreal" state relative to what we ordinarily take as reality but rather it was a synthesis of the dream (or variously the marvelous or the unconscious) and our commonsense of reality.[225] Surreality was not merely vaporous fantasy, as the Social Realists misconstrued it. To the contrary, it had a palpable existence on the continuum of human experience. And increasingly in the 1930s American life took on a surreal quality suggesting that the American Dream had become a nightmare. To see experience through a Surrealist lens conformed to the paradox of Surrealism, which blurred its founder's logical definitions, so long as the surreal were not equated with the unreal.

Although Williams came to understand Surrealism full well, he was willing to make the false equation because it suited his purposes to deny Surrealism while seeing the surreal all about him. The strategy of warding off foreign influences informed Williams' afternoon with Pavel Tchelitchew in the summer of 1937 at the Russian painter's studio apartment in midtown Manhattan. Tchelitchew dismissed Surrealism as "a lot of fooling nonsense" while the two were looking at his large unfinished canvas called *Phenomena*. Williams described the work in progress:

> The painting was before us. I looked at it for a long time. Nothing but human monsters of one sort or another . . . .
>
> To the left, the signature, a man with one enormous foot, the back of Diego Rivera it may be, painting the wall of a house. Siamese twins, women with six breasts, acephalic monsters, three-legged children, double-headed monsters, sexual freaks, dwarfs, giants, achondroplastic midgets, mongolian idiots and the starved, bloated, misshapen by idea and social accident — of all the walks of life.

Being able to identify the physiological distortions flattered the poet's doctor's ego, integrating art and medicine for the moment. But Williams had a larger interest in wanting to confirm *Phenomena* as phenomena "actually found in life." And so he was sympathetic to Tchelitchew's desire to establish an identity apart from the Surrealists. "The deeper at moments of penetration is his mastery of their work, the more vigorously at other moments must he fling himself off from them to remain himself a man."[226] So Williams spoke of Tchelitchew in relation to the Surrealists, but he was also speaking of himself.

Williams had gone to see Tchelitchew on the urging of Charles Henri Ford. Earlier in the spring of 1937 Ford had sent a poem entitled "The Garden of Disorder / to Pavel Tchelitchew" to Williams for his reactions. The doctor suggested verbal surgery in the manner of Pound ("cut, cut, cut—explain nothing") and then praised the poem: "It is a desperate beauty, the beauty you see in Tchelitchew. I've only seen one small thing of Tchelitchew, a drawing of a running girl with a big hind foot [an announcement card from the Julien Levy Gallery, Fig. 124]—I can see that you have caught him well in this poem."[227]

At about the same time that Williams visited the Russian emigré in New York he wrote the introduction to a collection of Ford's poems entitled *The Garden of Disorder* with a frontispiece by Tchelitchew. Without mentioning Surrealism Williams withdrew his equation of the surreal with the unreal. But other contrasts and oppositions came to mind, expecially those posited between art and politics: "This sort of

particularly hard, generally dreamlike poetry is inevitable today when the practice of the art tends to be seduced by politics." "Extraordinary word juxtapositions," one of the basic Surrealist techniques employed by Ford, apparently conjured the idea of "foil" and "counterfoil" to Williams: "So this book can be enjoyed immediately beside whatever hard-bitten poet of 'the revolution' it is desired to place it and there fecundate. . . ."[228]

While artists like Louis Guglielmi (Fig. 125), Henry Billings, and Peter Blume (Fig. 126) tried to fashion a proletarian Surrealism, the movement between politics and the surreal was perhaps best negotiated by Philip Evergood. Like Stuart Davis he was active in the Artists' Union and in one instance put his body on the line in a sit-in protesting cutbacks in the W.P.A. Evergood did not confine politics to his personal life by keeping his paintings free from social implications. That strategy was but one sort of foil and counterfoil. Another was to lift such juxta-

Fig. 122. Pavel Tchelitchew, *Study for Phenomena*, c. 1937-38. Oil on canvas, 35 x 45⅝ inches. Collection of Joseph H. Hirshhorn, courtesy of Sotheby Parke Bernet, Inc., New York.

Fig. 123. Pavel Tchelitchew, *Sketch for Phenomena*,
c. 1937-38. Ink on paper, 14 x 20 inches. Collection
of Ruth Ford.

Fig. 124. Pavel Tchelitchew, announcement
card for an exhibition at the Julien Levy Gallery,
New York, in the 1930s. Private collection.

Fig. 125. Louis Guglielmi, *The Various Spring*, 1937.
Oil on canvas, 15¾ x 19¾ inches. Whitney Museum
of American Art, New York; Promised gift of
Flora Whitney Miller 69.78.

Fig. 126. Peter Blume, *Light of the World*, 1932.
Oil on composition board, 18 x 20¼ inches.
Whitney Museum of American Art, New York;
Purchase 33.5.

positions into the art itself. In a sequence from *Horizons*, a sepia and wash of 1936 (Fig. 127), to *Lily and the Sparrows*, an oil of 1939 (Fig. 128), the former presents three children at a tenement window, their mother despairing over a sewing machine in the background. The window is blocked by a fire escape, and clothes on the line further obstruct the view. The claustrophobic space renders the title ironic. The meager horizons of this family were implicitly expanded three years later with *Lily and the Sparrows*. The painting appears to be a complete antithesis of the social reality previously dramatized. Six sparrows frame the beatific Lily as she reaches out from her tenement window to feed them. The child at the open window is surrounded by living creatures in contrast to the caged children who seek replenishment.

Yet *Lily and the Sparrows* is hardly a dream vision. Evergood claimed that the painting was rooted in experience: "I was walking along that section under the old El between 6th Street and West Broadway, in a sort of dream, thinking of something else, and I happened to stop at the curb, just dreaming, and look up, and here was an amazing sight. A little, bald-headed, white beautiful face was in a window with little bits of crumbs — alone." The strength of the painting is derived from that point of the marvelous joining dream and mundane life. *Lily and the Sparrows* looks back to *Horizons* not so much in antithesis finally as in fulfillment of human promise. It lends shape as much as it serves, as Williams said of Ford's poetry, "in active denial of all the unformed intermediate worlds in which we live and from which we suffer bitterly."[229]

Fig. 127. Philip Evergood, *Horizons*, 1936. Sepia and wash on paper, 15½ x 12½ inches. Montclair Art Museum, Montclair, New Jersey; Bequest in the Memory of Moses and Ida Soyer, 1974.

Fig. 128. Philip Evergood, *Lily and the Sparrows*, 1939. Oil on composition board, 30 x 24 inches. Whitney Museum of American Art, New York; Purchase 41.42.

# Epilogue: 137
## "Against the Weather"

138

"The times are too like those of 1913 to suit me. At that time it looked as if we were really building up to a period of major impression. They did not let it occur. As then there are too many now who do not want the artist to speak as only he can." So Williams wrote to Charles Henri Ford in 1938. He looked forward to a movement beyond Surrealism that would build a new American art. But the influx of artists from Europe indicated a threatening political climate. The weather had been bad, it promised to get worse. During the Spanish Civil War in 1937 Williams had joined the Bergen County Medical Board to Aid Spanish Democracy, and in an anthology of *Writers Take Sides* he spoke with characteristic bluntness: "If Italian history could look down on Mussolini today it would vomit!"[230]

The Second World War brought the Depression to a sad end. Americans turned from a domestic to an international scene both in shambles. No one would talk about an American scene again. The provincialism and naive propagandizing were best done with, but the issues that animated poets and painters, photographers, and sculptors went to the heart of their culture and society. Williams would not lose interest in the visual arts nor would he forsake the local: it was after all his universal in so many words.

1. While it has become a commonplace of recent scholarship to point out Williams' interest in the visual arts, there are only a few full-length studies, which have certain limitations. Mike Weaver's study, *William Carlos Williams: The American Background* (Cambridge: Cambridge University Press, 1971) still offers the best general survey of the poet's social and cultural contexts, with a strong consideration of the visual arts, especially Surrealism. In concentrating upon the poet's "background," however, Weaver generally excludes a discussion of Williams' poetry, which is the heart of the matter. Bram Dijkstra's *The Hieroglyphics of a New Speech: Cubism, Stieglitz, and the Early Poetry of William Carlos Williams* (Princeton, N.J.: Princeton University Press, 1969) limits itself mainly to Stieglitz and Cubism, while my own *Skyscraper Primitives: Dada and the American Avant-Garde 1910-1925* (Middletown, Conn.: Wesleyan University Press, 1975) focuses on Williams and Dada in the early 1920s. In his recent biography, *William Carlos Williams: Poet from Jersey* (Boston: Houghton Mifflin, 1975), Reed Whittemore takes but an obligatory bow toward the poet's relationship to the visual arts. What he probably intended as a salutory air of skepticism toward modernism actually comes across as condescending. For an insightful analysis of the biography, see Thomas R. Whitaker's review in *William Carlos Williams Newsletter* II, no. 2 (Fall 1976): 19-21.

2. Sam Hunter has stated the conventional view: "In the twenties a new mood of disenchantment set in, and modernism no longer served as a summons to action" (*Modern American Painting and Sculpture* [New York: Dell Publishing, 1959], p. 78).

3. See Michael Kammen, *People of Paradox* (New York: Alfred A. Knopf, 1974), pp. 91-116. In accordance with Kammen we might call such dislocations of cultural and social phenomena "paradoxes," though more severely and baldly they might be termed contradictions, especially if one views culture not as systemic (even paradoxes have a quality of self-containment) but as "fallout" of competing and conflicting notions about the life of a society — in this instance an American society that had all the semblance of disintegration during the 1930s. In this I follow Victor Turner's citation of Harold Rosenberg, who claims that "the culture of any society at any moment is more like the debris, or 'fall-out,' of past ideological systems, than it is itself a system, a coherent whole" (*Dramas, Fields, and Metaphors: Symbolic Action in Human Society* [Ithaca, N.Y.: Cornell University Press, 1974], p. 14). System, paradox, and fallout may exist along a continuum describing culture.

4. "A Man of Promise," *The New York Evening Post*, 3 July 1920.

5. Letter from Williams to John Riordan, 13 October 1926, ALS, Clifton Waller Barrett Library, University of Virginia, Charlottesville.

6. The concept of liminality has been developed extensively by the anthropologist Victor Turner in his study of aspects of Ndembu ritual in Africa. Strictly speaking, liminality refers to a period of transition during a ritual that moves individuals from one social status, role, or identity to another. Outside of a ritual context, as I should like to use the term, and as Turner himself has used it, liminality has broad reference to those individuals, objects, or situations that are structurally indeterminate, "betwixt and between" social and cultural definitions. As a consequence identity and definition become crucially ambiguous and ambivalent, sometimes to the extent that inversions and negations occur. Phenomena of a liminal quality have thus somehow slipped away from established social and cultural norms. See Victor Turner, "Betwixt and Between: The Liminal Period in *Rites de Passage*," chap. 4, *The Forest of Symbols: Aspects of Ndembu Ritual* (Ithaca, N.Y.: Cornell University Press, 1967), pp. 93-111. Turner tries to apply the concept of liminality to broader contexts in *Dramas, Fields, and Metaphors*.

7. "Questionnaire," *The Little Review* XII, no. 2 (May 1929): 87; letter from Williams to Marianne Moore, 2 June 1932, *The Selected Letters of William Carlos Williams*, ed. with intro. by John C. Thirlwall (New York: McDowell, Obolensky, 1957), p. 124; Williams, *Kora in Hell: Improvisations* (Boston: Four Seas Co., 1920), p. 17; Williams, *The Great American Novel* (Paris: Three Mountains Press, 1923), p. 10. (These last two works were republished in *Imaginations*, ed. Webster Schott [New York: New Directions, 1970].) In one of his first letters to Louis Zukofsky, Williams claimed, "Eyes have always stood first in the poet's equipment" (letter dated 5 July 1928, TL, Beinecke Rare Book and Manuscript Library, Yale University, New Haven, Conn.).

8. The prescription form is catalogued C8b in the Williams Archives at the Lockwood Memorial Library, State University of New York at Buffalo; letter from Williams to Wayne Andrews, 10 March 1932, *Selected Letters*, p. 119.

9. *The Autobiography of William Carlos Williams* (New York: Random House, 1951), pp. 152-53.

10. A general history of art galleries that exhibited modern art has yet to be written even though one is absolutely necessary for a social or economic history of twentieth-century American art. On an individual basis Stieglitz's galleries have been most closely studied, most notably by Dorothy Norman, *Alfred Stieglitz: An American Seer* (New York: Random House, 1973) and William I. Homer, *Alfred Stieglitz and the American Avant-Garde* (Boston: New York Graphic Society, 1977). For an account of Katherine Dreier and the Société Anonyme, see Aline B. Saarinen, *The Proud Possessors* (New York: Random House, 1958). Julien Levy has recently published his *Memoir of an Art Gallery* (New York: G.P.Putnam's Sons, 1977). Accounts of the Whitney Studio Club and the Museum of Modern Art can be found in *The Whitney Studio Club and American Art 1900-1932* (New York: Whitney Museum of American Art, 1975) and Russell Lynes, *Good Old Modern: An Intimate Portrait of the Museum of Modern Art* (New York: Atheneum, 1973).

11. *Autobiography*, p. 52.

12. For an excellent study of Breton as Surrealist leader, see Anna Balakian, *André Breton, Magus of Surrealism* (New York: Oxford University Press, 1971).

13. *Autobiography*, p. 148.

14. For an excellent account of these issues, see Richard Pells, *Radical Visions and American Dreams: Culture and Social Thought in the Depression Years* (New York: Harper and Row, 1973).

15. "Preface," *Selected Essays of William Carlos Williams* (New York: Random House, 1954), p. xiv. The painting of the Passaic River is at Yale University, and the *Self-Portrait* at the University of Pennsylvania.

16. There were seventeen Matisses and eighteen van Goghs, including a *Self-Portrait* (1886) on loan from John Quinn, at the 1913 Armory Show. Walter Pach's article, "The Point of View of 'The Moderns,'" in *The Century Magazine*, April 1914, pp. 851-64, was illustrated with Matisse's *Self-Portrait*. For a complete catalogue of the 1913 Armory Show, see *The Armory Show: International Exhibition of Modern Art, 1913*, vol. 1: Catalogues, intro. by Bernard Karpel (New York: Arno Press, 1972).

17. Emile Zola, from "The Experimental Novel," in Hazard Adams, ed., *Critical Theory Since Plato* (New York: Harcourt Brace Jovanovich, 1971), pp. 647-59.

18. *Autobiography*, p. 357.

19. William Carlos Williams, "Three Professional Studies," *The Little Review* V, nos. 10-11 (February-March 1919): 44; Williams, "Questionnaire," *The Little Review* XII, no. 2 (May 1929): 87.

20. *Autobiography*, p. 51.

21. Quoted in Whittemore, *Williams*, p. 38.

22. Stearns followed *America and the Young Intellectual* (New York: George H. Doran Co., 1921) by editing *Civlization in the United States: An Enquiry by Thirty Americans* (London: Jonathan Cape, 1922).

23. *Autobiography*, p. 137.

24. Letter from Hartley to Stieglitz, 23 October 1920, ALS, Beinecke Library, Yale; Williams, "Forward," to Robert Knoll, *Robert McAlmon: Expatriate Publisher and Writer* (Lincoln: University of Nebraska Press, 1957), p. vii.

25. Letter from Hartley to Stieglitz, 23 October 1920, ALS, Beinecke Library, Yale.

26. Williams praised the little magazine as "one expression. It represents the originality of our generation thoroughly free of an economic burden" ("The Advance Guard Magazine," *Contact*, second series, I, no. 1 [February 1932]: 89-90). The first series of *Contact* appeared in five issues: December 1920, January 1921, Spring 1921, Summer 1921, and June 1923.

27. *Autobiography*, p. 164. Barbara Haskell, Curator at the Whitney Museum of American Art, is currently preparing a retrospective of Hartley, whose only full-length study is Elizabeth McCausland, *Marsden Hartley* (Minneapolis: University of Minnesota Press, 1952).

28. Marsden Hartley, "The Poet of Maine," *The Little Review* VI, no. 3 (July 1919): 53, 54.

29. M.C.A. [Margaret C. Anderson], [Response], *The Little Review* VI, no. 3 (July 1919): 55.

30. William Carlos Williams, "A Maker," *The Little Review* VI, no. 4 (August 1919): 37, 38.

31. Ibid., p. 38.

32. "Further Announcement," *Contact*, no. 1 (December 1920): 10; Robert McAlmon, "Contact and Genius," *Contact*, no. 4 (Summer 1921): 16; William Carlos Williams, "Comment," *Contact*, no. 2 (January 1921): n.p. For an account of the genesis of "contact" out of McAlmon's flight experiences, see Weaver, *Williams*, pp. 31-32.

33. [Manifesto], *Contact*, no. 1 (December 1920): 1; Williams, "Comment," *Contact*, no. 2 (January 1921). n.p.

34. For the two pieces, see Gertrude Stein, "Henri Matisse" and "Pablo Picasso," *Camera Work*, special number (August 1912): 23-25, 29-30.

35. William Carlos Williams, "French Painting (Its Importance, a Definition, and the Influence Upon Modern Writing Traceable to It)," in *The Embodiment of Knowledge*, ed. Ron Loewinsohn (New York: New Directions, 1974), pp. 21-22.

36. Ibid., p. 22.

37. Ibid., p. 25; Williams, "A Matisse," *Contact*, no. 2 (January 1921): n.p.

38. Williams, "A Matisse."

39. Matisse had been unsuccessful in making a clay model of a reclining nude. In frustration he decided to paint the figure, adding some palm leaves to the scene in remembrance of his stay in Algeria the year before, hence the full title, *The Blue Nude — Memory of Biskra* (see Alfred H. Barr, Jr., *Matisse: His Art and His Public* [New York: Museum of Modern Art, 1951], p. 94).

40. Williams, "A Matisse"; Williams, "French Painting," p. 24. Williams, I believe, got the idea of an "American tree" from Marin. Although I have not found such a statement among Marin's writings, Paul Strand made the following reference: "When [Marin] says that an American tree is different absolutely from a European tree (which is deeply true), he means that it is the former and the difference in which he is concentratedly interested. That kind of American consciousness infuses all his work, marks an authentic acceptance and confrontation" ("Marin Not an Escapist," *The New Republic*, 25 July 1928, p. 254).

41. Williams, "A Matisse."

42. William Carlos Williams, "Rutherford and Me," unpublished fragment, Beinecke Library, Yale; letter from Hartley to Stieglitz, 9 October 1923, ALS, Beinecke Library, Yale.

43. Marsden Hartley, "The Red Man," *Adventures in the Arts* (1921; reprinted New York: Hacker Art Books, 1972), p. 27.

44. Quoted in Arnold Ronnebeck, "Hartley Gives Talk on the Original Research of Cézanne," *Rocky Mountain News*, 25 March 1928, p. 4.

45. Marsden Hartley, "Tribal Esthetics," *The Dial*, 16 November 1918, p. 6.

46. Quoted in Ronnebeck, "Hartley Gives Talk on the Original Research of Cézanne," p.4; Marsden Hartley, "Dissertation on Modern Painting," *The Nation*, 9 February 1921, p. 235.

47. William Carlos Williams, "Beginnings: Marsden Hartley," in "Two Pieces," *The Black Mountain Review* VII (Autumn 1957): 166.

48. I heard about "Marsden's breasts" from Williams' son Bill, but apparently Williams did not originate the sexual metaphor. Hartley himself referred to the "breasts" of Taos Mountain in a letter to Stieglitz, 20 June 1918, ALS, Beinecke Library, Yale.

49. William Carlos Williams, "Marsden Hartley," ms. for "Beginnings: Marsden Hartley," Beinecke Library, Yale, pp. 2-3.

50. Letter from Williams to Stieglitz, 27 June 1937, TLS, Beinecke Library, Yale. The Hartley exhibition was held at An American Place from 20 April to 17 May 1937.

51. Ibid.

52. For a later statement on art, see Marsden Hartley, "Art—and the Personal Life," *Creative Art* II, no. 6 (June 1928): xxxi-xxxiv.

53. Marsden Hartley, "Rex Slinkard: Ranchman and Poet-Painter," *Memorial Exhibition: Rex Slinkard, 1887-1918* (San Francisco: San Francisco Art Association, 1919), n.p. The essay was reprinted in Hartley, *Adventures in the Arts,* pp. 87-95. For an account of Slinkard's life and career, see John Alan Walker, "Rex Slinkard (1887-1918) Pioneer Los Angeles Modernist Painter," *Journal* (Los Angeles Institute of Contemporary Art), no. 3 (December 1974): 20-23.

54. Marsden Hartley, "The Business of Poetry," *Poetry* XV, no. 3 (December 1919): 158; Rex Slinkard, "Extract from Letters," *Contact*, no. 2 (January 1921): 3. Slinkard's letters also appeared under "Letters of Rex Slinkard," *Contact*, no. 1 (December 1920): 2-4; "Rex Slinkard's Letters." *Contact*, no. 3 (Spring 1921): 1-8.

55. William Carlos Williams, "Yours, O Youth," *Contact*, no. 3 (Spring 1921): 15.

56. See Jacques Maquet, *Introduction to Aesthetic Anthropology* (Reading, Mass.: Addison-Wesley Module, 1971), p.6.

57. William Carlos Williams, "Notes from a Talk on Poetry," *Poetry* XIV, no. 4 (July 1919): 215.

58. William Carlos Williams, "Glorious Weather," *Contact*, no. 5 (June 1923): n.p.; Williams, *Spring and All*, 1923, included in *Imaginations*, p. 111; letter from Hartley to Stieglitz, 9 October 1923, ALS, Beinecke Library, Yale.

59. The scholarship, memoirs, and other writings on Dada and individual Dadaists are too numerous to cite here. Some basic texts are Robert Motherwell, ed., *The Dada Painters and Poets* (New York: George Wittenborn, 1967); Hans Richter, *Dada: Art and Anti-Art* (New York: McGraw-Hill, 1965); Michel Sanouillet, *Dada à Paris* (Paris: Jean-Jacques Pauvert, 1965).

60. *Autobiography*, p. 134. The basic account of the 1913 Armory Show is Milton H. Brown, *The Story of the Armory Show* (New York: Joseph Hirshhorn Foundation, 1963). For an extensive account of New York Dada, see Tashjian, *Skyscraper Primitives;* William Agee, "New York Dada, 1910-30," in *Avant-Garde Art,* ed. Thomas B. Hess and John Ashbery (New York: Collier Books, 1968), pp. 125-54; Arturo Schwarz, *New York Dada: Duchamp, Man Ray, Picabia* (Munich: Prestel-Verlag, 1973). For studies of Duchamp and Picabia, see Arturo Schwarz, *The Complete Works of Marcel Duchamp* (New York: Harry N. Abrams, 1969); Anne D'Harnoncourt and Kynaston McShine, eds., *Marcel Duchamp* (New York: Museum of Modern Art, 1973); William A. Camfield, *Francis Picabia* (New York: Solomon R. Guggenheim Museum, 1970).

61. McAlmon has said, "Bill was intent on meeting young French writers, the Dadaists, Tristan Tzara, and the Surrealists, to get to the root of what they were driving at.... They were frequently likable and bright and good conversationalists, but Bill would have it that they were profound and moved by significant impetus" (*Being Geniuses Together: 1920-1930*, rev. and with supplementary chaps. by Kay Boyle [Garden City, N.Y.: Doubleday, 1968], p. 186).

62. William Carlos Williams, "America, Whitman, and the Art of Poetry," *The Poetry Journal* VIII, no. 1 (November 1917): 27, 31.

63. In one interview soon after landing in New York, Duchamp praised the city as "a complete work of art" ("A Complete Reversal of Art Opinions by Marcel Duchamp, Iconoclast," *Arts and Decoration* V [September 1915]: 427-28).

64. Matthew Josephson, "A Note on Philippe Soupault," in Philippe Soupault, *Last Nights of Paris*, tr. William Carlos Williams (New York: Macaulay Co., 1929), pp. 7, 10-11.

65. William Carlos Williams, "Paterson," *The Dial* LXXXII, no. 2 (February 1927): 91-93. The poem also appears in *The Collected Earlier Poems of William Carlos Williams* (Norfolk, Conn.: New Directions, 1951), pp. 233-35.

66. Williams, "Between Walls," *Collected Earlier Poems*, p. 343.

67. Stella's *Brooklyn Bridge* (c. 1919) was illustrated in the first issue of *Broom* (November 1921); his lecture "On Painting," delivered at the Société Anonyme, was printed in the second issue of *Broom* (December 1921): 119-23; see, too, Stella, "Brooklyn Bridge, Text and Painting," *transition*, nos. 16-17 (June 1929): 86-89. For the "Stella Number" of *The Little Review* IX (Autumn 1922), with sixteen reproductions of Stella's work, Williams sent a letter praising the magazine: "I speak of the *Little Review*, you see, as if it were an object, as if it were a piece of sculpture" ("Reader Critic," p. 60). The most complete study of Stella is Irma B. Jaffe, *Joseph Stella* (Cambridge, Mass.: Harvard University Press, 1970).

68. William Carlos Williams, *I Wanted to Write a Poem: The Autobiography of the Works of a Poet*, reported and ed. by Edith Heal (Boston: Beacon Press, 1958), p. 52. According to Wallace Stevens, "To a man with a sentimental side the anti-poetic is that truth, that reality to which all of us are forever fleeing" ("Preface," *Collected Poems, 1921-1931* [New York: Objectivist Press, 1934], p. 2).

69. Williams, *Great American Novel*, p. 26.

70. Williams, *I Wanted to Write a Poem*, pp. 28-29.

71. Ibid., p. 29; letter from Stuart Davis to Williams, 18 September 1920, ALS, Lockwood Memorial Library, SUNY Buffalo. Demuth's acquaintance with Davis in Provincetown at this time may have forged another link to Williams. See Emily Farnham, *Charles Demuth: Behind a Laughing Mask* (Norman: University of Oklahoma Press, 1971), p. 75. Hartley was perhaps another connection. Writing from Gloucester to Stieglitz, he claimed, "Stuart Davis is closing some nice work here and bids fair to become the new serious American painter" (21 October 1920, ALS, Beinecke Library, Yale).

72. "Perpetuum Mobile: The City," *Collected Earlier Poems*, pp. 384-90.

73. Williams, *I Wanted to Write a Poem*, p. 36; "The Pot of Flowers" (untitled, designated II), in *Spring and All* in *Imaginations*, p. 96. The poem also appears in *Collected Earlier Poems*, p. 242.

74. *Autobiography*, p. 49.

75. Letters from Demuth to Stieglitz, 31 August 1921, and 10 October 1921, ALS, Beinecke Library, Yale.

76. Letter from Demuth to Williams, 13 October 1921, ALS, Lockwood Memorial Library, SUNY Buffalo. The book Demuth alluded to is either Marcel Sembat, *Matisse et son oeuvre* (Paris: NRF, 1920) or Elie Faure, *Henre Matisse* (Paris: Cahiers d'aujourd' hui, 1920).

77. Letter from Demuth to Williams, 13 October 1921, ALS, Lockwood Memorial Library, SUNY Buffalo; letters from Demuth to Stieglitz, 15 August 1927, 10 October 1921, and 28 November 1921, ALS, Beinecke Library, Yale.

78. For an analysis of Demuth's paintings of Lancaster, see S. Lane Faison, "Fact and Art in Charles Demuth," *Magazine of Art* XLIII, no. 4 (April 1950): 122-28.

79. William Carlos Williams, "Postscript by a Poet," *Art in America* XLII, no. 3 (October 1954): 215.

80. Hartley, "The Poet of Maine," p. 54.

81. Quoted in *Marchand du sel: Ecrits de Marcel Duchamp*, ed. Michel Sanouillet (Paris: Le Terrain Vague, 1958), p. 111.

82. Four of Demuth's illustrations accompanied Edna Kenton, "Henry James to the Ruminant Reader: The Turn of the Screw," *The Arts* VI, no. 5 (November 1924): 245-55. Three issues earlier, Williams' poem "It Is a Living Coral" had appeared (*The Arts* VI, no. 2 [August 1924]: 91-92).

83. Charles Demuth, "Across a Greco Is Written," *Creative Art* V, no. 3 (September 1929): 629-34.

84. Ibid., p. 634.

85. Williams, "Forward" to Knoll, *Robert McAlmon*, p. ix.

86. William Carlos Williams, "McAlmon," ms. c. 1924, B87b, Lockwood Memorial Library, SUNY Buffalo. Williams owned a copy of *George Grosz* (intro. by Hi Simon [Chicago: Musterbookhouse, 1921]), which had twelve illustrations.

87. Robert McAlmon, "Distinguished Air," in *There Was a Rustle of Silk Stockings* (New York: Belmont Books, 1963), p. 12. The original publication was *Distinguished Air* (Paris: Contact Editions, 1925) in which the title story appeared.

88. Henry McBride, "Charles Demuth Memorial Show," *New York Sun*, 18 December 1937; Charles Demuth, "A Foreword: Peggy Bacon," *Peggy Bacon Exhibition* (New York: The Intimate Gallery, 27 March -17 April 1928), p. [2].

89. *Autobiography*, p. 172. "The Great Figure" originally appeared in *Sour Grapes* (Boston: The Four Seas, 1921), p. 78; republished in *Collected Earlier Poems*, p. 230. "The Great Figure" and Demuth's painting of it have been commented upon several times, most recently by James Breslin, "William Carlos Williams and Charles Demuth: Cross-Fertilization in the Arts," *Journal of Modern Literature* VI, no. 2 (April 1977): 248-63.

90. Williams, *Selected Letters*, pp. 97-98.

91. Ibid., p. 107. "The Crimson Cyclamen" originally appeared in Williams, *Adam & Eve & The City* (Peru, Vt.: Alcestis Press, 1936); republished in *Collected Earlier Poems*, pp. 397-404. Marsden Hartley's "Farewell, Charles" appeared in *The New American Caravan* (New York: W.W. Norton, 1936), pp. 552-62.

92. Matthew Josephson, *Life Among the Surrealists* (New York: Holt, Rinehart and Winston, 1962), pp. 253-54, 248.

93. Williams, "A Maker," p. 38.

94. See Paul Strand, "Photography and the New God," *Broom* III (November 1922): 252-58.

95. *Autobiography*, p. 164. Sheeler's photograph of the Baroness's *Portrait of Duchamp* appeared in *The Little Review* IX (Winter 1922), opposite p. 40. Sheeler's views on Duchamp appear in his *Papers* (Archives of American Art, Film NSH-1), frames 72, 79.

96. *Autobiography*, p. 199; Man Ray, *Self Portrait* (Boston: Atlantic, Little, Brown, 1963), p. 188.

97. William Carlos Williams, "Lines on Receiving The Dial's Award," *The Dial* LXXXII, no. 3 (March 1927): 211-12. The poem also appeared partially revised in *Collected Earlier Poems*, p. 350.

98. Letter from Hartley to Alfred Stieglitz, c. Spring 1918, ALS, Beinecke Library, Yale.

99. Henry McBride, "Asceticism Pays," undocumented clipping in the *Sheeler Papers*, frame 381.

100. *Sheeler Papers*, frames 105-106.

101. William Carlos Williams, "Introduction," *Charles Sheeler: Paintings, Drawings, Photographs* (New York: Museum of Modern Art, 1939), p. 6.

102. Letter from Williams to Constance Rourke, 10 January 1938, copy at Yale University. Quoted in Weaver, *Williams*, pp. 62-63.

103. *Sheeler Papers*, frame 125.

104. For an account of Objectivism, see Weaver, *Williams*, pp. 53-55. The most complete account of Precisionism can be found in Martin L. Friedman, *The Precisionist View in American Art* (Minneapolis: Walker Art Center, 1960).

105. *The Imagist Poem: Modern Poetry in Miniature*, ed. with intro. by William Pratt (New York: E.P. Dutton, 1963), p. 18; *Autobiography*, p. 265.

106. Louis Zukofsky, "Comments," *Poetry* XXXVII, no. 5 (February 1931): 268.

107. *Sheeler Papers*, frame 92.

108. Ibid., frame 101.

109. William Carlos Williams, "Classic Scene," *The New Republic*, 12 May 1937, p. 10. The poem is also in *Collected Earlier Poems*, p. 407.

110. Henry Adams, *The Education of Henry Adams* (Boston: Houghton Mifflin, 1918), p. 381.

111. Williams read Zukofsky's manuscript on Henry Adams in 1928 before it was serialized as "Henry Adams, A Criticism In Autobiography" in *Hound and Horn* III, no. 3 (April-June 1930): 333-57; III, no. 4 (July-September 1930): 518-30; IV, no. 1 (October-December 1930): 46-72. Williams also read Zukofsky's appended "Beginning Again with William Carlos Williams," *Hound and Horn* IV, no. 2 (January-March 1931): 261-64. For the appropriate correspondence, see Williams to Zukofsky, 12 July 1928, 30 August 1928, 20 September 1929, 28 February 1930, Humanities Research Center, University of Texas at Austin.

112. *Sheeler Papers*, frame 102.

113. Lincoln Kirstein, "Mural Painting," in *Murals by American Painters and Photographers* (New York: Museum of Modern Art, 1932), pp. 9-10. For an account of the affair from a radical point of view, see Hugo Gellert, "We Capture the Walls," *The New Masses* VII, no. 12 (June 1932): 29. Although Russell Lynes claims that the encounter was murky (*Good Old Modern*, pp. 98-101), it is clear that the radical artists who were found objectionable caricatured wealthy individuals who were museum patrons. Further, the Museum of Modern Art backed down when public pressure or the threat of it was applied.

114. Letter from Williams to John Riordan, 26 January 1926, TLS, Clifton Waller Barrett Library, University of Virginia.

115. Louis Lozowick, "What Should Revolutionary Artists Do?" *The New Masses* VI, no. 7 (December 1930): 21; Lozowick, "Art in the Service of the Proletariat," *Literature of the World Revolution*, no. 4 (1931): 127.

116. For a complete listing of exhibitions at Stieglitz's galleries, see Norman, *Alfred Stieglitz,* pp. 232-38.

117. William Carlos Williams, "What of Alfred Stieglitz?" unpublished manuscript, c. 1946, Beinecke Library, Yale, p. 2.

118. Letter from Stieglitz to Hartley, 27 October 1923, ALS, Beinecke Library, Yale.

119. The two untitled and since uncollected poems ("Picture showing" and "My luv") appeared in *Manuscripts,* no. 1 (February 1922): 15.

120. Letter from Stieglitz to Williams, 24 November 1929, ALS, Lockwood Memorial Library, SUNY Buffalo. "The Somnambulists" appeared in *transition,* no. 18 (November 1929): 147-51.

121. Letter from Williams to Stieglitz, 27 June 1937, TLS, Beinecke Library, Yale. Williams finally wrote "Against the Weather: A Study of the Artist," *Twice a Year,* no. 2 (Spring-Summer 1939): 53-78, and "Raquel Hélène Rose," *Twice a Year,* nos. 5-6 (Fall-Winter 1940 – Spring-Summer 1941): 402-12.

122. Paul Rosenfeld, *Port of New York* (1924; reprinted Urbana: University of Illinois Press, 1961), pp. 242, 103. In fairness to Rosenfeld, Susan Sontag has highly praised his essay on Stieglitz in her study *On Photography* (New York: Farrar, Straus and Giroux, 1977), p. 118.

123. Williams, "What of Alfred Stieglitz?," pp. 4-5.

124. *Autobiography*, p. 236.

125. Letter from Stieglitz to Williams, 24 November 1929, ALS, Lockwood Memorial Library, SUNY Buffalo; letter from Williams to Stieglitz, 27 November 1929, TLS, Beinecke Library, Yale.

126. William Carlos Williams, "Appreciation," *John Marin Memorial Exhibition* (Los Angeles: Art Galleries, University of California, 1955), n.p.

127. Stieglitz sent Williams a copy of the Marin letters, and the poet wrote back asking for a second copy (15 December 1931, ALS, Beinecke Library, Yale). For a reprint of the letters, which were first privately printed in New York in 1931, see *Letters of John Marin,* ed. with intro. by Herbert J. Seligmann (Westport, Conn.: Greenwood Press, 1970).

128. Quoted in Barbara Haskell, *Arthur Dove* (San Francisco: San Francisco Museum of Art, 1974), p. 77.

129. Quoted in Norman, *Alfred Stieglitz,* p. 161.

130. Charles Demuth, "Introduction," *Georgia O'Keeffe Paintings, 1926* (New York: The Intimate Gallery, 11 January–27 February 1927).

131. Georgia O'Keeffe, *Georgia O'Keeffe* (New York: Viking Press, 1976), n.p.

132. See Williams, "Young Love," *Collected Earlier Poems,* pp. 253-55. The poem originally appeared in *Spring and All.*

133. Quoted in Weaver, *Williams,* p. 62.

134. William Carlos Williams, "The American Background," *America and Alfred Stieglitz,* ed. Waldo Frank, Lewis Mumford, Dorothy Norman, Paul Rosenfeld, and Harold Rugg (New York: The Literary Guild, 1934), pp. 29, 32.

135. Letter from Williams to Louis Zukofsky, 17 February 1932, TLS, Beinecke Library, Yale.

136. Quoted in Norman, *Stieglitz,* p. 76.

137. Quoted from Lozowick's unpublished autobiography in Cynthia Jaffee McCabe, *The Golden Door: Artist-Immigrants of America, 1876-1976* (Washington, D.C.: Smithsonian Institution Press, 1976), p. 22; letter from Williams to Fred Miller, 15 July 1943, TLS, Clifton Waller Barrett Library, University of Virgina; see Letter III, "What Is An American," J. Hector St. John Crèvecoeur, *Letters from an American Farmer* (Garden City, N.Y.: Dolphin Books, n.d.), pp. 45-91.

138. For a fascinating history and contemporary account of Paterson, see Christopher Norwood, *About Paterson: The Making and Unmaking of an American City* (New York: Saturday Review Press, 1974). For an account of labor strife in Paterson and Passaic, see Morris Schonback, *Radicals and Visionaries: A History of Dissent in New Jersey* (Princeton, N.J.: D. Van Nostrand, 1964).

139. Thus in a letter to Ezra Pound, who became a notorious anti-Semite living to regret and recant such attitudes, Williams wrote in complaint about his many projects: "God what a fool. I am sick with work as it is but I suppose the Jew in me likes punishment" (25 June 1928, *Selected Letters,* p. 101). At other times, but especially after the Second World War, when the consequences of anti-Semitism became sickeningly clear, Williams took a more affirmative view of his own Jewish background.

140. Letter from Hartley to Stieglitz, 9 October 1923, ALS, Beinecke Library, Yale. See, too, Eugene Jolas' biographical sketch of Williams in his edited *Anthologie de la Nouvelle Poésie Américaine* (Paris: Kra, 1928), p. 249.

141. Royal Cortissoz, "Ellis Island Art," *American Artists* (New York: Charles Scribner's Sons, 1923), pp. 17-22; Thomas Craven, *Modern Art* (New York: Simon and Schuster, 1934), p. 312.

142. Craven, *Modern Art,* pp. 39-41.

143. Williams, "What of Alfred Stieglitz?" pp. 4-5.

144. Stephen Kayser, Preface, *Haggadah for Passover,* copied and illustrated by Ben Shahn, tr. with intro. by Cecil Roth (Boston: Little, Brown, 1965), p. vii. For a survey of Jewish artists in America, see Alfred Werner, "Ghetto Graduates," *The American Art Journal* V, no. 2 (November 1973): 71-82; for a discussion of whether or not there is a Jewish art, see Harold Rosenberg, "Is There a Jewish Art?" *Commentary* XLII, no. 1 (July 1966): 57-60; for a fascinating account of Shahn's life, see Selden Rodman, *Portrait of the Artist as an American: Ben Shahn: A Biography with Pictures* (New York: Harper, 1951).

145. Quoted in James Thrall Soby, *Ben Shahn: Paintings* (New York: George Braziller, 1963), p. 11; William Carlos Williams, "Impromptu: The Suckers," *Collected Earlier Poems,* pp. 315-16. It is difficult to imagine that Williams did not know of Shahn until the 1950s when the two men finally met. Shahn did him a version of *Paterson* (1950), which Williams admired, and there is a portrait of the poet illustrated in Bernarda Bryson Shahn, *Ben Shahn* (New York: Harry N. Abrams, 1972), p. 338. In 1955 Williams interceded for Edward Dahlberg persuading the artist to illustrate the novelist's *The Sorrows of Priapus* (New York: New Directions, 1957). (For their correspondence see the Ben Shahn Papers at the Archives of American Art.) Back in the early 1930s, however, Shahn was making himself known in New York. The Sacco-Vanzetti series was reviewed by Williams' friend Matthew Josephson, "The Passion of Sacco-Vanzetti," *The New Republic,* 20 April 1932, p. 75. The exhibition was held at the Downtown Gallery, 5-17 April 1932, at the time when Sheeler was establishing himself there. Diego Rivera asked Shahn to be his assistant on the mural project at Rockefeller Center which gained notoriety when it was removed. In 1933 Shahn did another series of paintings on Tom Mooney, a labor leader who was dubiously convicted of a bombing in San Francisco. An illustration appeared with Jean Charlot, "Ben Shahn," *Hound and Horn* VI, no. 4 (July-September 1933): 632-34.

146. For a succinct discussion of Gorky's Armenian heritage, see *Arshile Gorky: Drawings to Paintings* (Austin: University of Texas, 1975).

147. William Carlos Williams, *Yes, Mrs. Williams* (New York: McDowell, Obolensky, 1959), p. 94.

148. Williams, "The Wanderer," *Collected Earlier Poems,* pp. 11-12.

149. Quoted by Williams in *Kora in Hell,* p. 13.

150. For a brief account of the increasing attention paid to American folk art in the twentieth century, see Jean Lipman and Alice Winchester, *The Flowering of American Folk Art* (New York: Viking Press in cooperation with the Whitney Museum of American Art, 1974), pp. 8-14.

151. "Notes on the Exhibitions," *The Arts* V, no. 3 (March 1924): 161. The matter of an industrial folk art was broached by Williams' friend Matthew Josephson in "Apollinaire: Or Let Us Be Troubadours," *Secession,* no. 1 (Spring 1922): 9-11. For an account of the issues involved, see Tashjian, *Skyscraper Primitives,* pp. 116-42.

152. Williams, *Kora in Hell,* pp. 11-12.

153. William Carlos Williams, "Painting in the American Grain," *Art News* LIII, no. 4 (July-August 1954): 20-23, 62, 78. Subsequent references will be taken from the *Selected Essays.*

154. William Carlos Williams, *In the American Grain* (New York: Albert and Charles Boni, 1925), front matter.

155. Williams, "Painting in the American Grain," *Selected Essays*, pp. 329-30, 336.

156. Ibid., p. 329.

157. Ibid., pp. 330, 333, 334.

158. The caption for the illustration of *Bowl of Fruit with Plates* accompanying Williams' essay in *Art News* erroneously identifies the painting as a "Shaker still life," which is unlike the graphics the Shakers actually did, and identifies further the depicted table's "simulated wood graining," which is also unlikely in Shaker furniture. The drawers appear to have metal pulls as well—another discrepancy that suggests the table was not Shaker. Williams was probably attracted to the plain lines of the table's structure.

159. According to Williams, Sheeler "is the watcher and surveyor of that world where the past is always occurring contemporaneously and the present always dead needing a miracle of resuscitation to revive it" ("Introduction," *Sheeler*, pp. 6-7). For all that Williams railed at Eliot, the gist of Williams' idea can be found in T.S. Eliot, "Tradition and the Individual Talent," *Selected Essays* (New York: Harcourt, Brace and Co., 1950), pp. 3-11.

160. *Autobiography*, pp. 332-34.

161. Marius De Zayas, Preface to Charles Sheeler, *African Negro Sculpture* (New York: privately printed, 1918), n.p. For an account of Sheeler's association with De Zayas, see Charles W. Millard, III, *Charles Sheeler: American Photographer*, published as entire issue of *Contemporary Photographer* VI, no. 1 (1967), n.p.

162. Marius De Zayas, "Photography," *Camera Work*, no. 42 (January 1913): 17. For a detailed account of De Zayas' ideas on photography and modern art, see Tashjian, *Skyscraper Primitives*, pp. 23-28.

163. Alain Locke, "A Collection of Congo Art," *The Arts* XI, no. 2 (February 1927): 70.

164. For the most recent history of black American art, see David C. Driskell, *Two Centuries of Black American Art* (New York: Los Angeles County Museum of Art and Alfred A. Knopf, 1976).

165. See Alain Locke, ed., *The New Negro* (New York: Albert and Charles Boni, 1925). In 1923 De Zayas wrote an essay on African sculpture entitled "Negro Art," *The Arts* III, no. 3 (March 1923): 199-205. Illustrated with photographs by Sheeler, the article was probably occasioned by an exhibition of African art at the Brooklyn Museum. The organizer of the exhibition, Stewart Culin, subsequently wrote an essay entitled "Negro Art" for *The Arts* III, no. 5 (May 1923): 347-50.

166. Locke, "A Collection of Congo Art," p. 61.

167. The most blatant racist statements can be found in Marius De Zayas, *African Negro Art: Its Influence on Modern Art* (New York: Modern Gallery, 1916).

168. Quoted in Edmund L. Fuller, *Visions in Stone: The Sculpture of William Edmondson* (Pittsburgh: University of Pittsburgh Press, 1973), p. 3.

169. In 1932 Sheeler wrote the foreward to Merle Armitage, *The Art of Edward Weston* (New York: E. Weyhe, 1932). For an account of their relationship, see Millard, *Sheeler: American Photographer*, n.p.

170. Robert F. Thompson, *African Art in Motion* (Berkeley: University of California Press, 1974), pp. 5-29.

171. See Isamu Noguchi, *A Sculptor's World* (New York: Harper & Row, 1968), pp. 16-17, 22-23.

172. Stephen Alexander, "Art," *The New Masses* IV, no. 12 (March 1935): 29.

173. For an account of Johnson's life and art, see Adelyn Breeskin, *William H. Johnson: 1901-1970* (Washington, D.C.: Smithsonian Institution Press, 1971).

174. *Autobiography*, p. 202. For a collection of views of Nancy Cunard, see *Nancy Cunard: Brave Poet, Indomitable Rebel, 1896-1965*, ed. Hugh Ford (Philadelphia: Chilton Book Company, 1968). For an account of her press, see Hugh Ford, *Published in Paris: American and British Writers, Printers, and Publishers in Paris, 1920-1939* (New York: Macmillan, 1975), pp. 253-89.

175. *The Negro Anthology*, ed. Nancy Cunard (London: Published by Nancy Cunard at Wishart and Co., 1934), pp. 93-96. Williams' part in making the anthology is told by Hugh Ford, "Introduction," *Negro: An Anthology*, ed. by Nancy Cunard and ed. and abridged by Hugh Ford (New York: Frederick Ungar, 1970), p. xviii.

176. *Black Man and White Ladyship, An Anniversary* (London: Utopia Press, 1931) along with two issues of *The Negro Worker* (III, nos. 4-5 [April-May 1933], and IV, nos. 8-9 [August-September 1933]) were in Williams' library and have been deposited in the Beinecke Library, Yale.

177. William Carlos Williams, "A Tentative Statement," *The Little Review* XII, no. 2 (May 1929): 98.

178. Letter from Williams to Zukofsky, 10 February 1933, TLS, Humanities Research Center, University of Texas.

179. William Carlos Williams, "A Note on the Art of Poetry," *Blues* I, no. 4 (May 1929): 78; Williams, "Good . . . For What?" *The Dial* LXXXVI, no. 3 (March 1929): 250. "The Five Dollar Guy" appeared in *The New Masses* I, no. 1 (May 1926): 19, 29. Whittemore gives a brief account of the libel suit in *Williams*, pp. 206-07.

180. William Carlos Williams, "A Man Versus the Law," *The Freeman* I, no. 15 (June 1920): 349. The poem first appeared in *An Early Martyr and Other Poems* (New York: Alcestis Press, 1935), since reprinted in *Collected Earlier Poems*, pp. 85-86.

181. William Carlos Williams, [Letter to the Editor], *The New Masses* VI, no. 7 (December 1930): 22.

182. See Diego Rivera, "Mickey Mouse and American Art," *Contact*, second series I, no. 1 (February 1932): 37-39.

183. *Autobiography*, p. 299.

184. In a brief review of *Credit Power and Democracy* by C. H. Douglas and A. R. Orage, Pound concluded with a parenthetical statement: "Don't imagine that I think economics interesting — not as Botticelli or Picasso is interesting. But at present they, as the reality under political camouflage, are interesting as a gun muzzle aimed at one's own head is 'interesting,' when one can hardly see the face of the gun holder and is wholly uncertain as to his temperament and intentions.)" ([Untitled], *Contact*, no. 4 [Summer 1921]: n.p.).

185. William Carlos Williams, [Contribution to "What is Americanism? A Symposium on Marxism and the American Tradition"], *Partisan Review and Anvil* III, no. 3 (April 1936): 13. The best account of Williams' politics can be found in Weaver, *Williams*, pp. 89-114.

186. Haakon M. Chevalier, "Worker Find Your Poet," *Dynamo* I, no. 1 (January 1934): 1-3; Norman Macleod, "Oil!" *Nativity*, no. 2 (Spring 1931): 32-34; William Carlos Williams, [Three versions of "Final Paragraphs"], manuscript C8a, Lockwood Memorial Library, SUNY Buffalo.

187. *Collected Earlier Poems*, pp. 315-17; Williams, [Editorial Statement for *Blast*], unpublished manuscript C54, Lockwood Memorial Library, SUNY Buffalo.

188. William Carlos Williams, "1928: a Musty Old Democratic Party Poem on the Campaign before last," unpublished manuscript A76, Lockwood Memorial Library, SUNY Buffalo.

189. Williams, [Editorial Statement for *Blast*], unpublished manuscript C54, Lockwood Memorial Library, SUNY Buffalo.

190. See, for example, Horace Gregory's criticism of Objectivism from a left point of view in "Correspondence," *Poetry* XXXVIII, no. 1 (April 1931): 51-58.

191. Williams, *I Wanted to Write a Poem*, p. 59. The pamphlet was entitled *William Zorach: Two Drawings. William Carlos Williams: Two Poems* (Stovepipe Press, 1937). "Advent of To-day" is in *Collected Earlier Poems*, p. 411; "The Girl" in *The Collected Later Poems of William Carlos Williams* (Norfolk, Conn.: New Directions, 1950), p. 123.

192. For an account of Zorach's life, see William Zorach, *Art Is My Life: The Autobiography of William Zorach* (Cleveland: World Publishing Co., 1967). Williams and Zorach also shared an admiration for the sculptor Brancusi. Zorach wrote an essay on Brancusi in the mid-1920s ("The Sculpture of Constantin Brancusi," *Arts* IX, no. 3 [March 1926]: 143-49) and Williams, who visited Brancusi's studio in Paris in 1924, wrote an appreciation of the sculptor on the occasion of a retrospective exhibition at the Guggenheim Museum in 1955 ("Brancusi," *Arts* XXX, no. 2 [November 1955]: 21-25).

193. William Carlos Williams, "The So-Called So-Called," *The Patroon* I, no. 1 (May 1937): 37, 39. "Proletarian Portrait" appeared in *Direction* I, no. 3 (April-June 1935): 145, along with "Aphorisms for Revolutionary Artists" by C. Day Lewis and "Clinical Prescription" by Ruth Lechlitner (p. 144). The poem was initially titled "Study for a Figure Representing Modern Culture" and first appeared in *Galaxy: An Anthology*, comp. by Beatrix Reynolds and James Gabelle (Ridgewood, N.J.: Gayren Press, 1934), p. 98.

194. Letter from Williams to Zukofsky, April 1935, TLS, Humanities Research Center, University of Texas.

195. Raphael Soyer, *Raphael Soyer* (New York: American Artists Group, 1946), p. 4.

196. Williams did not collaborate with Isabel Bishop until 1955 when *Art News Annual* decided to publish a portfolio of "Poets and Pictures." Seven poets were asked to write or present poems for the occasion. Artists were then chosen to embellish upon a particular poem. Williams contributed "The King," which was accompanied by a sketch by Isabel Bishop (*Art News Annual* XXIV [December 1955]: 82-83).

197. Alfred Stieglitz, "Bill Heywood at 291," *Twice a Year*, nos. 5-6 (Fall-Winter 1940 – Spring-Summer 1941): 136-37.

198. Ibid., p. 137.

199. See Stieglitz's letter to Hugo Gellert, 28 October 1934, TLS, and his letter to Waldo Frank, 6 July 1935, TLS, Beinecke Library, Yale.

200. Charles Demuth, "Questionnaire," *The Little Review* XII, no. 2 (May 1929): 30.

201. Marsden Hartley, "George Grosz at An American Place," *George Grosz: Exhibition of Water Colors (1933-1934)*, 17 March-14 April 1935, An American Place, p. 5. For Grosz's cartoon, "Proven Proverbs," see *Americana* I, no. 10 (August 1933): 31.

202. The two series of *The American Scene* with six lithographs each were published by the Contemporary Print Group, New York.

203. Thomas Hart Benton, "America and / or Alfred Stieglitz," *Common Sense* IV (January 1935): 22-25; reprinted in *A Thomas Hart Benton Miscellany: Selections from His Published Opinions, 1916-1960*, ed. Matthew Baigell (Lawrence: University Press of Kansas, 1971), pp. 65-74.

204. Letter from Stieglitz to Benton, 24 December 1934, ALS, Beinecke Library, Yale.

205. Letter from Benton to Stieglitz, 13 February 1921, ALS, Beinecke Library, Yale; Thomas Hart Benton, Interview in *The New York Times*, 8 February 1935, p. 23, in *A Thomas Hart Benton Miscellany*, p. 75.

206. Stuart Davis, [Reply to Thomas Benton], *Art Digest*, 1 April 1935, p. 13; reprinted in *Social Realism: Art as a Weapon*, ed. David Shapiro (New York: Frederick Ungar, 1973), pp. 102-07.

207. O'Keeffe, *Georgia O'Keeffe*, n.p.

208. Grant Wood, *Revolt Against the City* (Iowa City, Ia.: Whirling World Series, no. 1, 1935); reprinted in James M. Dennis, *Grant Wood: A Study in American Art and Culture* (New York: Viking Press, 1975), pp. 229-35.

209. Williams, "Good . . . For What?" p. 251; William Carlos Williams, "The Flower," *U.S.A.: A Quarterly Magazine of the American Scene*, no. 1 (Spring 1930): 31. The poem is in *Collected Earlier Poems*, pp. 236-38. Other artists who appeared in *U.S.A.* included Charles Sheeler, Yasuo Kuniyoshi, Walker Evans, Edward Weston, Isamu Noguchi, and Reginald Marsh.

210. William Carlos Williams, "The Farmer," (untitled, designated III), in *Spring and All* in *Imaginations*, pp. 98-99.

211. Lincoln Kirstein, "An Iowa Memling," *Art Front* I, no. 6 (July 1935): 8. See, too, Clarence Weinstock, "Joe Jones," *Art Front* I, no. 6 (July 1935): 6; "Joe Jones," *Direction* I, no. 2 (January 1938): 22-23; William Carlos Williams, "An American Poet," *The New Masses* XXV, no. 9 (23 November 1937): 17-18.

212. Ben Shahn, Interview, *Ben Shahn* ed. John D. Morse (New York: Praeger, 1972), pp. 135-39; Eleanor Roosevelt, "The Roosevelts Come to Arthurdale," in *The Thirty-Fifth State: A Documentary History of West Virginia*, ed. Elizabeth Cometti and Festus P. Summers (Morgantown: West Virginia University Library, 1966), p. 568.

213. Shahn also vacationed with Evans at Truro on Cape Cod. Shahn has recounted the photography "lesson" he received from Evans: "Well, it's very easy, Ben. F9 on the sunny side of the street. F45 on the shady side of the street. For 1/20 of a second hold your camera steady" (*Ben Shahn*, p. 135).

214. Lincoln Kirstein, "Photographs of America: Walker Evans," *American Photographs* (New York: Museum of Modern Art, 1938), pp. 194, 196; William Carlos Williams, "Sermon with a Camera," *The New Republic*, 12 October 1938, p. 282.

215. Kirstein, "Photographs of America: Walker Evans," p. 197; Williams, "Sermon with a Camera," pp. 282-83.

216. William Carlos Williams, manuscript for "Sermon with a Camera," C18b, Lockwood Memorial Library, SUNY Buffalo.

217. Williams, *Kora in Hell*, p. 10; Nathanael West, "Some Notes on Violence," *Contact*, second series I, no. 3 (October 1932): Williams, "McAlmon," manuscript B87a, Lockwood Memorial Library, SUNY Buffalo. Williams vigorously defended *Miss Lonelyhearts* in his review of the novel, "Sordid? Good God!" *Contempo* III, no. 2 (25 July 1933): 5,8.

218. Letter from Hartley to Stieglitz, 9 October 1923, ALS, Beinecke Library, Yale.

219. *Contact*, second series I, no. 1 (February 1932), title page; letter from Williams to Zukofsky, 17 February 1932, TLS, Humanities Research Center, University of Texas; Williams, "How to Write," *New Directions in Prose and Poetry*, no.1 (1936): n.p. Compare with André Breton, *Manifesto of Surrealism* (1924) in *Manifestoes of Surrealism*, tr. Richard Seaver and Helen R. Lane (Ann Arbor: University of Michigan Press, 1969), pp. 29-30. Nicolas Calas, *Wrested from Mirrors*, tr. William Carlos Williams, with an etching by Kurt Seligmann (New York: Nierendorf Gallery, 1941). For a more detailed account of Williams and Surrealism, see Weaver, *Williams*, pp. 18-56; for Surrealism and American painting, see Jeffrey Wechsler, *Surrealism and American Art, 1931-1947* (New Brunswick, N.J.: Rutgers University Art Gallery, 1977).

220. Adolf Wolf, "Jamais!" *Art Front* II, no. 12 (January 1937): 18.

221. Although Castellón was classified as independent of the Dada and Surrealist movements in *Fantastic Art, Dada, Surrealism* (ed. Alfred H. Barr, Jr. [New York: Museum of Modern Art, 1936]), he obviously attended to Surrealist imagery and knew what the movement was all about.

222. Pickett's *Coryell's Ferry* was included with work by Arp, Calder, Miró, and Schwitters, among others, prefaced by an essay by James Johnson Sweeny, "Seeing and Representation," *transition*, no. 24 (June 1936): 62-66; for Sheeler's photographs of the Ford plant see Eugene Jolas, "The Industrial Mythos," *transition*, no. 18 (November 1929): 123.

223. See Charles Henri Ford, *ABC's for the children of no one, who grows up to look like everyone's son* (Prairie City, Ill.: James A. Decker Press, 1940). Cornell's first one-man exhibition at the Julien Levy Gallery was held 6 December-9 January 1940. (For a schedule of Cornell's appearances at the Julien Levy Gallery, see Levy, *Memoir of an Art Gallery*, pp. 296-312.) On 25 January 1940 Williams wrote to Charles Henri Ford: "I finally got in to see the 'objects' but whether I shall be able to get in tomorrow (Thursday) is more than I can say" (ALS, Humanities Research Center, University of Texas). The evidence is circumstantial, but perhaps those "objects" were Cornell's "Surrealist Objects," as his exhibition was entitled.

224. William Carlos Williams, "Paterson," *The Dial* LXXXII, no. 2 (February 1927): 91-93; the poem is also in *Collected Earlier Poems*, pp. 233-35.

225. See Breton, *Manifesto of Surrealism* in *Manifestoes of Surrealism*, pp. 10-14.

226. William Carlos Williams, "An Afternoon with Tchelitchew," *Life and Letters Today* XVII, no. 10 (Winter 1937): 55-58. The essay has been reprinted in *Selected Essays*, pp. 250-54, though it has been mistakenly identified as a later essay on Tchelitchew in *View*.

227. Letter from Williams to Ford, 25 March 1937, TLS, Beinecke Library, Yale.

228. William Carlos Williams, "The Tortuous Straightness of Charles Henri Ford," in Charles Henri Ford, *The Garden of Disorder and Other Poems* (Norfolk, Conn.: New Directions, 1938), pp. 9-10. (Also in *Selected Essays*, pp. 235-36.)

229. Philip Evergood quoted in John I. H. Baur, *Philip Evergood* (New York: Harry N. Abrams, 1975), p. 36; Williams, "The Tortuous Straightness of Charles Henri Ford," p. 10.

Epilogue: "Against the Weather"

230. Letter from Williams to Ford, 30 March 1938, TLS, Beinecke Library, Yale; Williams, [Statement], *Writers Take Sides: Letters about the War in Spain from 418 American Authors* (New York: League of American Writers, 1938), p.64.

# Selected 153
# Bibliography

Aaron, Daniel. *Writers on the Left.* New York: Oxford University Press, 1977.

Agee, James, and Walker Evans. *Let Us Now Praise Famous Men.* Boston: Houghton Mifflin, 1941.

Agee, William C. *The 1930's: Painting and Sculpture in America.* New York: Whitney Museum of American Art, 1968.

Andrews, Edward D. *The People Called Shakers.* New York: Dover, 1963.

Ashton, Dore. *A Joseph Cornell Album.* New York: Viking Press, 1974.

Baigell, Matthew. *The American Scene: American Painting of the 1930s.* New York: Praeger Publishers, 1974.

_____. *Thomas Hart Benton.* New York: Harry N. Abrams, 1973.

Breslin, James E. *William Carlos Williams, An American Artist.* New York: Oxford University Press, 1970.

Brown, Milton H. *The Story of the Armory Show.* New York: Joseph Hirshhorn Foundation, 1963.

Bry, Doris. *Alfred Stieglitz: Photographer.* Boston: Museum of Fine Arts, 1965.

Carter, Dan T. *Scottsboro: A Tragedy of the American South.* Baton Rouge: Louisiana State University Press, 1969.

*Catalogue of the Collection: Whitney Museum of American Art.* Intro. by John I. H. Baur. New York: Whitney Museum of American Art, 1974.

Coles, Robert. *William Carlos Williams: The Knack of Survival in America.* New Brunswick, N.J.: Rutgers University Press, 1975.

Cowley, Malcolm. *Exile's Return.* New York: Viking Press, 1951.

Dennis, James M. *Grant Wood: A Study in American Art and Culture.* New York: Viking Press, 1975.

Dijkstra, Bram. *The Hieroglyphics of a New Speech: Cubism, Stieglitz, and the Early Poetry of William Carlos Williams.* Princeton, N.J.: Princeton University Press, 1969.

_____, ed. *A Recognizable Image: William Carlos Williams on Art and Artists.* New York: New Directions, 1978.

Dochterman, Lillian. *The Quest of Charles Sheeler.* Iowa City: University of Iowa Press, 1963.

Driskell, David C. *Two Centuries of Black American Art.* New York: Los Angeles County Museum of Art and Alfred A. Knopf, 1976.

Farnham, Emily. *Charles Demuth: Behind a Laughing Mask.* Norman: University of Oklahoma Press, 1971.

Ford, Hugh. *Published in Paris: American and British Writers, Printers, and Publishers in Paris, 1920-1939.* New York: Macmillan, 1975.

Frank, Waldo, Lewis Mumford, Dorothy Norman, Paul Rosenfeld, and Harold Rugg, eds. *America and Alfred Stieglitz.* New York: Literary Guild, 1934.

Friedman, Martin L. *Charles Sheeler.* New York: Watson-Guptill Publications, 1975.

_____. *The Precisionist View in American Art.* Minneapolis, Minn.: Walker Art Center, 1960.

Gilbert, James Burkhart. *Writers and Partisans: A History of Literary Radicalism in America.* New York: John Wiley & Sons, 1968.

Goodrich, Lloyd, and Doris Bry. *Georgia O'Keeffe.* New York: Whitney Museum of American Art, 1970.

Guimond, James. *The Art of William Carlos Williams.* Urbana: University of Illinois Press, 1968.

Haskell, Barbara. *Arthur Dove.* San Francisco: San Francisco Museum of Art, distrib. by New York Graphic Society, Boston, 1974.

Hoffman, Frederick J., Charles Allen, and Carolyn F. Ulrich. *The Little Magazine.* Princeton, N.J.: Princeton University Press, 1946.

Homer, William I. *Alfred Stieglitz and the American Avant-Garde.* Boston: New York Graphic Society, 1977.

_____, ed. *Avant-Garde Painting and Sculpture in America 1910-25.* Wilmington: Delaware Art Museum, 1975.

Howe, Irving, and Lewis Coser, with the assistance of Julius Jacobson. *The American Communist Party, A Critical History, 1919-1957.* Boston: Beacon Press, 1957.

Huggins, Nathan I. *Harlem Renaissance.* New York: Oxford University Press, 1971.

Josephson, Matthew. *Infidel in the Temple: A Memoir of the Nineteen-Thirties.* New York: Alfred A. Knopf, 1967.

_____. *Life Among the Surrealists.* New York: Holt, Rinehart and Winston, 1962.

Kammen, Michael. *People of Paradox.* New York: Alfred A. Knopf, 1974.

Knoll, Robert. *Robert McAlmon.* Lincoln: University of Nebraska Press, 1957.

Lane, John R. *Stuart Davis: Art and Art Theory.* Brooklyn, N.Y.: The Brooklyn Museum, 1978.

Larkin, Oliver W. *Art and Life in America.* New York: Holt, Rinehart, and Winston, 1964.

Lasch, Christopher. *The New Radicalism in America, 1889-1963: The Intellectual as a Social Type.* New York: Alfred A. Knopf, 1965.

Levy, Julien. *Memoir of an Art Gallery.* New York: G.P. Putnam's Sons, 1977.

156

Lipman, Jean, and Alice Winchester. *The Flowering of American Folk Art, 1776-1876*. New York: Viking Press in cooperation with the Whitney Museum of American Art, 1974.

McAlmon, Robert. *Being Geniuses Together: 1920-1930*. Revised and with supplementary chapters by Kay Boyle. Garden City, N.Y.: Doubleday, 1968.

McCabe, Cynthia Jaffee. *The Golden Door: Artist-Immigrants of America, 1876-1976*. Washington, D.C.: Smithsonian Institution Press, 1976.

McCausland, Elizabeth. *Marsden Hartley*. Minneapolis: University of Minnesota Press, 1952.

McKinzie, Richard D. *The New Deal for Artists*. Princeton, N.J.: Princeton University Press, 1973.

McMillan, Dougald. *transition: The History of a Literary Era, 1927-1938*. New York: George Braziller, 1976.

Mangione, Jerre. *The Dream and the Deal: The Federal Writers Project, 1935-1943*. Boston: Little, Brown, 1972.

Martin, Jay. *Nathanael West: The Art of his Life*. New York: Farrar, Straus, and Giroux, 1970.

Millard, Charles W., III. *Charles Sheeler: American Photographer*. In *Contemporary Photographer* VI, no. 1 (1967).

Miller, J. Hillis. *Poets of Reality: Six Twentieth-Century Writers*. Cambridge, Mass.: Harvard University Press, 1966.

Norman, Dorothy. *Alfred Stieglitz: An American Seer*. New York: Random House, 1973.

Norwood, Christopher. *About Paterson: The Making and Unmaking of an American City*. New York: Saturday Review Press, 1974.

O'Keeffe, Georgia. *Georgia O'Keeffe*. New York: Viking Press, 1976.

Park, Marlene, and Gerald E. Markowitz. *New Deal for Art: The Government Art Projects of the 1930s with Examples from New York City and State*. Hamilton: Gallery Association of New York State, 1977.

*Paul Strand: Sixty Years of Photographs*. Profile by Calvin Tomkins. Millerton, N.Y.: Aperture, 1976.

Pells, Richard. *Radical Visions and American Dreams*. New York: Harper and Row, 1973.

Richter, Hans. *Dada: Art and Anti-Art*. New York: McGraw-Hill, 1965.

Rodman, Selden. *Portrait of the Artist as an American. Ben Shahn: A Biography with Pictures*. New York: Harper, 1951.

Rose, Barbara. *American Art Since 1900: A Critical History*. New York: Frederick A. Praeger, 1967.

Rubin, William S. *Dada, Surrealism and Their Heritage*. New York: Museum of Modern Art, 1968.

Shapiro, David, ed. *Social Realism: Art as a Weapon*. New York: Frederick Ungar Publishing, 1973.

Stott, William. *Documentary Expression and Thirties America*. New York: Oxford University Press, 1973.

Stryker, Roy Emerson, and Nancy Wood. *In This Proud Land: America 1935-1943 as Seen in the FSA Photographs*. Greenwich, Conn.: New York Graphic Society, 1973.

Tashjian, Dickran. *Skyscraper Primitives: Dada and the American Avant-Garde 1910-1925*. Middletown, Conn.: Wesleyan University Press, 1975.

Taylor, Joshua. *America as Art*. Washington, D.C.: Smithsonian Institution Press, 1976.

Terkel, Studs. *Hard Times*. New York: Random House, 1970.

Tyler, Parker. *The Divine Comedy of Pavel Tchelitchew*. New York: Fleet Publishing, 1967.

Waldman, Diane. *Joseph Cornell*. New York: George Braziller, 1977.

Wallace, Emily. *A Bibliography of William Carlos Williams*. Middletown, Conn.: Wesleyan University Press, 1968.

Weaver, Mike. *William Carlos Williams: The American Background*. Cambridge: Cambridge University Press, 1971.

Wechsler, Jeffrey. *Surrealism and American Art, 1931-1947*. New Brunswick, N.J.: Rutgers University Art Gallery, 1977.

Whittaker, Thomas R. *William Carlos Williams*. New York: Twayne Publishers, 1968.

Whittemore, Reed. *William Carlos Williams: Poet from Jersey*. Boston: Houghton Mifflin, 1975.

Wilder, Mitchell, ed. *Georgia O'Keeffe*. Fort Worth, Tex.: Amon Carter Museum of Western Art, 1966.

Williams, William Carlos. "Appreciation." *John Marin Memorial Exhibition*. Los Angeles: Art Galleries, University of California, 1955.

———. *The Autobiography*. New York: Random House, 1951.

———. *The Collected Earlier Poems*. Norfolk, Conn.: New Directions, 1951.

———. *The Collected Later Poems*. Norfolk, Conn.: New Directions, 1950.

———. *The Embodiment of Knowledge*. Ed., Ron Loewinsohn. New York: New Directions, 1974.

———. *The Farmers' Daughters*. Norfolk, Conn.: New Directions, 1961.

———. *I Wanted to Write a Poem*. Reported and edited by Edith Heal. Boston: Beacon Press, 1958.

———. *Imaginations*. Ed., Webster Schott. New York: New Directions, 1970.

———. *In the American Grain*. New York: New Directions, 1956.

_____. "Introduction." *Charles Sheeler: Paintings, Drawings, Photographs*. New York: Museum of Modern Art, 1939.

_____. *Paterson*. Norfolk, Conn.: New Directions, 1963.

_____. *Pictures from Brueghel*. Norfolk, Conn.: New Directions, 1962.

_____. *Selected Essays*. New York: Random House, 1954.

_____. *The Selected Letters*. Ed., John C. Thirlwall. New York: McDowell, Obolensky, 1957.

_____. *Yes, Mrs. Williams: A Personal Record of My Mother*. New York: McDowell, Obolensky, 1959.

Bruce Alter, Figs. 81, 82

John Barry, Fig. 107

E. Irving Blomstrann, Figs. 100, 101

Barney Burstein, Fig. 45

Geoffrey Clements, Pls. II, III, V, VI, VII, X, XI, XIII, XV, XVI, frontispiece, Figs. 6, 7, 8, 9, 10, 12, 13, 15, 24, 26, 32, 33, 36, 37, 43, 48, 51, 52, 56, 57, 58, 59, 65, 66, 69, 71, 72, 75, 78, 79, 80, 84, 85, 86, 90, 93, 94, 97, 98, 99, 103, 104, 109, 110, 120, 123, 124, 125, 126, 128

Bevan Davies, Fig. 121

John Ferrari, Fig. 55

Edward Hipple, Figs. 14, 91

P.C. Rainford, Figs. 68, 95, 115, 116

Sandak, Inc., Fig. 4

Arthur Siegel, Fig. 50

Joseph Szaszfai, Figs. 22, 23

Taylor & Dull, Inc., Fig. 89

Jerry Thompson, Figs. 49, 87

Charles Uht, Fig. 108

Malcolm Varon, Pl. VIII

A.J. Wyatt, Figs. 17, 18, 19, 20

Designed by Creative Arts for Industry       159
Exhibit Design by Art Clark
Typeset by Just Your Type, Upper Saddle River, New Jersey
Printed by William J. Mack Company, North Haven, Connecticut